Julian Spalding

THE BEST ART YOU'VE NEVER SEEN

101 HIDDEN TREASURES FROM AROUND THE WORLD

ROUGH GUIDES

www.roughguides.com

Credits

Rough Guides Reference

Reference Director: Andrew Lockett
Editors: Kate Berens, Tom Cabot, Tracy Hopkins, Matthew Milton,
Joe Staines and Ruth Tidball

The Rough Guide to The Best Art You've Never Seen

Editing: Joe Staines
Design and layout: Diana Jarvis
Picture research: Joe Staines
Proofreading: Jason Freeman, Gillian Tait

Thanks are due to the following for help in tracking down the more elusive images: Fionnuala Cavanagh, Stephanie Seegmuller, Natasha Foges, Evaldas Jocys and Ingo Hessel. Thanks also to Kate Berens for her wide-ranging help during the book's final editorial stages.

Publishing information

This first edition published October 2010 by
Rough Guides Ltd, 80 Strand, London WC2R 0RL
3rd Floor, Mindmill Corporate Tower, Plot No. 24A, Sector 16A Film City, Noida – 201 301 (U.P.), India
Email: mail@roughguides.com

Distributed by the Penguin Group
Penguin Books Ltd, 80 Strand, London WC2R 0RL
Penguin Group (USA) 375 Hudson Street, NY 10014, USA
Penguin Group (Australia) 250 Camberwell Road, Camberwell, Victoria 3124, Australia
Penguin Books Canada Ltd, 10 Alcorn Avenue, Toronto, Ontario, Canada M4V 1E4
Penguin Group (NZ) 67 Apollo Drive, Mairangi Bay, Auckland 1310, New Zealand

Typeset in SeriaPro to an original design by Diana Jarvis
Printed and bound in Singapore by Teinwah Press Ltd.

288pp; includes index

A catalogue record for this book is available from the British Library

ISBN: 978-1-84836-271-0

The publishers and authors have done their best to ensure the accuracy and currency of all the
information in **The Best Art You've Never Seen**, however, they can accept no responsibility
for any loss, injury, or inconvenience sustained as a result of information or advice contained in the guide.

1 3 5 7 9 8 6 4 2

The Best Art You've Never Seen

Julian Spalding

Contents

Introduction

This book is about looking at art. That may sound simple enough, but modern artistic theories have made this business unnecessarily convoluted. Two ideas in particular – that art can exist for its own sake (as if anything can), and that *anything* can be art – have so clouded the debate that art itself has become hidden. The old cliché runs, "I don't know much about art, but I know what I like", but the truth is that you only have to look at art to know about it. The proof is in the looking. If a work of art doesn't speak to you, there's a strong chance that it actually has nothing to say.

But how do you recognize art? You know it when you see it – and seeing is everything. Art lights up the place where it is, a wall, a room, all around you. Art glows in your mind. When you look at it, it makes you more visually alert, more conscious, more alive. It's this uplifting mental light that I look for when hunting for art: the stimulus you get from looking at expressions of real feeling. The trouble is that for every artist who is genuinely inspired there are hundreds, if not thousands of would-be artists who dress themselves up in artistic clothes. And of course few artists are on top form all the time; even great ones produce dull, lifeless works now and then. The only way to sort out genuine, strong art from weak imitation is to look at it and trust your responses. Much genuine art is hidden in every generation, often sidelined by the showy creations of shallow self-promoters and, in our day, by a bevy of conmen and chancers. It's a long drawn-out process, weeding out the art that's worth looking at, and which everyone should have the chance to see, but that's what I've spent a lifetime doing in my career in galleries and museums: hunting for art that truly merits public display and that can have a lasting impact.

I chose this career because I wanted to show real works of art to people, rather than droning on about slides in darkened rooms or, for that matter, writing art books illustrated with glossy prints. So why have I written this one? Because this book is about looking at art beyond the page. My work in museums involved handling art, lifting paintings, moving sculptures and sorting through prints, watercolours and drawings. I knew the backs of pictures as well as their fronts, felt the weight of objects and became familiar with how they'd been made. I became intensely aware that art was the product of human hands as well as minds. Like seeing behind the scenes in a theatre, it made works of art more accessible for me, and less mysterious – but at the same time my admiration grew for the artistry and imagination that went into their making. So began a lifetime of looking at real art, in museums, galleries and wherever I could around the world, in the locations the work was made for and where it still survived. I came increasingly to prefer art in its living context, rather than the inevitably artificial and often, regrettably, precious atmosphere of museums. This book is a gleaning from a great many memorable hours spent with art around the world. If it doesn't inspire its readers with the desire to go and see some of these things for themselves, it will have failed.

Seeing real art is almost always surprising. First of all there's its scale. Most people glaze over when reading the height, width and depth of an object, but even if you persevere and try to imagine it in your mind's eye, seeing it in three-dimensional reality is a totally different experience. Then you don't have to calculate; all you do is feel. The immensity of the Kailash Temple

in India (see p.90), by far the largest single carved stone block in the world, is simply staggering. How, you wonder, can this weight be carried by carved elephants with such delicately waving ears? Your mind reels as you imagine the labour involved in the exquisite delicacy of the carving, and your heart cries out at its terrible destruction. When you see how small the Trundholm Chariot (see p.55) actually is, its original use as an educational toy quickly ceases to be theoretical and becomes obvious. When you walk into one of the caves at Mogao in China (see p.22), your fears fall away and you sense your spirits soaring. None of these sensations can be truly gained from looking at pictures in books.

There is a growing assumption among public officials responsible for looking after the world's great works of art that providing virtual access to them is enough, while the treasures themselves remain safely tucked up in stores. But, it has to be asked, what's the point of keeping them in the public domain if no one can see them? They might as well be sold off to the highest bidder, solving at a stroke a nation's debt crisis. But our lives would be much depleted if great works of art are lost from sight. There's a world of difference between looking at a facsimile of *Les Très Riches Heures du Duc de Berry* (see p.228) and seeing an actual page of the manuscript. On one level, it's the difference between looking at a sleek, modern, manufactured glass and seeing a lumpy medieval one, green-swirled with bubbly imperfections. That's the difference between an age when everything was handmade and our own era of impersonal mass production. Pixel images on computer screens are one further remove from direct physical contact. Seeing the shadow of a calf's backbone in the buckled surface of vellum is evocative enough in

itself. But seeing the minute painstaking strokes of the artist, laid down on this uneven surface, is like watching a medieval painter at work. In museums you can see the actual touch of Leonardo. This revelatory intimacy is lost in reproduction and evaporates in virtual simulation.

One of the great strengths of visual art is that, like music, it can communicate directly across language barriers. The meaning of art from far-off times and cultures can hit us suddenly, like a lightning flash. It's only later, if we listen carefully, that we hear the boom that locates the source of the explosion. I've tried to use words to trace these sources of artistic inspiration, to evoke some of the beliefs, thoughts and feelings that went into the making of the works of art I've illustrated. But I'm painfully aware that words are clumsy when used to describe purely visual sensations. Verbal descriptions can never be more than an approximation of experiencing the real thing. All art worthy of the name is multi-layered, and a book of this kind can only lift one or two veils on meanings that might at first be buried. This book is only a beginning, a stimulus to further looking. The real art that it's about is hidden beyond it.

Much art has always been hidden, but in different ways. While working on this book, it amused me to discover that *Hihokan*, the term used for the erotic museums which proliferate throughout Japan, means House of Hidden Treasures. This book is a child of its time, produced in an age and within a culture in which sex is on open display. The Warren Cup (see p.141) and *The Origin of the World* (see p.138) are now on permanent exhibition in major public museums in London and Paris. This would have been inconceivable

fifty years ago; even twenty-five years ago the police would probably have been called. Sadly the inclusion of such images in this book is likely to restrict its sales in Islamic countries, though *The Origin of the World* was in fact commissioned by a Muslim. Chapter 5 also includes some haunting images of death, produced in an age when funerals were very public affairs. Nowadays we shuffle death out of the way, preferring not to see or think about human mortal remains.

The Best Art You've Never Seen could have been solely about obscure works of art around the world which deserve to be better known. If I'd had an unlimited budget, that would have been possible, for few things would delight me more than to travel the world in search of hidden treasures, both from past cultures and within contemporary societies. But such a book would cost a small fortune, not just in airfares but, more significantly, in fees for photography and the publishing of images. The cost of the latter has escalated dramatically in the last few years, and many wonderful things which I initially wanted to include have proved prohibitively expensive to illustrate in a book of this type, aimed at reaching a wide public and selling at a reasonable price. Public access to works of art is being restricted by the extortionate financial demands of their custodians. These include many leading museums which, in their ceaseless imperative to generate income, have sadly compromised their educational remit. The art we predominantly see in the modern world is increasingly the art that someone with a vested interest – usually a dealer – has paid for us to see.

The 101 artworks illustrated in this book have all, at some point or in some way, been hidden from view. But the book is not solely about the hidden meanings of art that are not at first apparent, and it doesn't just illustrate neglected art that ought to be better known – worthy though such a project would be. Instead, it takes a broader view, examining in what ways art is hidden today and asking whether it could make a greater contribution to our lives. The answer to this latter question is surely a resounding yes. While claiming to be the custodians of art, nearly all museums bury countless treasures in storerooms, the worst being those that harbour loot from imperial times. In France, the cultural establishment allows two of the world's greatest works of art, the *Très Riches Heures du Duc de Berry* (see p.228) and the *Mona Lisa* (see p.237) to remain hidden: one never to be publicly displayed, the other doomed to remain disfigured by layers of discoloured varnish. This book is a plea for the right to see the great art of the world. More than that, it is a *cri de coeur* for the creation and showing of much better art today. If readers put down this book feeling more ambitious about what they would like to receive through their eyes, it will have done its job.

Julian Spalding
Edinburgh, 2010

Acknowledgements

This book is indebted to all those who have shared their enthusiasms with me. The number is countless through a long professional life, but I'd like to mention a few who are relevant to the contents in this book. Stanley Simmonds, who taught me art at school, introduced me to the work of the medieval sculptor Gislebertus; Philip Rawson, the oriental curator, to the Indian miniatures of Nihal Chand; Frank Constantine, my last boss, who encouraged my broad view of art, and told me to go and see the Mesdag Panorama; the painter Rose Hilton who told me about David Kemp; the gallery dealer Rebecca Hossack who showed the works of Mathias Kauage; David Phillips, the museum curator and writer, who enthused about Čiurlionis and Kula canoes; Linda Reynolds, the Renaissance lecturer, who told me about the monasteries of Moldavia; Tim Stead, the furniture maker and sculptor, who showed me the works of Eduard Bersudsky who, when I got to know him, in turn, introduced me to the sculptures of Enku. And so it went on, and, thankfully, goes on. Some artists' works I stumbled on by chance. Walking into Peter Angermann's exhibition in Nuremberg was like diving into a bath of exuberant colour. I couldn't believe what I was looking at as I tried to make out Francesco Pianta's carvings in the gloom beneath Tintoretto's paintings at San Rocco in Venice. I was similarly bewildered when I wandered into the museum in the undercroft of Westminster Abbey – how was it that I'd never heard about such wonderful things, and could they really be that old? But again I was dependent on people I didn't know choosing to show these works of art, and beyond them, of course, to the artists who'd created them in the first place. Looking at art is a way of making contact with people, and I want to thank everyone who has aided me on this journey of discovery.

I would like to thank Andrew Lockett for suggesting that I write this book, and Louise Greenberg for her advice and encouragement, particularly in its early stages when I became discouraged by the prohibitive expense of illustrating many items on my initial list. I would like to thank my darling wife Gillian who has accompanied me, over the years, on voyages in search of art, who introduced me to many little known artistic treasures in her favourite country, Italy, who compiled much of the locations list, and who read through what I wrote with her Scot's eye for precise, grammatical expression. The text has benefitted immensely from her painstaking exactitude. This book is based largely on works of art I've known about, not on new searches, but I'd like to thank several friends who've helped us by providing foreign bases, particularly Paddy Barras, Linda Reynolds, Anna and Mike Sixsmith, Irene Lassus and David Phillips. Above all, I must express my gratitude to my editor at Rough Guides, Joe Staines, who has kept a rigorous intellectual grip on what could have been rather a sprawling concept, and who has obliged me, through unrelenting questioning, to spell out exactly what I mean, and who has tenaciously pursued, showing considerable negotiating skills, many of the more elusive images in this book. And, finally, my thanks go to the designer, Diana Jarvis, who has in her black and white treatment instinctively understood my ambition for this book: to inspire further interest in art and challenge received opinion.

101 Hidden Treasures

from Around the World

1 Hidden by Chance

The art of past ages survives almost entirely by accident. Most of it was destroyed by the ages that came after, pilfered for reusable materials, like metal, wood and stone; left to rot in abandoned temples, public buildings and sacred sites; or deliberately hacked to pieces by people who believed in different gods, heroes and moral orders. It's only in modern times, and still mainly in Western societies, that people have sought out the art of foreign cultures from the past and preserved it for its own sake. And it's only recently that we've come to believe in something called "art", which transcends beliefs and time. The people who painted and carved images of their gods would be aghast to see them exposed to public gaze in our galleries and museums. These survivals are, in any case, extremely fitful – generally the results of luck rather than judgement – even from ages as near to us as the Renaissance. Yet we confidently build up a picture from them and talk about "World Art", when the vast bulk of human artistic output, including countless masterpieces, is lost forever. The chance survivals that we treasure merely hint at the wonders that have gone. What's surprising is that a rock fall in a cave, the diversion of a stream or a storm at sea have preserved works of art of such quality. These can't have been exceptions, but standard productions. The truth is that our ancestors created many more beautiful things than we can now possibly imagine.

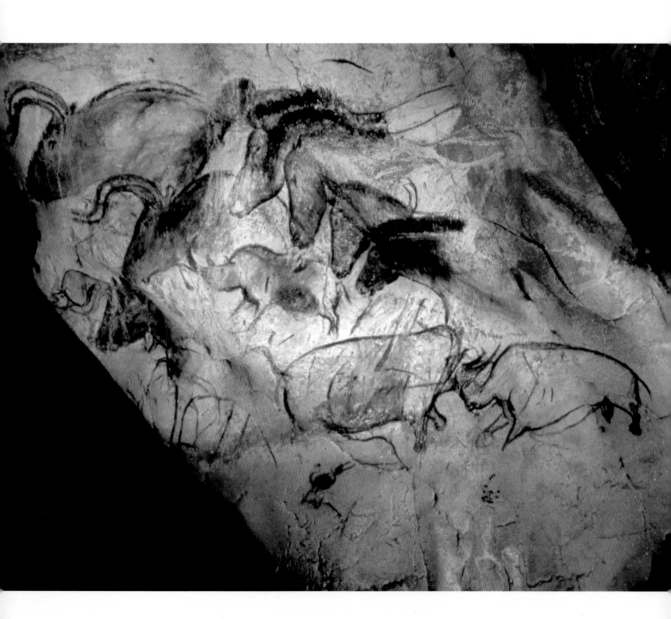

Chauvet Cave

Artists unknown

Charcoal on rock | c.30,000 BCE | Vallon-Pont-d'Arc, Ardèche, France

T he world's oldest paintings were discovered in 1994. The French cave expert, or speleologist, Jean-Marie Chauvet and his two colleagues felt a draught coming out of a fissure in a cliff, which they knew could mean a hidden cave. Picking away fallen rubble, they crept through a cavity into a rock chamber. They trod carefully, in each other's footsteps, fearful of disturbing any vestiges from prehistoric times. This led them to one of the most remarkable finds of modern times – a network of elaborately painted caves, untouched since the entrance to them was buried by a landfall, perhaps 20,000 years ago.

The facts emerging from Chauvet are changing history. Radiocarbon dating indicates that some of the images were painted as long ago as 30,000 BCE, which makes them twice the age of the more famous paintings at Lascaux, and by far the oldest known art in the world. People didn't live in these caves. Remains have been found of small fires, for use as lighting, but no evidence of cooking, nor of any other day-to-day activity. These paintings were not decorations for a domestic environment, or an early kind of art gallery – there is no evidence of shuffling feet. Nor is there any indication of ritual activity, altars or sacrifices, or even of intermittent shamanistic ceremonies. The skull of a bear found resting on a boulder seems likely to have been put there casually, out of the way; bears used the caves at various times, and many had died in them. Nothing suggests that this was an altar for a "bear cult", as some have imagined. There is no sign of anything but the activity of painting itself, deep underground.

Even more mysterious are the images: lions, rhinoceroses, horses; few of the animals painted were hunted for food. Reindeer and fish formed the staple diet of these people, but depictions of them are absent. These paintings were not created to improve the hunt, as the most commonly accepted interpretations of cave art would have it. What, then, were they for?

We can only guess. Virtually nothing remains of these people's daily lives or beliefs. We don't even know if they painted images of themselves. But if they could paint animals like this, they could have painted anything. What's telling is what they didn't paint – there are no clouds, mountains, grass or trees in Paleolithic art, and people are at most only summarily indicated. But the beasts are gloriously living, never frozen contours but roaming lines, forever charging, prowling, grazing on the hills far above their creators' heads. It's highly likely that that is what these painters were doing – creating. They were drawing life out of the living rock, deep in the fearful bowels of the earth. They drew them as creatures emerging. Perhaps these were the beasts which had imparted strength and majesty to the ancestors of their tribe. They imagined them appearing in the shadows shifting in the firelight. And they drew them one on top of the other, because the Earth, like any mother, could give birth to many young. What we are watching on these walls is a womb giving life.

The French government has decreed that the Chauvet Cave will never be open to the public. Our earliest and, in its majestic vigour, our greatest art, will remain a hidden treasure forever.

Tuc d'Audoubert Bison

Artist unknown

Unglazed clay | 60cm long | c.12,000 BCE | Tuc d'Audoubert Cave, Ariège, France

The distinction between painting and sculpture is a modern construction. People must have modelled as soon as they drew, and our earliest pictures were done on bulging surfaces. We are the same as the people who emerged out of Africa 150,000 years ago. The first human children, playing on a beach, would be indistinguishable from kids today. It is an extraordinary but seldom observed fact that children's art is the same all over the world; it only becomes different when children begin to imitate grown-ups. Given who we are, how can we not have drawn faces in the sand and shaped wet clay in our fingers – fingers that rapidly had to learn how to make everything they needed? Some of our early pictures survive, scratched on isolated outcrops or hidden deep in caves but, strangely, hardly any sculptures. The reason for this is surely not that they didn't exist, but that they've either been lost through natural decay or, if cut in stone, destroyed purposefully by later tribes of different cultures. A handful of extraordinary survivals give a glimpse of what Stone Age sculpture looked like.

Hidden at the very back of the Tuc d'Audoubert cave in France, 9000 metres from the entrance, inaccessible to the public and reached only after an arduous, cramped crawl, is a chamber that was once very damp. About 15,000 years ago, someone went there to model two bison in clay. They cracked soon after their making, for the cave was already beginning to dry out. The artist's hand scrapes are clearly preserved nearby. Even

more remarkably, some heel prints were discovered in the clay floor which had been made by very young children. It has been suggested that they were dancing – but people usually dance on their toes. Children walk on their heels if they don't want to get their feet clogged with slippery mud. They're not frightened if they're doing that. It's more likely they were giggling loudly, to keep the ghouls at bay, while the adult with them was modelling. The bison are beautiful creations, absolutely confident in form, made by someone who had made bison before and knew every bone and muscle in their bodies. The expressions on their faces and their straggling fur were created with a few strokes and cuts. The finger marks are clearly visible, made as the hand swept over their soft clay backs. It was a loving act. And one bison, perhaps, is in the act of loving too, arching its back to impregnate the mud. Could this sculpture show man not just praising, but actually stimulating the Earth's creation? It would be understandable if this were so, for image-making must have seemed, then, to be a formidable power. No other creature could do it. The images made must have appeared to have had lives of their own, especially when eyes were added. That's why image-making is still hedged with taboos by many ancient religions, such as Hinduism and Islam. And it may also be one reason why so few sculptures survive from the Stone Age. They were created in special, perhaps desperate circumstances, as an act of faith, and destroyed later by others who feared their power.

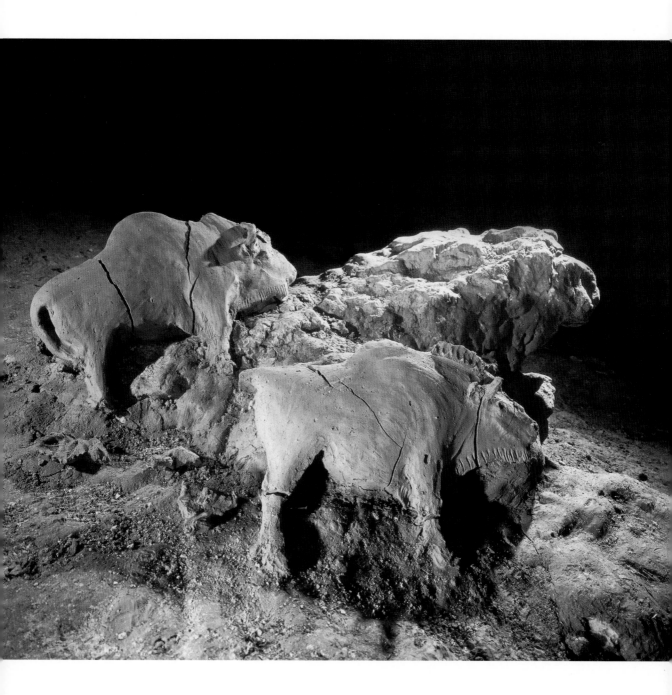

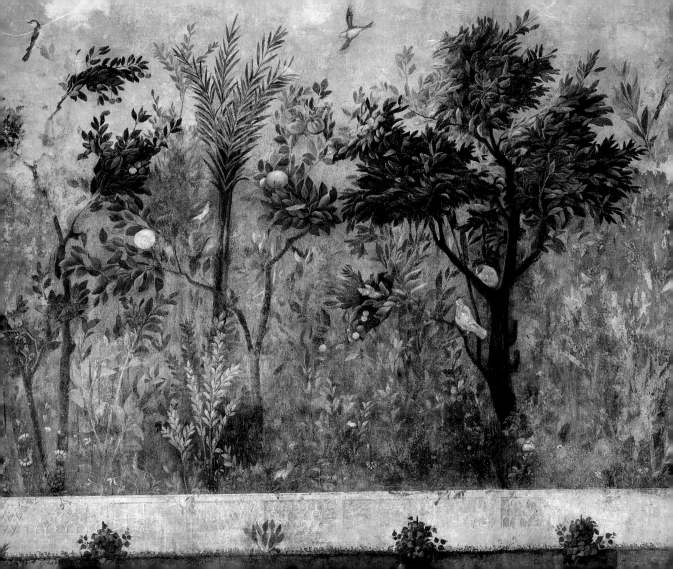

Villa of Livia Frescoes

Artist unknown

Fresco | c.1 CE | Museo Nazionale Romano, Rome, Italy

The little-visited National Museum of Rome occupies an old palace just beside Rome's central railway station. Most tourists hurry to leave this rather bleak locality, though the museum contains one of the most beautiful and rarest works of art in the city. On the top floor is a large, windowless room clad with frescoes from floor to ceiling. Entering it, you feel as if you are stepping into a garden. The illusion is created very simply. The floor is extended into a narrow painted border of grasses and squat bushes, with a low trellis wall behind, beyond which rise trees of many types. The effect might sound claustrophobic – like standing in the middle of a wood – but the scale is grand, and the illusionary setting continuing back in space over the low wall creates a feeling of airy expansiveness. And there is another reason for this sense of airiness, which, once you tune into it, quite takes your breath away. This isn't a regimented garden. Everything you can see is free-living and moving. The branches bend, the leaves rustle, the birds – swallows, orioles and blackbirds – balance, dip and fly high in the air against the slowly drifting summer clouds. This sensation of movement is gentle but all-pervasive, the perfect rendering of a refreshing summer breeze. The feeling of coolness is created not only by association but by tone.

What the painter, or more probably the painters, of this wonderful diorama observed in nature is that leaves are generally lighter underneath, so that when the wind blows they flip over to create a dappled effect of light and shade, as if they were reflections from water rippling underneath. The flying birds, too, reveal paler underwings. Nature seems to be saying that life is kinder out of the sun. For that was surely the purpose of this room – to provide a cool environment for eating and drinking and idling through the long, sweltering summer heat.

The room was originally an underground chamber off the terraced garden in the Villa di Livia, on a hill at Prima Porta, north of Rome. It was the home of Livia Drusilla (58 BCE – 29 CE), the wife of the emperor Augustus, for many decades the most powerful woman in Rome, and the founding mother of an imperial clan. Celestial signs attended the events of her life, as befitted anyone of eminence. On the morning of her marriage to Augustus in 38 BCE (after he had forced her first husband to divorce her), a white chicken with a laurel twig in its beak was dropped into her lap by an eagle. She bred a famed lineage of white hens from the chicken, and planted a laurel grove in her garden. This provides the backdrop to the fresco and adds to its significance. The painting is not just an evocation of a summer garden, but an image of an era of plenty initiated by Augustus' marriage to Livia. And there is yet another layer of meaning: it was a widely held belief in Ancient Rome that when a king died, trees wilted. The vigour in this painting is not just a cooling breeze. Fruits of all seasons ripen together – everything is well in the era of Augustus. This is the painted equivalent of "long live the king!"

Dancing Satyr of Mazara

Artist unknown

Bronze | 200cm | 3rd–2nd century BCE |
Museo del Satiro Danzante, Mazara del Vallo, Sicily, Italy

T he torso and head of this leaping figure were caught in the nets of fishermen trawling a sandy sea bed off the coast of Sicily in 1998. They returned a few weeks later and brought up his left leg, and the colossal foot of a bronze elephant! No one knows if these sculptures were related parts of a group, but the likelihood is that they were – perhaps a great Dionysian procession, complete with exotic beasts. There must originally have been hundreds of such sculptures. This is obvious just from the quality of the fragments that survive. Casting bronze is a tricky business, especially on this scale. The finest impressions are made by the lost wax process, in which a thin shell of wax is sandwiched between an inner shell, which will become the hollow core of the statue, and an outer mould whose inside has imprinted in it all the surface details of the sculpture, in reverse. The molten bronze is then poured in, in order to eject the wax shell without damaging the containing moulds – an extremely delicate procedure. The technique was known from at least 2000 BCE, from Mesopotamia across India to China, but the Greeks developed it to an extraordinary degree, and in this case on an elephantine scale.

The Greeks loved bronze, and the allegory of it: a hot liquid made permanent, like passion made lasting. They loved the shiny, skin-like quality of its finish, just as they rubbed their lithe, naked bodies with oil and bronzed them in the sun. And they loved the details that could be trapped in it – veins, fingernails

and twists of hair – for the Greeks were naturalists as well as naturists. Bronze enchanted them, even more than marble. The story of Greek sculpture is one of a gradually gathering crescendo, starting in stone and ending in bronze. It began with a majestic march of naked youths and draped girls, perfectly upright, putting their best feet forward and smiling gloriously, as the sun rose majestically at dawn. Slowly their positions eased, and grace flowed through every limb. They were still made of marble. But then bronze gave the Greeks the freedom to run and dance and – as with this satyr – fly.

It is not at all clear how this satyr was positioned, even which way up he was; he could easily have been doing a back somersault. A small cavity near the base of his spine is usually thought to have sported a tail, but that doesn't explain why this hole is off-centre. It could have been used for a supporting rod. But whatever its intended angle, the movement in this figure, tense through every muscle, is electrifying. Other cultures have created angels, but this is a body of sinew, flesh and blood. The Greeks, even when carried away, are all the more impressive for being down to earth. Their realism can be seen here in the hair, an extraordinary twisted knot, as if he's just got out of the bath. Only the pointed ears betray this creature's otherworldliness. He's a satyr, part goat or horse, a wild follower of Dionysus, the god of wine, who dances through the forest and makes love to everyone. No wonder his alabaster eyes – though they've lost their pupils – shine.

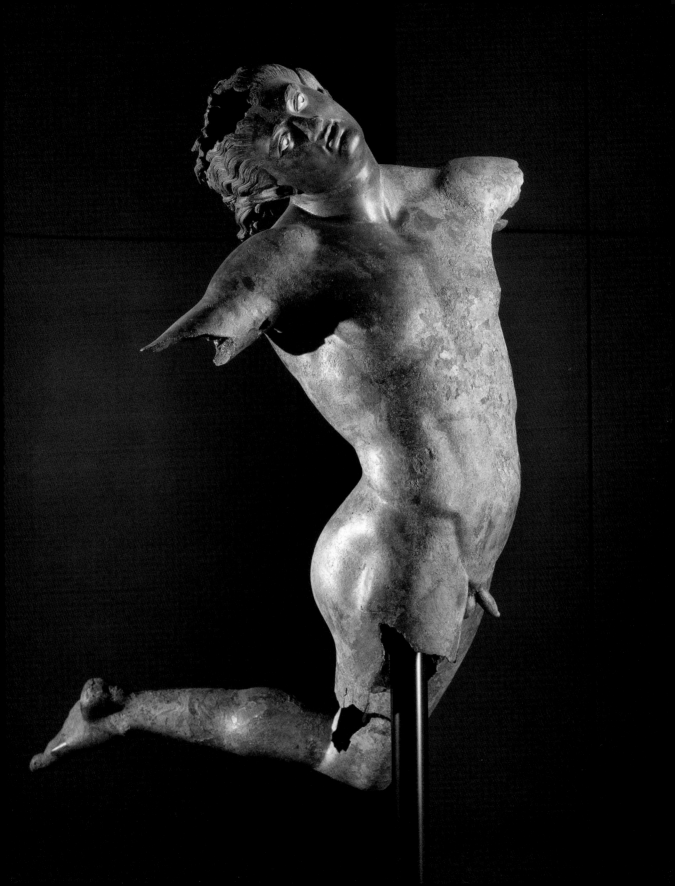

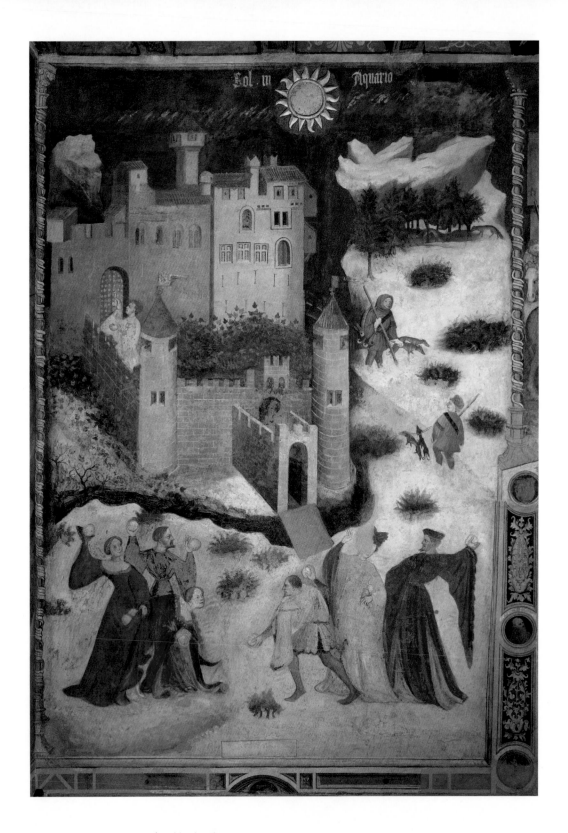

Sol in Aquario

Cycle of the Months

Maestro Venceslao

Fresco | c.1400 | Castello del Buonconsiglio, Trento, Italy

T hough for many centuries a powerful bishopric, the medieval Italian town of Trento, in the South Tyrol, is now firmly off the beaten track. On the hill overlooking it is the Buonconsiglio castle, flanked by the ancient town walls. A passage along this wall links the castle to a tower above one of the old town gates. This was taken over in the late fourteenth century by Bishop George of Liechtenstein and used as a charming extension to his residence, much to the townspeople's irritation. Ignoring the complaints, he had the main room lavishly decorated with a sequence of paintings showing aristocrats and peasants living cheerfully together throughout the year, from January to December.

In 1407 the people rebelled, and one of the first things they demanded was the return of the gateway into public ownership. The painted room was sealed up, and with it a fading vision of the world. The *Cycle of the Months* frescoes were a projection of how the bishop wanted life to continue to be, with everyone knowing their God-given slot, whether that was to dig turnips (the work of peasants) or to hunt on horseback (the privilege of nobility). His was a backward vision in a world in which new ways of making money and new ideas about humanity were challenging the accepted social orders of the past. Walking along the passage from the castle to the tower today is like taking a journey back in time: when you eventually arrive in the high painted room, you find yourself surrounded by a bright landscape full of activity, as if you'd woken into a vivid dream of medieval life that was, even then, a nostalgic view.

The artist who painted the frescoes, possibly a Bohemian master called Wenceslaus, responded to the spirit of the commission. He showed people enjoying themselves. January (shown opposite) is a case in point: nowhere else in art do aristocrats come out to play in the snow, men and women alike chucking snowballs about with determined, impish delight, their long sleeves dragging in the drifts. Oddly – but surely intentionally – the castle's roof is snow-free, and its garden is full of summer growth. It's an image of the warmth of their protected life. Maestro Venceslao was painting a dream, but he wanted to make it as real as possible, so the whole cycle is packed with direct observation.

Two peasant hunters, wearing their masters' liveries, go hunting with dogs. One brings back a hare, while his dogs scent a badger hiding under a shrub. Behind them a fox lurks in a copse, under the shadow of which the earth is bare. All the months are full of such vividly observed details. In April, there are still mushrooms in the woods. Roses come out in May, lilies in June. A peasant couple glance lasciviously at one another under their peaked straw hats, as they gather in the hay. Icicles hang from the gutters in December as the peasants, now looking cold and grumpy, chop logs for the winter fires. As for the gentry, they have three tasks for three seasons: from April to June they go courting, from July to September they go hawking, and from October to March they keep warm inside. During the winter months they're hardly to be seen, except when they come out to play in the snow.

Cacaxtla Murals

Artist unknown

Fresco | c.900 CE | Cacaxtla, Tlaxcala, Mexico

G reen dominates your first impression of the great Mayan sites of Central America – steep pyramids of mossy stone emerging through the shrouded jungle canopy. It's almost impossible to imagine these structures as they were when they were new, on exposed plateaux of bare earth and rock, spacious and free of vegetation. The original impression would have been of blue and red – the blue of the open sky, but also the blue of rivers and flowing water in the paintings that covered the buildings. But the dominant mood would have been set by the red. The basic colour of these buildings was a brilliant, deep, resonant red, as hot and vital as blood. The Maya, at least in the upper echelons of their strictly hierarchical society, didn't believe in going back to nature but in rising above it. In their attempt to express the higher state of their existence and the meaning of the hidden forces of life and death that ruled their universe, no means were left unexploited, no surface uncovered, and no opportunity wasted. Few cultures have created such high and elaborate headdresses. The Maya lived in an imaginative world, and all the people in their celestial cities had a role to play which was vital for the wellbeing of everyone. We can glimpse this in fragments of pottery and carvings, in the ruins of their extraordinary buildings, in a handful of paintings, but the fabulous totality of their culture is now hidden forever.

Though every surface of Mayan temples and palaces was elaborately painted inside and out, hardly any murals remain. The most famous ones at Bonampak are much deteriorated and extremely difficult to read, especially as visitors are now no longer allowed into the rooms, but have to squint at them from the door. Those at Cacaxtla, only discovered in 1976, are much better preserved and displayed. They evoke an extraordinary world. In the one oposite a muscular warrior, wearing an eagle-beaked mask so big it's swallowed him, with wings on his arms and claws on his feet, brandishes a huge phallic sceptre, tied with bows like a sheaf of corn, that spits a tongue of flame. He's standing on a grinning snake whose scales are elongating into feathers. Under and around it runs a segmented ocean where turtles and sea creatures play. A startled parrot squawks behind the warrior as if to say… something rude no doubt, for the Maya, like everyone, loved tricks and jokes.

The more that is understood about Mayan religion – many of whose gods have no known names – the more elusive it becomes. What is clear is that it involved ritual enactment. This eagle warrior isn't a fiction on a wall, but a depiction of a real person, one of an elite band who fought the leopard warriors depicted on the adjacent wall, in a sacred battle that re-enacted the daily fight between night and day and death and life. The ritual was probably held for divination purposes, and ended in the loser's sacrifice. Seven serpents of blood then spurted from his truncated body – shown in a painting nearby – symbolizing the growth of new corn. Red continually turned into green. Now all that's left is the green.

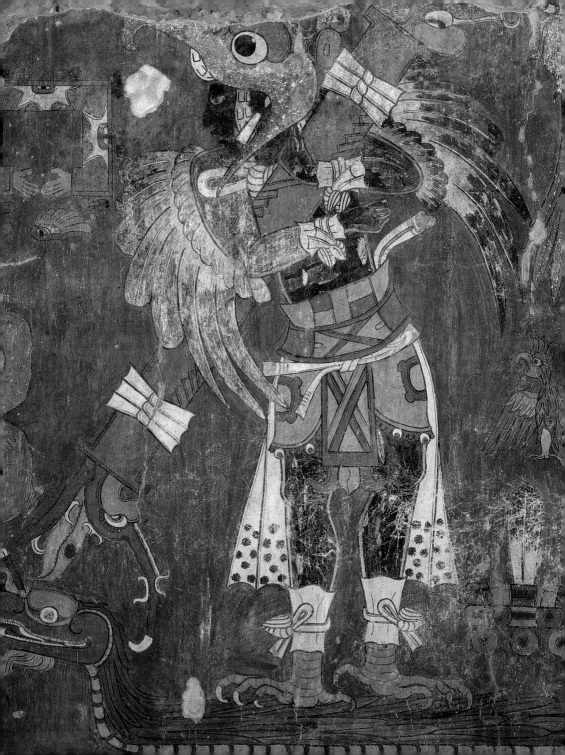

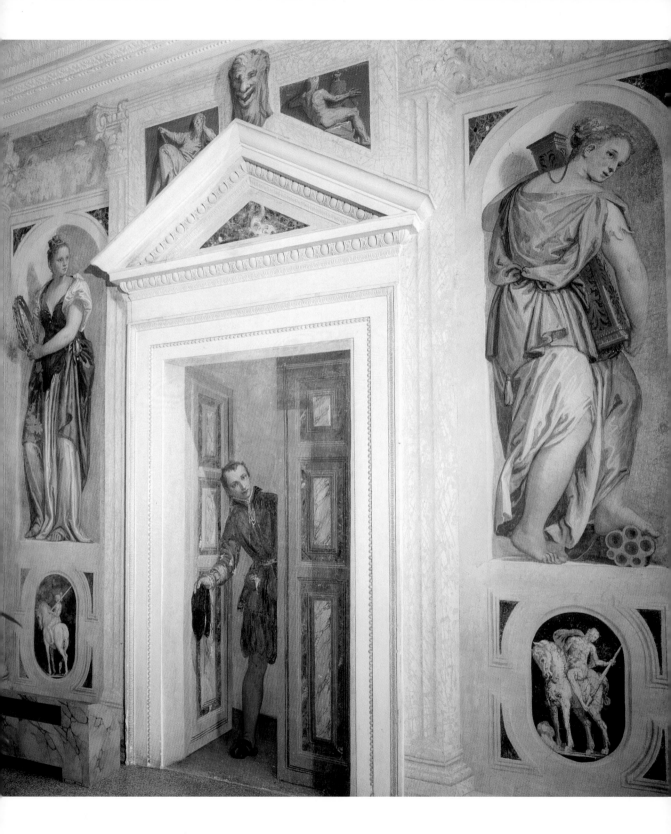

Villa Barbaro Frescoes

Paolo Veronese

Fresco | c.1560–61 | Villa Barbaro, Maser, Italy

T he true greatness of Paolo Veronese (1528–1588) was buried during his own age and is buried again in ours. He ranks among the world's liveliest and most lucid painters of everyday life: a dog stretching, a monkey scratching, children squabbling. But though he loved to paint such incidents, the aristocrats and priests who paid him wanted to see uplifting tales from the Bible and classical antiquity. He gave them what they asked for by the yard. His *Marriage at Cana* was in its time the largest painting in the world. Napoleon, when he conquered Italy, wanted it for the Louvre (where it still is) but it had to be cut in half to get it there. Our age finds these vast confections difficult to take; they seem overblown, portentous charades, out of tune with both modern faith and our more worldly forms of hero-worship. In museums people tend to walk by his pictures. Had he painted only what he wanted, Veronese would probably still rank as one of the world's most popular artists. He slipped everyday scenes into his pictures wherever he could. His vast *Last Supper* included a servant with a nose bleed and a cat teasing a dog as it played with a bone under the table just by Christ's feet. The cardinals were scandalized; such incidents lowered the tone. Veronese argued that a painter should be allowed the freedom of a poet or a jester. The Church was not amused but the artist refused to concede. A compromise was reached – the great painting was renamed *The Feast in the House of Levi*, a subject without such high solemnity. Veronese, instinctively, didn't want to be solemn; he wanted to play.

Only at the Villa Barbaro can one see Veronese with his hair down, letting his brushes rip. A servant opening a door is an artistic *tour de force*: the door frame and floor are real; the door, inner floor and servant aren't. They appear even more real because the statues in the niches are so obviously painted. Veronese plays with appearances through all the rooms. As you stroll around the villa, your eye is repeatedly tricked: a dog peeps out from behind a pillar; a pair of shoes lies on a mat, and – what's that? – the artist has forgotten his brush, and left it lying on a ledge. Everything is painted. What's surprising is that these effects aren't finicky tricks of *trompe l'oeil*, but broadly, almost casually, brushed.

Veronese was a master at painting how things appear not when you examine them closely, but glimpsed as you're passing by. When you walk into the central atrium, the Hall of Olympus, you instinctively look up. Your peripheral vision has sensed the presence of another pair of eyes watching you from above. It's only a painting of Giustiana, the lady of the house. How could you have been so tricked? But the illusion is beautifully judged, the recession back into space and the shadows, the little details of the half-hidden lapdog and the parrot, the child, a portrait of the youngest son, and the wet nurse, swarthy and raising one finger perhaps in recognition of your presence. Everything is where it ought to be if the real Giustiana had just come out from her private apartments to see who you were, and was about to wave a greeting. Her presence is so

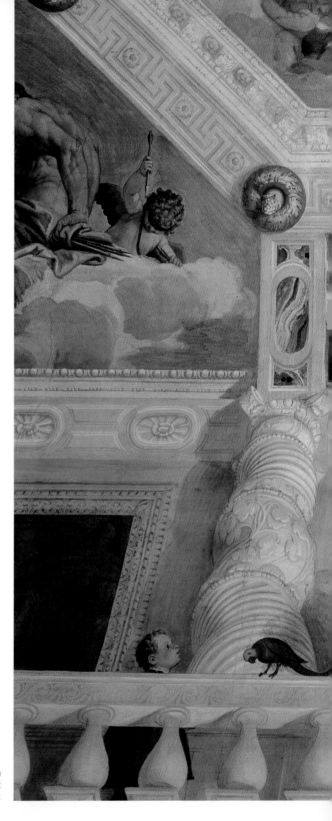

potentially welcoming, warm and human, and it's made all the more real by the obviously painted, decorative figures behind her. With remarkable economy, Veronese gives you just enough information to make you believe something is there. That's why his painting is so buoyant and airy. The whole space is illuminated by his light touch.

This lightness is partly due to the architecture. The villa is one of the masterpieces of Andrea Palladio, Veronese's friend. This is one of the few places where their work together survives almost intact. Their client was a mutual friend, Daniele Barbaro, ambassador to the court of Elizabeth I of England and famed translator of the writings of the Roman architect Vitruvius. Palladio's ambition was to re-establish the classical ideal of architecture, based on proportion and the human form. Peace and harmony made room for fun, which Veronese supplied in brushloads. At the end of one corridor he painted himself coming in through a door, in hunting gear: the real Veronese, at play and at work.

The villa remained in the Barbaro family for years, and then became the home of a series of Italian aristocratic families, apart from a brief period during World War I when it was used as a military headquarters, and a few of its frescoes were damaged. Afterwards it was returned to domestic use and is still lived in today. None of its owners has felt any desire to change such a delightful environment.

A painting of Giustiana, the lady of the house, peering over a painted balcony beneath a painted ceiling to see who has just entered the real room below.

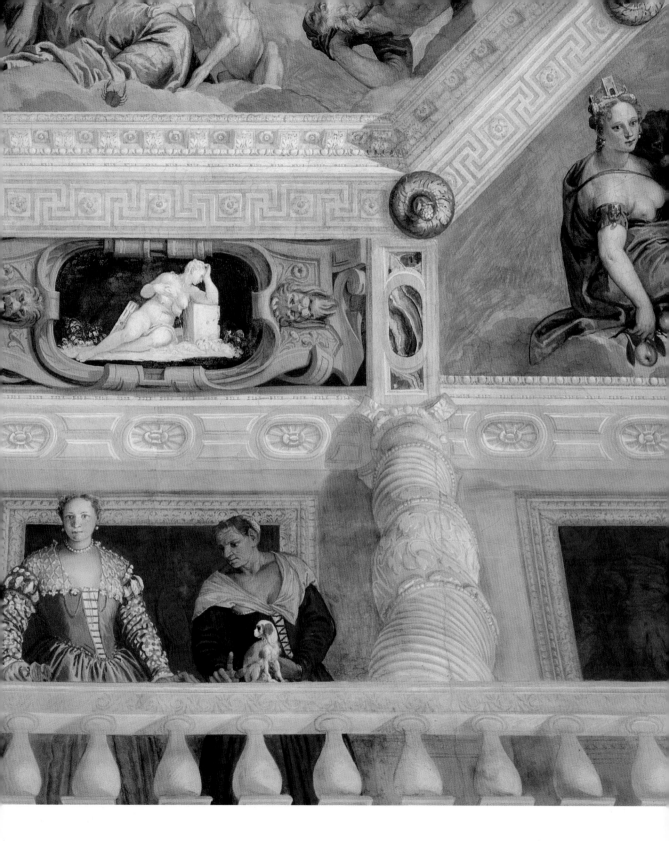

② Hidden by Place

Position and poverty can be great preservers. The two go hand in hand, as any estate agent knows who recites the mantra "location, location, location". If you live in a desirable spot, and have money to spend, the best thing to do is to improve, not move. So out go the old furnishings and decorations – all that we now call art – whereas those people living on the margins have to make do with old things. They tend to make a virtue of necessity, preserving traditions against the encroachment of the new. In rural locations many old building styles have survived, often along with the art that went with them. A wonderful instance can be found in Moldavia, on the fringes of Christian Europe, where paintings can still be seen on the exteriors as well the interiors of churches, a practice that used to be widespread but which was increasingly abandoned as religious observance became more intimate and Christ's second coming seemed less imminent. The extraordinary painted cave temples at Mogao in China were left undisturbed because the Silk Road shifted south and was then abandoned for transport by sea. Some of the world's greatest paintings, such as the altarpieces featured here by the Master of Moulins and Enguerrand Quarton, might well not have survived intact, and certainly not in their original locations, had the places they were made for not been off the beaten track of princes, wealthy collectors and priests with modernizing views. Out of sight was out of mind, and many wonders have survived as a result.

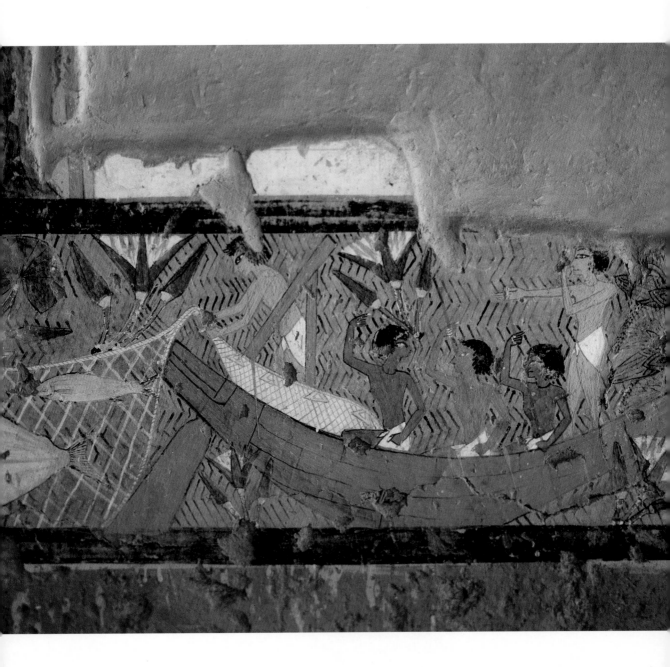

Tomb of Ipy the Sculptor

Artist unknown

Mural painting | c.1250 BCE | Deir el-Medina, Egypt

The popular myth of the pharaoh's overseers whipping gangs of forced labour as they heaved stones for the pyramids was created by a materialistic nineteenth century, proud of its new democracies and of having (just) abolished slavery. The truth is that under its divine kingship, Ancient Egypt was surprisingly egalitarian. Women had equal rights with men, owned their own property and could initiate a divorce. Foreign settlers, like the Hebrews, had their own homes. The peasant farmers paid taxes not in shares of crops but in days of labour. These provided the huge labour force needed to maintain the irrigation systems. When the Nile was in flood and the peasants couldn't work on the waterways, they built temples and tombs in the desert for their rulers.

The beauty and precision of these great monuments suggest that they were built eagerly by the community as a whole, in much the same way that the great Gothic cathedrals rose above the higgledy-piggledy townscapes of medieval Europe. Temporary teams of workers were led by specialists – scribes, draughtsmen and painters, stonemasons, sculptors and jewellers – and because they had access to the secret knowledge of the afterlife, these skilled artisans lived in villages apart.

Deir el-Medina is one such village, tucked into the hills behind the Valley of the Kings and buried under sand dunes for three thousand years before excavations began two hundred years ago. These have unearthed remarkable evidence of everyday life: bed linen, an erotic manual, a spare wig. The better-off craftsmen built tombs there for themselves. It's often thought that the Ancient Egyptians were morbidly obsessed with death (all that gruesome embalming), but the opposite was true: they were enchanted by life, and wanted it to go on and on. The decoration in royal tombs is often obsessively repetitive, but then so many prayers had to be said for deceased pharaohs. The tombs of the craftsmen at Deir el-Medina didn't have to be so formal. They could enjoy themselves, because there wouldn't be any work for them in the next world – no tombs were needed there, for nobody would die again. Their painting became relaxed. They knew the rules, but could break them because they were painting for themselves. In the scene shown opposite the man fishing in the bow of the boat has turned round so both his shoulders overlap, instead of being painted chest-facing as was the convention. Patterns still predominate – zigzags for water, splays for lotus flowers – but here they're not graceful or solemn; they dance and jiggle. This little scene is a hymn to the joyous rhythm of existence.

The Ancient Egyptians were ever alert to the proximity of death; it stalked beside them in the desert sands. They built houses there, in stone, for the living dead. What a contrast to their daily lives in the narrow strip of fertile land, so gloriously and mysteriously inundated every year by the rising Nile! Their life there was one of fleeting rhythms, rippling reflections under shaded palms, of love transmuting into joy. A poem found at Deir el-Medina is hauntingly evocative: "My lover has come| My arms spread out to embrace her| My heart is as joyful as a fish in a pond| O night, may you last forever." The homes for their temporal lives, even those of kings, were temporary structures built of mud bricks and painted plaster. Virtually nothing of their daily existence remains, but a glimpse of it is given in the tombs of the ordinary people living in Deir el-Medina.

Mogao Caves

Artists unknown

Sculpture and fresco | c.538 CE | Mogao, China

A veritable Vatican of Buddhism is to be found in the far northwestern reaches of China. Seven hundred and thirty-five cave-shrines were dug into a cliff face adjacent to the source of a spring at Mogao, some 25 kilometres outside Dunhuang. They pepper the surface like sand martins' nests. Some are small inside, but others are vast, housing colossal statues of the Buddha, seated or recumbent, carved out of the living rock. The entrances to them are however generally domestic in scale, and so were easily barricaded. Access used to be by vertiginous, cantilevered wooden staircases and platforms, sometimes richly carved and painted, but mostly rickety and primitive. Most of this superstructure has gone, replaced in the 1960s by solid concrete paths and steps. Worse still, most of the original undulating surface of the cliff has been levelled flat and reinforced by concrete slabs. The whole site now looks like a vast public lavatory, with numbered metal doors on cubicles at different heights.

Once inside, however, the art sweeps you off your feet. Nowhere else in the world can you see such free and spontaneous painted expressions of joy. Angelic beings and banners fly among the clouds in the heavens of these tent-like, buried structures, while beneath them Buddha and his acolytes incandesce in flames of rising prayers. The blues are so bright they look as if they had been put on yesterday. The greens are just as fresh. The technique is true fresco, the pigment applied directly on to wet plaster, with some finishing touches added after the plaster had dried. Most of the paintings are in remarkably good condition, though a few have suffered where the lead-based white pigment has turned black.

They were created over a period of a thousand years, from the fourth to the fourteenth century, and represent the peak of many styles of Chinese art. It would take a week to do justice to them, especially as only a small proportion is open at any one time. One of the most extraordinary is the Tang Dynasty cave, no. 217, a great, cavernous, pillared chamber, virtually impossible to photograph, banded from floor to ceiling with emerald meadows and mountains. It's like walking into a promised land of eternal spring pastures, leaving the arid desert air outside.

These shrines were the flowering of hopes and fears, commissioned by the wealthy merchants who stopped at Mogao, then a major resting place on the Silk Road, the main trade route that linked China with the rest of the known world. Merchants leaving China with their caravans of goods prayed there to the Buddha for protection, and on their return thanked him for bringing them safely home. For Mogao stood on the frontier between the homeland and the wild desert, where they journeyed in constant dread of hearing the pounding horses of vicious raiders. How often merchants must have promised Buddha a share of their fortunes if they survived an attack. The cave-shrines are those promises made permanent. And they were kept fresh by a change in transportation methods. By the fourteenth century, the majority of goods carried along the Silk Road were being taken by sea. A few monks lingered at Mogao, but gradually the shrines were closed and bolted. The stairways collapsed and the grottoes were preserved, waiting to be rediscovered by archaeologists and treasure seekers in the nineteenth century.

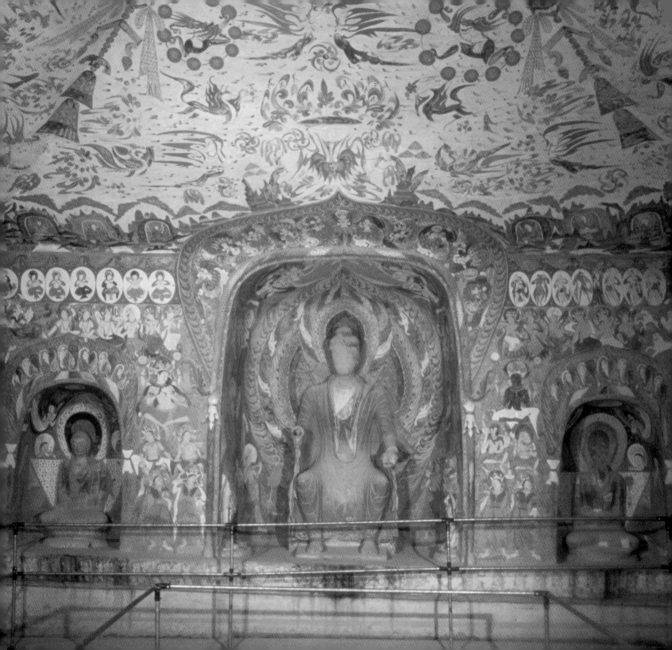

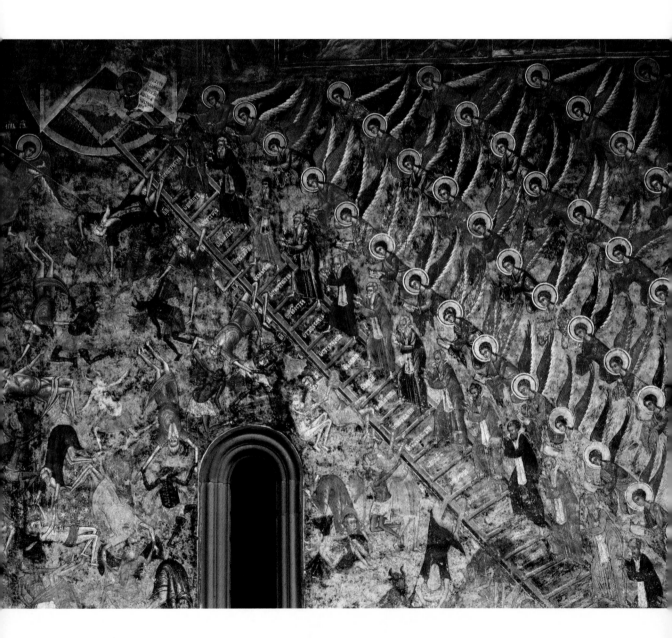

Suceviţa Monastery

Ion and Sofronie

Fresco | 1583 | Church of the Resurrection
Suceviţa Monastery, Moldavia, Romania

O n the upper pastures of the mountains of Moldavia, east of Transylvania, on the extreme edge of Christian Europe, stands a remarkable group of churches. They are covered with paintings both inside and out. Many buildings of the late Middle Ages had exterior decorations, but hardly any remain. The Moldavian frescoes survived because of the churches' huge overhanging eaves, which protected them from rain, sun and snow – and because they were so far off any beaten track. In clearings in the forest, they look like jewelled caskets, rare survivals from a very different age. They date from the fifteenth through to the early seventeenth century, when Moldavia was a powerful principality. Stephen the Great and Holy (1432–1504) carved out a space for himself and his people by fighting off the Hungarians, Poles and, even more importantly, the Ottomans. He won all but two of the 36 battles he fought, many against "the infidel", and Pope Sixtus IV declared him "True Champion of the Christian Faith".

Christianity flourished on this war-torn frontier, and Stephen and his successor princes constructed churches, and established small monastic communities to sustain and protect them. They built them in thanksgiving for their success in battle, as well as to house their own tombs. For these were not only gathering places for local worship, but resting places for the bodies of the great and good until the Day of Judgement. People attended them to pray both for their own souls and for the souls of their departed leaders. This chimed with older local beliefs, some of which still linger today, such as the midwinter tradition of wearing masks of old men and women in order to appease the ancestral spirits who return at that time to be fed and well treated. If these living dead returned at other times, they had to be kept away with garlic, for they could get up to mischief. The tomb-churches focused these ancient "superstitions" on a Christian goal and on the eternal well-being of their leaders, a strategy that inspired local craftsmen to great artistic heights. Most of these makers were anonymous: the names of the brothers Ion and Sofronie who painted the frescoes on the Church of the Resurrection at Suceviţa have come down to us, but little else about them.

These artists were inspired because they were painting the House of God – the Celestial City of Jerusalem that St John had seen on Patmos and described in the Book of Revelation, descending from the clouds and landing on Earth on the Last Day, a city built of rubies and emeralds, sapphires, topaz and amethyst, and threaded throughout with gold. These were the beautiful visions that settled down on the hills of Moldavia, nestling over the tombs of the good men who had saved their people from the ravages of the Hungarians, Poles and the "damned infidel". Every painting in these churches focuses on the soul's aspiration to beatitude. The Ladder of Divine Ascent was a favourite motif. Conceived by St John of Sinai, a sixth-century hermit monk, it itemizes the steps each soul has to take to achieve salvation: 23 to overcome vices, seven to build virtues. Angels help souls to rise; devils try to make them fall. But everything is bathed in sapphire blue, for this was God's wall.

Adoration of the Magi

Pietro Perugino

Fresco | 414 x 469cm | 1504 |
Oratorio di S. Maria dei Banchi, Città della Pieve, Italy

I n Umbria, just south of Lake Trasimeno, there are two quiet hilltop towns each boasting a chapel with a superb mural. In both towns you walk straight off the street, through heavy doors, and find yourself facing a wall of scintillating colour. This is the way to see paintings from the great age of fresco: coming across them by surprise, viewing them suddenly as a whole, contemplating them in good light, and being able to study them quietly and close to. You can do all that in Città della Pieve and Panicale, where two late frescoes by Pietro Perugino (c.1448–1523) survive virtually unchanged.

Both altarpieces were painted within a year of each other, and are so similar in scale, position and feeling it is as if they were conceived as a pair. They are in pristine condition, protected for centuries by their custodians. The chapel in Panicale which houses the *Martyrdom of St Sebastian* was attached to a convent and closed to the public. Virtually the only damage it has sustained is from two nail-holes, made to hang a veil over the saint's private parts during primmer times. The *Adoration of the Magi* was painted for the Compagnia dei Disciplinati, a charitable foundation that still exists. A text from 1900 refers to the "great curtain" behind which it used to be kept.

In each fresco Perugino's colours are remarkably fresh and extraordinarily subtle, various and imaginative. The later, bizarre colouring of Michelangelo is foreshadowed here in Perugino's shimmering, mother-of-pearl hues. Following through this array of colours is like watching dawn rising through a prism. Celestial blue shifts into violet, rose into green and gold into purple, white into tangerine. The effect is mesmerizing and cumulative. Both frescoes show figures set against an open architectural frame, beyond which spread distant hills and a central lake. Perugino's typical feathery poplars are as delicate as seeded grasses seen against the sky. But it's the light in them that quietly leads you in, as it rises imperceptibly from pure white to the subtlest hazy deep blue, which is echoed in the lake. And when you leave the little chapel in Panicale there it is, in the distance, the lake, spread beneath you.

In both pictures, Perugino has painted the local view. That's what makes seeing these frescoes so hauntingly memorable: you can see for yourself what the artist painted. Moreover, the fact that he was born in Città della Pieve and grew up in the surrounding hills makes these paintings seem deeply felt, unlike many of his altarpieces which appear to have been churned out. As a local lad, he offered to paint the *Adoration of the Magi* for 100 florins, half his going rate. He would start, he said, when they sent him a mule to get him there from Florence – he wasn't going to walk. They knocked him down to 75 florins, and by 1507 still owed him 25. He complained, but eventually agreed to the offer of a house in the town in lieu. The convent at Panicale still owed him 11 florins for the *Martyrdom of St Sebastian* two years after he'd completed it. His biographer Vasari maintained that he had a dread of poverty which made him mean and cantankerous. An avowed atheist, he is said to have refused the sacraments as he lay dying. But still his paintings are full of sweetness and light.

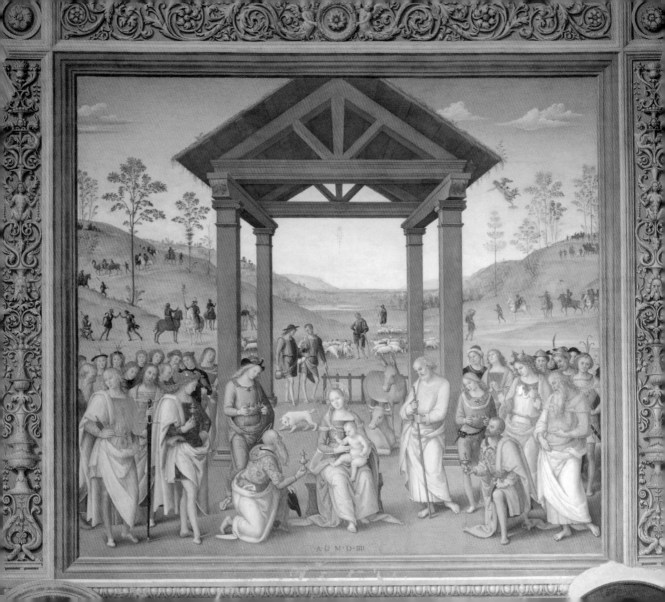

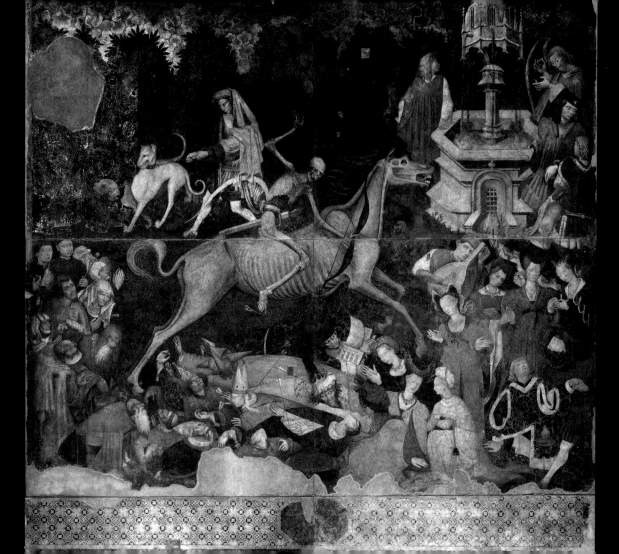

Triumph of Death

Artist unknown

Fresco | 600 x 642cm | c.1446–49 |
Galleria Regionale della Sicilia, Palermo, Sicily

T he Regional Art Gallery in Palermo contains the remains of one of the great paintings of the world. The sight of it covering one wall of a former chapel stops you in your tracks. It's just as emotionally gripping as Picasso's Guernica, a painting that was inspired by it. The similarity between the two is artificially close because the Palermo painting has changed considerably over time; the greens and blues have turned almost black and the yellows and pinks have faded, giving the figures a gaunter look. Picasso purposefully painted his picture in tones; he thought colour inappropriate to the tragedy of the bombing of Guernica. The artist of the Triumph of Death had a different ambition. He wanted to show death riding through life. The grey horse with its skeletal rider would be all the more startling if we could see it as originally intended, riding through a garden, with green trees behind it and a blue sky above. Then the pestilent vapours rising into the air, so beautifully painted in crisp, cutting coils, and the cadaverous horse and rider, so hauntingly shaded, would look like ghosts journeying through the heart of life. The extraordinary abstractions which inspired Picasso would then come into their own, particularly the drawing of the horse's head, with its skull and jaws protruding through its taut thin flesh.

This isn't abstraction for pattern-making, but abstracting to increase power. Nor are details left out when they add to the effect. Little flakes of skin curl on Death's ankle bones, the last remnants of his earthly covering. As he rides, bishops, kings and noblemen are laid low in an ungainly heap. Just in front of him,

the rich lounge around the fountain of youth, ladies chat, minstrels play and men return from the hunt, in blissful ignorance of Death's imminence. At his back are the destitute, the desperately ill and crippled, who reach out and pray to Death to take them with him. Behind them stand two figures surveying the scene, looking out at us. They've been taken to be the artist and his assistant.

One reason why this great painting is so little known is that no one knows who the artist was. His mature and highly individual style seems to have come out of thin air. Of course it can't have done, but none of his other work survives or has yet been securely identified. The picture was painted for the courtyard of the nearby Palazzo Sclafani, probably when it was converted into a hospital in the fifteenth century. Though the artist's treatment is original, his theme was popular. Death increasingly haunted the late medieval imagination – particularly in the form envisaged by St John in the Book of Revelation, as a rider on a pale horse. These paintings were warnings, and the warnings got stronger when the Black Death struck in 1346, killing as many as a third of Europe's people. Waves of plagues followed. Images of Death, writ large, rode across the walls of churches and many public buildings. Hardly any survived the ravages of time and the Enlightenment's distaste for such doom-mongering. The Palermo fresco might well have been lost much more recently, had it not been detached and transferred under the direction of an American commission established by President Roosevelt in June 1943 to salvage and protect artistic monuments threatened by the war.

Coronation of the Virgin

Enguerrand Quarton

Oil on panel | 183 x 220cm | 1453–54 |
Musée Pierre-de-Luxembourg, Villeneuve-lès-Avignon, France

Crowds jostle to see the Louvre's most celebrated treasures, but if you want to see great painting undisturbed, all you have to do is cross to the northern galleries where French Renaissance art is on display. Here you will find the exquisite *Pietà* from Villeneuve-lès-Avignon, and in all likelihood you'll have it to yourself. A thin-boned dead Christ is draped over the Virgin's knee, his fingers contracted in agony. St John carefully removes the crown of thorns, lifting Christ's head up with his other hand, his fingers parting the golden rays that radiate from the anguished face. Few hands in art express grief so precisely and so gently. Though we can't be certain who painted this picture, all the evidence suggests it was the work of Enguerrand Quarton (c.1410–66), who worked in Villeneuve-lès-Avignon where this *Pietà* came from. And it's there you have to go to see Quarton's finest securely attributed work, the *Coronation of the Virgin*, one of the great hidden treasures of France.

We know nothing about the *Pietà*, but a lot about the *Coronation*: most unusually, the contract commissioning it survives. Dated 14 April 1453, it itemizes what Jean de Montagnac, chaplain of the church of the Charterhouse of Villeneuve, wanted the finished painting to show and what he was prepared to entrust to the artist's imagination. "There should be the form of Paradise, and in that Paradise should be the Holy Trinity, and there should not be any difference between the Father and the Son; and the Holy Ghost in the form of a dove; and our lady in front as it will seem best to Master Enguerrand ... Below the heavens the world, in which should be shown a part of the city of Rome ... and on the other side of the sea, will be part of Jerusalem ... and beneath the Cross of our Lord, Purgatory and Hell." Montagnac had been seriously ill in 1449 and made a will requesting that a painting showing him as a donor before the Virgin be placed on his tomb in the church of the Charterhouse. On recovering, he cancelled the order, and instead undertook a pilgrimage to Rome and Jerusalem. The *Coronation* painting is a thanksgiving for his recovery and a record of his pilgrimage.

The altarpiece is surely by the same artist as the Avignon *Pietà* – a master at painting hands. All the hands in the *Coronation* express subtly different feelings, even those of the Father and Son. The fingers of the Virgin overlap and part in a way that only Enguerrand could handle, and no one ever plucked a harp more adroitly than the angel in the upper right. Every face is a convincing portrait (Montagnac is shown kneeling to the right of the Cross) and the Madonna is an extraordinary vision of sensually restrained perfection. The Earth stretches beneath, with the earliest representation of the local Mont St Victoire, to be eternalized centuries later by Cézanne. Spiky angels dart above the crinkling cloud line, while sparks rise up out of the fires of hell. The joke in Giotto's Arena Chapel (see p.232), which Enguerrand might well have seen, is repeated here with added fury: two bare legs try to escape hell's fires, but are seized by a skeletal demon with cobwebbed bat wings, a product of Enguerrand's piercing but humane imagination.

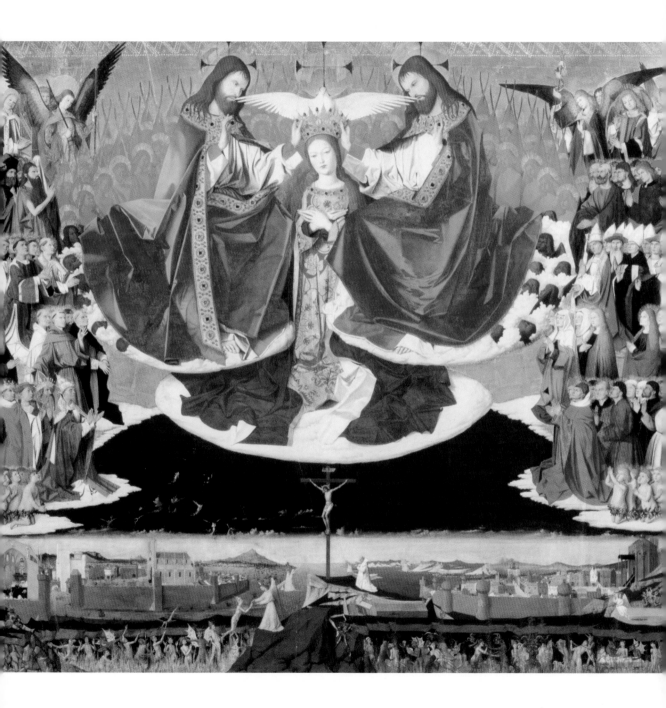

Portinari Chapel
Vicenzo Foppa and others

Fresco and stucco | completed 1468 |
Basilica of Sant'Eustorgio, Milan, Italy

Tourists to Milan flock in droves to Leonardo's *Last Supper*, but hardly anyone visits the basilica of Sant'Eustorgio on the edge of the old city, though it contains an exceptional Renaissance chapel whose decorative scheme survives virtually unchanged. The church was built there, legend has it, when the tomb of the three Magi was brought to the city by Sant'Eustorgio, and the oxen pulling the cart stopped and refused to go any further. Locals took it as a sign, but when you see their tomb inside the church you can't blame the beasts. It's colossal, made of vast stone slabs with a huge pitched roof on which is carved in stark simplicity SEPULCRUM TRIUM MAGORUM, beneath a single, magnificent shooting star. Of course this was a medieval fiction, but it worked: the church became a major pilgrimage site.

Its status was enhanced by the acquisition of the body of St Peter Martyr, a Dominican monk who was assassinated in 1252 on the orders of the Cathars of Milan. His murder was depicted in one of the frescoes in the chapel (see overleaf). Legend had it that he wrote "Credo in Unum Deo" (I believe in one God) in his blood on the ground before he died. He was declared a saint after 337 days, the fastest canonization in the history of the Church. Peter had preached against the heretic Cathars who believed that Jesus had not been born in the flesh or crucified on the Cross, but was immaterial and immortal. St Peter was buried in a beautiful tomb made by Balduccio Pisano which originally stood in the main basilica but was moved in the eighteenth century to the Portinari Chapel.

The director of the Milan branch of the Medici bank, Pigello Portinari, commissioned the building in 1462 as a funerary chapel for his family. A couple of decades later his brother Tommaso, director of the Bruges branch, hired Hugo van der Goes to paint the extraordinary altarpiece known by the Portinari name, which is now one of the treasures of the Uffizi. Both brothers sought immortality through art. Pigello's chapel follows the classic form, pioneered by Brunelleschi, of a hemisphere perched on top of a cube, like the Old Sacristy of S. Lorenzo in Florence, the family chapel of the Medici themselves. But this chapel, the first Renaissance building in Milan, was constructed from local materials by local artisans.

There was no building stone in the area, just clay, so the Portinari Chapel was made of brick and terracotta. And the craftsmen let their spirits soar in it. They modelled angels dancing with great bells of flowers – imagine the sound of celestial flower bells! – and painted them all the colours of the rainbow. There's another spectrum on the ceiling: the dome is made of overlapping feathers painted red, yellow, green and blue, as if a multicoloured peacock were fanning its tail open to heaven. In the corners of the walls beneath this joyous multitude, Vicenzo Foppa (c.1430–c.1515) painted scenes from the life of St Peter Martyr, plus

the Assumption and the Annunciation. In choosing this last subject, Portinari was probably currying favour with the new ruler of Milan, Francesco Sforza, who had made his triumphal entry into the city on Annunciation Day. Whatever the material motive, the painting is superb. The angel Gabriel and the Virgin Mary look at each other across the open space of the arch. They both seem to have alighted there, on either side of the light-filled void beneath. But there's another play of light within the picture: in the illusionistic, receding space, up to the balcony and beyond, to God appearing in the sky. The dawn-like quality of this pictorial light can be seen in the murder of St Peter Martyr, despite its gruesome subject. The combined effect of real and illusionary light-filled space in this chapel creates an extraordinarily uplifting impression. This makes the substantial appearance of the angels, in high relief with their bells, all the more surprising and effective. They exist in a heavenly zone where matter can have substance because it is wholly pure. Their bells ring with good news. We know virtually nothing about Foppa and the other artists and craftsmen who created this magical ensemble, which is one reason why the Portinari Chapel remains so little known.

A hired assassin murders St Peter Martyr in the peaceful countryside outside Milan, as his fellow friar, Dominic, tries unsuccessfully to escape.

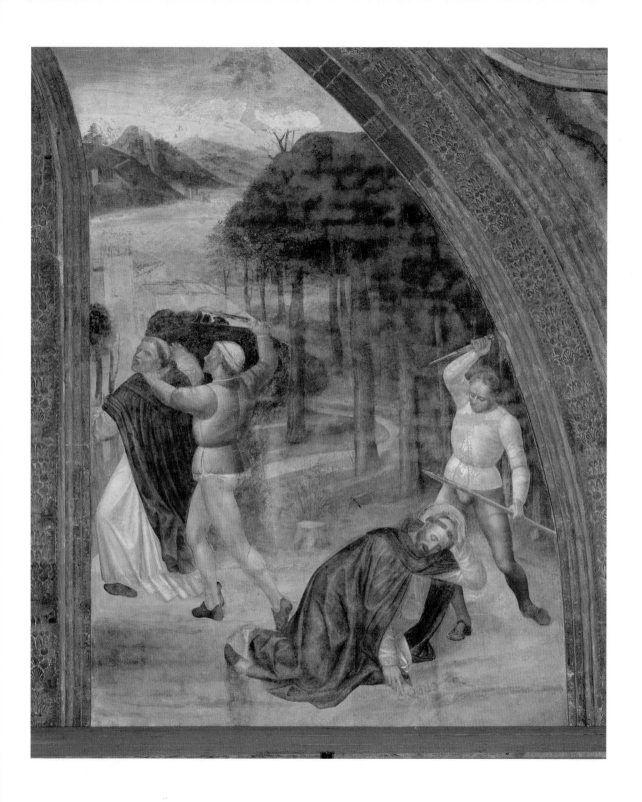

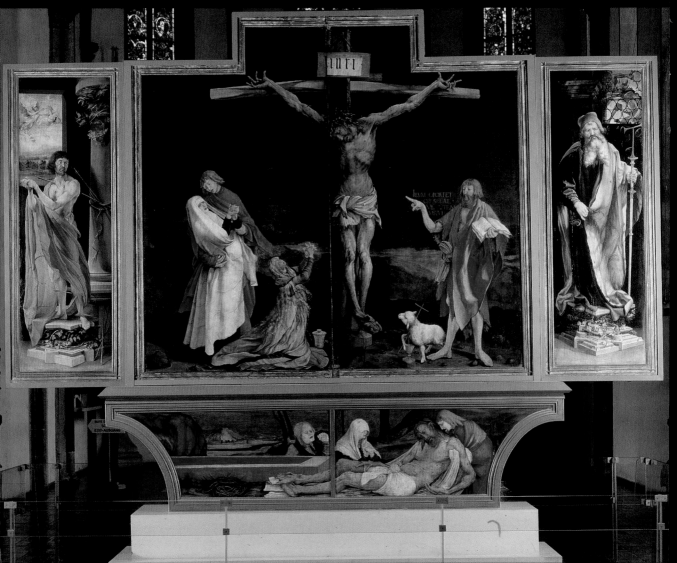

Isenheim Altarpiece

Mathis Grünewald

Oil on panel | 269 x 590cm | 1515 | Musée d'Unterlinden, Colmar, France

By the time Joachim von Sandrart wrote his general history of German painting in 1675, no one could remember anything about the artist who had painted the colossal altarpiece in Colmar a century and a half before, not even his name. So Sandrart called him Grünewald, the man from the green woods, and the name stuck because there was something wild and extraordinary about his art. And so we continue to refer to one of the greatest geniuses of world art, even though historians have pretty conclusively identified him as one Mathis Neithard (c.1475–1528), a painter and – like Leonardo da Vinci – a water engineer, who was so poor at the end of his life that he had to sell paints and curative soaps to eke a living, and who died of the plague in Halle in 1528.

Neithard's Isenheim Altarpiece ranks among one of the greatest expressions of Christian belief, but for a long time it suffered as obscure a fate as its maker. It only survived because it was in an out-of-the-way corner of Europe, though evidently much treasured by its owners who dismantled it and hid it from Protestant iconoclasts, the vandals of the French Revolution and greedy collectors like the Holy Roman Emperor, Rudolph II, who chanced to see it in 1597 and wanted it for his palace in Prague. So it remained in Colmar, until it was put on show in the Unterlinden Museum in 1853, in separate sections, with a few bits missing, but miraculously mainly complete. The writer J-K Huysmans became a great enthusiast in the late nineteenth century, followed by painters such as Beckmann, Dix and Picasso, but only slowly has it found a wider public. Even so, comparatively few visitors go to see it, though it is one of the most moving and unforgettable man-made sights on earth.

You have to see the Isenheim Altarpiece in the flesh to appreciate its massive scale, intense realism, glorious colour and exhilarating composition. Standing in front of it is like viewing the whole Christian story from the perilous rim of one's own imminent death. The whole altarpiece has now been beautifully redisplayed, not behind glass panels like those that now sadly obscure Van Eyck's earlier Ghent Altarpiece, but vividly all around you. This openness of display, though magnificent, in fact hides a crucial aspect of the altarpiece's meaning. It was never meant to be seen all at once, but to be slowly revealed in a dramatic sequence of scenes. Moreover, research now suggests that the altarpiece didn't open, like a butterfly's wings, but rolled apart, like scenery flats on a stage. This explains why Christ's body, in both the Crucifixion and in the Entombment scene below, was unusually placed off centre.

There was a religious reason for this. The altarpiece was painted for the hospital order of St Anthony, famed for being able to cure the then widespread, fatal disease called St Anthony's Fire, which turned limbs to charcoal and racked the chest with choking spasms. The monks in the hospital amputated blackened limbs in a last desperate attempt to check the disease. Before the operation, sufferers prayed at this altar. One can imagine them wringing their hands in much the same way that the Virgin and Mary Magdalene clench theirs

at the foot of the Cross. No one in the history of art has painted hands so expressively and convincingly as Neithard, with protruding veins, torn nails and taut sinews. One can imagine the feelings in the minds and hearts of the kneeling believers as they saw the panels of this altarpiece slide slowly apart and watched Christ, too, lose an arm and his lower, mutilated legs.

Disease was then believed to be a punishment for wrong-doing. Christ had suffered for people's sins. This is the major theme of the altar. One side panel shows St Anthony being attacked by demons, fusions of the nastiest aspects of nature hell-bent on his destruction. The very rafters of his ruined house are morphing into stinging, biting, sword-wielding bugs. The translated inscription reads: "Where were you, Jesus, why were you not there to heal my wounds?" In the panels flanking the Crucifixion, St Sebastian, pierced by an arrow, and St Anthony, about to be attacked by a demon at the window, both stand on bases that float above stone foliage that's so deeply cut it looks as if it's coming alive. Nature undermines Christians everywhere, and crowns their Saviour's head with thorns. The message is clear: suffering and death are the human lot.

St Anthony is tormented by demons but doesn't abandon his faith. The bloated figure in the left foreground is covered with bloody pustules, a symptom of the disease known as St Anthony's Fire.

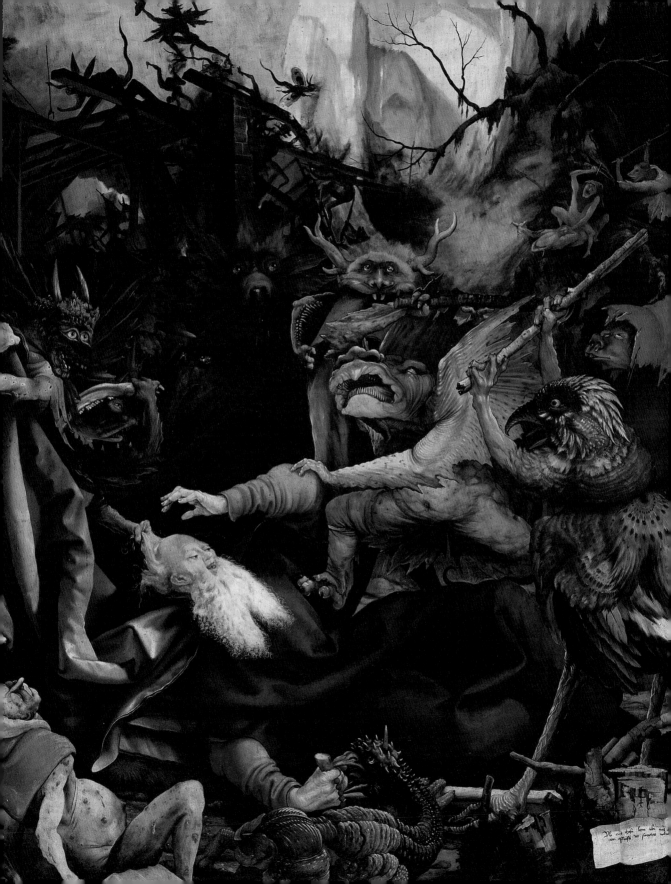

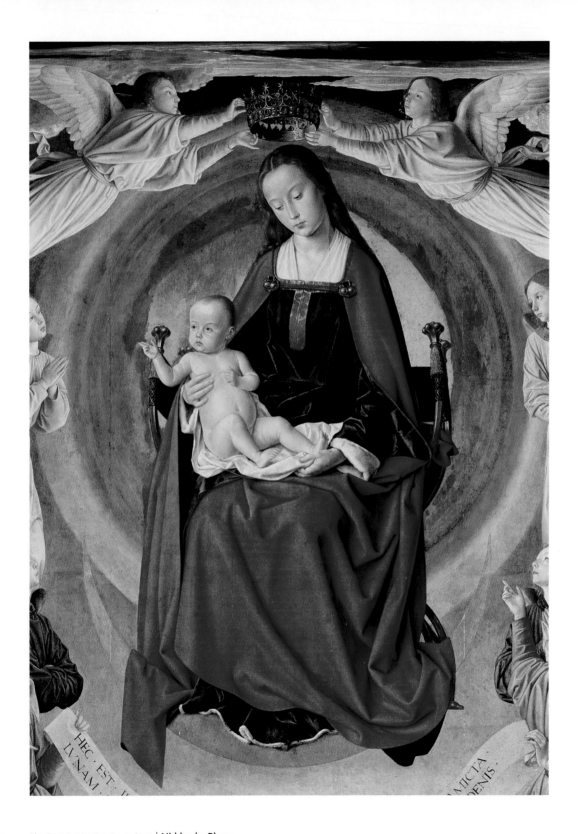

Bourbon Altarpiece

Master of Moulins

Oil on panel | 159 x 267cm | c.1498 | Notre-Dame Cathedral, Moulins, France

French art of the fifteenth century survives largely as a scattering of tantalizing fragments, which are much less appreciated than their Italian and Flemish counterparts. This great masterpiece is hardly known outside the specialist world of art history, due no doubt to its location in the little-visited city for which it was painted, as well as to the impossibility of assigning a conclusive identity to its painter. There was probably an earthly motive for the commission. The powerful Duke and Duchess of Bourbon (depicted in each wing of the triptych) were then effectively regents of France, but they only had a daughter (shown with her mother). An altarpiece dedicated to the Mother of Jesus might help to bring them a son.

But the inspiration for the painting is more profoundly religious. This might account for the extraordinary quality of light in the picture. This master was remarkable in his clarity of vision. Earlier painters in oil, such as Van Eyck and Antonello da Messina, depicted figures, buildings and flowers so crisply that they look as though they are embedded in rock-crystal. The Master of Moulins (active c.1480–c.1500) carved his forms not out of hard transparency but from soft, all-suffusing light. Leonardo (see p.237) was famous for painting mist; the Master of Moulins painted radiance. His angels are made of light, as substantial and insubstantial as a reflection in a glass. But the magical

glow in this picture isn't just an image of the ether, that upper band of purer air above our heads where angels were wont to fly; it is an image of something much closer to Earth, and more immediate for our lives. What the Master of Moulins was trying to paint was the living, breathing flesh of the Virgin Mary, the Mother of Jesus Christ.

From its inception, Christianity had a problem. If Jesus was the son of God, could he therefore have been flesh and blood? The Catholics said he was as we are, but to the Orthodox Church he was as Adam before the fall and as saints are in heaven – pure and undefiled. The Church split early on this issue, leaving the Catholics with the thorny problem of having to decide how earthly Jesus actually was. It was a dispute that ran for centuries, and eventually embroiled his mother. Was she partly divine too? Some thought she had been conceived by God in the womb of the elderly St Anne, and this dogma, called the Immaculate Conception, was officially sanctioned by the Church in 1476, opening the door to new streams of worship and new images. This triptych is one such image. Mary sits in a halo, not an arc of a rainbow like those visible on Earth, but completely circular, as seen in heaven. She rests her feet on a crescent moon, an image of female purity and fecundity that long predates Christianity. The sky is lighter below and darker above: the moment

depicted is dawn. The sun has not yet risen – Christ is born, but his mission hasn't yet begun. We know it's coming, because the warm glow of his immanence lights up the underside of the topmost clouds, the underwings and brows of the flying angels holding up the Virgin's crown. This incipient glow suffuses the pink in the faces of the angels and the Madonna, and the body of the baby Jesus. It's as if the Master of Moulins was trying to suggest flesh that was free from the taint of sin, the pure substance of the Immaculate Conception.

The triptych's outer panels show the Duke and Duchess of Bourbon and their daughter praying to the Virgin Mary for a male heir. St Peter intercedes for the duke, St Anne – Mary's mother – for his wife and daughter.

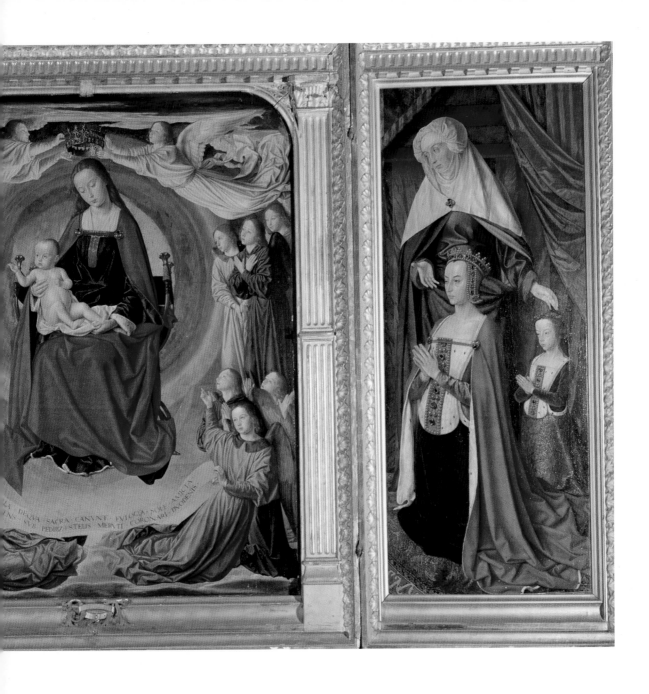

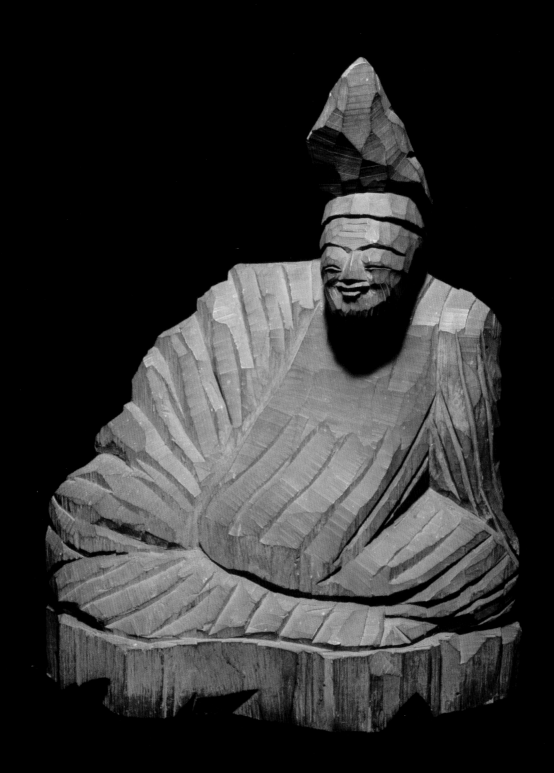

Kakinomoto no Hitomaro

Enku

Japanese cypress wood | 52cm | c.1681–88 | Higashiyama Shinmei Shrine, Gifu, Japan

J apan's 250 years of voluntary isolation from the West ended in 1856, and the country quickly transformed itself into a modern technological society. But by the 1930s the gleaming machine age had begun to pall. Enthusiasts scoured the countryside for traditional hand-made arts and crafts, many of which looked remarkably modern and abstract. Professor Tsuneyoshi Tsuchiya became fascinated by one extraordinary sculptor, Enku (c.1632–1695), whose works were as radically expressive as anything by Brancusi, Barlach or Picasso. At the Koga Shrine in Gifu Prefecture, he found a collection of 1500 short poems by the artist, praising the beauties of nature and recording where he'd stayed. Professor Tsuchiya retraced the artist's steps, and, searching through the dingy outbuildings of ancient, isolated temples, unearthed no fewer than five thousand works. Two thousand more have since been discovered.

Enku was born in a village now absorbed into the modern city of Hajima in Gifu Prefecture. He was a farmer's son, but tradition has it that his mother died in a flood, and his life was spent in a spiritual quest to appease her ghost. He entered the Takada Buddhist Temple in Owari Province as a novice, and then became a wandering priest. Buddhism had come from Korea to Japan in the sixth century CE but it merged with the indigenous nature worship of Shintoism, especially in country districts where Enku mostly lived and worked. Buddhist priests were among the few people allowed freedom to travel, and Enku took advantage of this, walking all over Japan, staying in temple shelters on sacred mountains amidst wolves and bears :a holy man appeasing local demons and spirits, saying prayers over the sick and dying, and honing images of saints and spirits wherever he went. He worked rapidly, with an axe and chisels, only indicating forms, features and gestures with the simplest hacks, cuts and slices, as if he was reluctant to moderate the wood too much or interrupt its living flow, for like everyone in Japan at that time, he believed that spirits lived in trees. One life-size statue is inscribed with a note that the tree was cut, purified, carved and sanctified all in one day. In 1975 a box was found in the Arako Kannon-ji in Nagoya containing 1020 carvings by Enku, finger-length splinters of wood, each carved with the hint of a distinct Bodhisattva, as if the wood had split into a thousand pieces, each one a reflection of Buddha's multiplying beneficence. Sculpture was for Enku an act of prayer, and a gift for people wherever he went, both adults and children, a living embodiment of their hopes and a bastion against their fears.

The carving of Kakinomoto no Hitomaro was made late in Enku's life for a shrine where poetry-reading festivals were held. It's an imaginative tribute to one of the earliest and greatest Japanese poets. Japanese poetry collates sensations of nature with human feelings. One of Hitomaro's famous poems was "I Loved Her Like the Leaves". Enku senses wood in the same way. He has seen the belly's fall, the lapping robes and the mountain peak of the old man's hat within the block as his chisel cut – boldly, variously and naturally. And within this appearance in the wood, the poet smiles, as if about to utter once again his magic words.

Sandham Memorial Chapel

Stanley Spencer

Oil on canvas | 1927–32 | Burghclere, Hampshire, England

D eep in the English countryside, inside a modest brick building tucked behind a small orchard, is a hymn to normal living. Getting up in the morning, washing underwear and scrubbing the floor acquire an unaccustomed radiance when viewed against the ghastly backdrop of war. Fear hangs around you when you walk into this chapel, but it is a shadow that gives form to feelings of love and hope. Stanley Spencer (1891–1959) dreamed of painting these pictures when he served in World War I. He wanted to create his own equivalent of the Arena Chapel in Padua (see p.232), though he had never been there. Fortunately two enthusiastic collectors of his work, Mr and Mrs J.L. Behrend, decided to pay for it. Mrs Behrend's brother, Lieutenant Henry Willoughby Sandham, had died as a result of the war, and they commissioned the chapel in his memory. It took Spencer four years to paint.

Stanley Spencer was born into an old family of village builders, in Cookham, Berkshire, the seventh of eleven children. His father read the Bible to the family every night, vigorously enacting the parts, and played the organ in church. Many of his children learnt musical instruments and played together – Bach, Mozart and Beethoven – in their little, crowded house. Stanley drew, and went to art school – first locally and then in London – where his exceptional talent was soon recognized, but he still caught the train home every evening, earning the nickname "Cookham". He couldn't stay away from the source of his inspiration. For it was there, he said, that he "walked with God", between the high, clipped privet hedges, under the candle-lit horse chestnut, and down among the punts on the river's edge.

When the war came Spencer joined the Royal Army Medical Corps, serving first at a military hospital in Bristol, where trucks repeatedly brought new loads of wounded to fill the 1600 beds. Spencer bathed invalids and scrubbed floors. Then he was assigned to the 68th Field Ambulances in Macedonia, before volunteering to serve on the front line. Though vividly described in his letters and memoirs, none of the horrors he lived through can be seen in his paintings. They are there by implication. He painted those seconds of brief respite when war could be forgotten, struggling to get dressed under a mosquito net (Spencer caught malaria twice), spiking litter with a bayonet, spreading red jam on slabs of bread – moments of normality seen with a magical intensity. A soldier washing at a sink, his hair lathered with soap suds, a white towel hung over his shoulder, suddenly becomes a sultry angel.

On the end wall, Spencer painted a resurrection. He had seen a Bulgarian driver dead among the wreckage of his cart. Here he awakens between his horses. It's in part a literal rebirth between spreading thighs, but also a childhood memory, when after a nightmare he was allowed to nestle between his parents in their white-pillowed bed. All around him other soldiers rise, holding on to their crosses, like the mysterious little figure in Giotto's masterpiece (see p.233). These crosses aren't regimented as in military cemeteries – Spencer hated mindless conformity – but cascade higgledy-piggledy, forming a brilliant spatial *jeu d'esprit* above the actual Cross on the altar, the visual equivalent of a cantata by Bach, which, he told his brother, sounded to him "like angels shrieking for joy".

Residenz Ceiling Fresco
Giambattista & Giandomenico Tiepolo

Fresco | 1752–53 |
Grand Staircase, Residenz, Würzburg, Germany

One of the greatest works by Giambattista Tiepolo (1696–1770) was painted not in Italy but Germany. It's among the largest ceiling paintings in the world: 677 square metres of glorious brushwork, completed in 219 days with the help of the artist's sons, the brilliant Giandomenico (1727–1804), then aged 23, and 14-year-old Lorenzo. The painting still amazes anyone who climbs the great staircase, itself the stupendous creation of the young architect, the former bell and gun founder, Balthasar Neumann. Above your head a vast dome opens, filled with luminous, billowing clouds and the usual tumbling gods and goddesses, rosy backsides, horses' rumps and dangling feet. But that's not what holds your attention. Much more extraordinary is what's happening lower down, along the sides.

As you climb the staircase you appear to be walking up through a vast hole in the world, and peering over the edge at the continents stretching away in four directions: America to the north, Africa to the east, Asia to the west, and to the south, Europe. You want to walk further up so that you can see more, though of course you never can, for the staircase doesn't take you that high. You remain below, walking round the balcony, peering up at the borders of the painting above you, a fictive rim beyond the real architectural cornice on the wall, and you keep on gazing, trying to make out what's going on. Everywhere you look you feel like a child in a crowd who can't quite see

over into the adult world beyond, and this gives a real sensation of wonder and excitement. It's art created by concealment.

The detail overleaf shows a small section of the representation of America, then thought, despite the inroads of colonization, to be the wildest place on Earth. To the right are heaped the severed heads of four Europeans, one with an arrow through the eye. Further over a youth is turning something on a spit – is it a chunk of human flesh? Cannibalism was still believed to be widespread in that continent. America herself sits proudly astride a crocodile. A pageboy who, despite his feather mantle, looks as though he's just stepped up from the court kitchens below, offers her a drink from a gigantic porcelain cup of… what? Could it be chocolate, the new drink from America that was now all the rage in Europe, and is still drunk almost neat in Spain? A man in a feather tunic sprawls over the fictive architecture in front. The fish in the sky are part of a ring of zodiacal signs that overarch the whole composition. Allegory and reality get jumbled up in the oddness of the angle of vision.

The relative familiarity or strangeness of things depends on how you look at them, and the young Giandomenico in particular realized the potential of a fresh point of view. Though Giambattista Tiepolo was responsible for the overall design of the whole ceiling, it seems highly likely that the young Giandomenico both conceived and painted many of the bizarre images round the lower edges. The differences in their

designs represent a generation gap. Partly this was temperamental. Father and son painted each other's portraits in the bottom left corner of *Europe* (see p.48): Giandomenico looks conventional and charming; Giambattista passionate and concerned. These were probably projections of each other's personalities. For the father, the world was still divinely ordered, with goodness descending from heaven above. He was probably responsible for painting the sky. His son painted strange new worlds erupting from below. He was surely responsible for painting the fascinating chaotic jumble around the borders. By the mid-eighteenth century the whole world was seething. The old hierarchical assumptions were soon to be undermined forever by the American and French revolutions.

In the final desperate months of World War II, the Allies were determined to teach the Germans, who were still fighting, a last, obliterating lesson. A few cities were selected to be wiped out, among them Würzburg, which was thought to be an easy target. On 16 March 1945, over a thousand tons of bombs were dropped on the city centre in just seventeen minutes. Almost every roof was smashed including almost all those of the Residenz, except, by an extraordinary fluke, that over the grand staircase. The palace and much of the old city centre was rebuilt after the war. Between 2003 and 2006, the great ceiling was expertly cleaned and restored, and now looks as fresh and glorious as when the Tiepolos laid down their brushes.

America is personified as an Amazon wearing a feather headdress. A painted balustrade rises above the real one.

3 Hidden by Choice

Religious paintings and sculptures weren't "works of art" but images that people trusted their gods would inhabit when they prayed to them. The "artists" who made them didn't see painted eyes but the glances of the divine occupants who graced these images with their presence. Such glances were for the eyes of believers only, and many images were hidden behind veils and curtains. The makers of these sacred images would be horrified to see them exposed to the ungodly crowds drifting through galleries today. They would be even more terrified by the spirits let loose from tombs. All those beautifully crafted artefacts, now in museum showcases, were made to enable the dead to see their gods in the next world, not for the eyes of the living. Religion was, as it still is for many, a contained activity, performed behind closed doors. Andrea del Castagno's *Last Supper* was unknown for centuries until a closed order of nuns left their convent in Florence in 1861. The art made for everyday life was often restricted too, hemmed in with secret symbols and taboos, its meaning deliberately hidden from anyone not of your tribe or faith. It was the same throughout the world, from the symbols on Scotland's Pictish Stones to the patterns on Kula Boats from the South Seas. And several secular artists, such as the nineteenth-century printmaker Rodolphe Bresdin, chose to obscure their work with personal references and private symbolism. The novelist Victor Hugo went so far as to restrict his extraordinary output as a visual artist to his circle of friends and the interior of his Guernsey home.

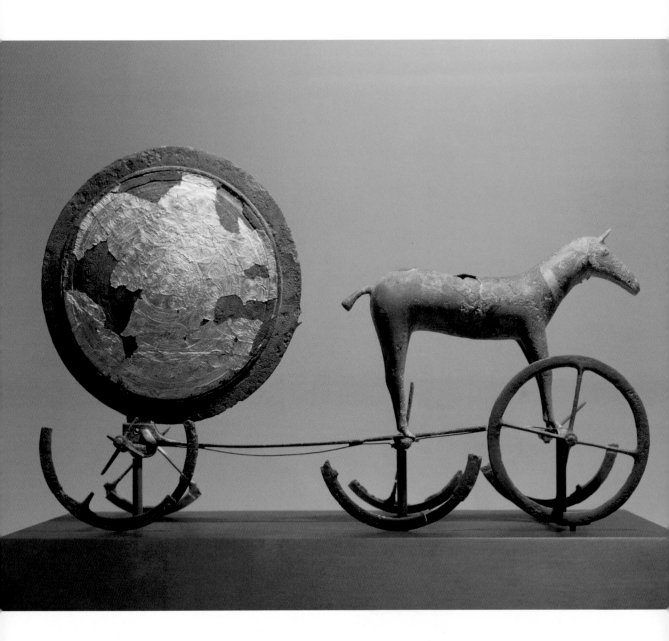

Trundholm Sun Chariot

Artist unknown

Bronze| 59cm | c. 1200 BCE |
National Museum of Denmark, Copenhagen, Denmark

The Trundholm Sun Chariot could easily have been carried in someone's arms. It was found in a peat bog in 1902, deliberately broken into little pieces and carefully placed there about 3500 years ago. No one knows why the treasure was hidden in this way, but bogs in Denmark were often used as sacrificial sites. Bodies of people who had been ritually killed were placed in them, as well as ceremonial swords, foreign armour and lurs – long, coiling hunting horns. Two bronze helmets found in one bog had owl-like eyes and beaks, and strange curved horns with hollow ends, which experts now think once held feathers – perhaps used by the followers of some arcane bird cult. It was these curious objects that gave rise to the misconceived stereotype of the much later Vikings wearing ludicrously impractical horned helmets on their raids. It's probable that the early Nordic people knew the preserving properties of bogs, as the Ancient Egyptians did of their adjacent desert sands. It's also likely that these people believed, in common with many others, that water-holes, lakes and river sources were entrances to the underworld. So a sacrifice in a bog was an offering both to the gods and to eternity. Why so many of these gifts were broken up we don't know. Perhaps it was to indicate that their function in this life was over, and they could return to where they belonged.

Although it is far from clear what function the Trundholm Chariot performed, it certainly had a purpose, because nothing then was made just for ornament or art. A convincing theory is that it was a model made to teach initiates how the sun moved across the sky. The sun had to be pulled, for it had no legs, and what would be strong and fleet enough to pull it but a celestial horse? So the model of the heavenly pair was rolled across the floor on the wheels of a cart (it's not really a chariot) from left to right, as the sun appears to move from east to west when viewed by people living in the north. Then the elder turned the cart round and rolled the horse and sun back, revealing the magic – for there was no gold on the other side. The sun was a flat disc which shone on one side only. That was why the world went dark when the sun returned to the east at night.

This conception is beautifully simple, poetic and, moreover, convincing, for no one then had any idea that the sun and Earth were both spheres, or that one went round the other. The flat Earth we stood on implied a flat sun which we looked at face-on. The gilded, fine-grained interlocking spirals are a beautifully condensed evocation of the molten substance of the sun, too hot to look into. The other side is decorated with spirals as well, but there is no sign that they were ever gilded. The horse that pulls the sun (evidently a mare, or possibly a spirit being) is surprisingly charming with its rounded, cocked-up ears and beady eyes, perhaps designed to appeal to children. It wears an expression of smiling, innocent wonder as it loyally performs its sacred function. This educational toy has the emotional clarity of a vision.

Funeral Banner of Lady Dai

Artist unknown

Painted silk | 205cm long | c.170 BCE | Hunan Provincial Museum, Changsha, China

T his painting on silk is by far the oldest of its kind in the world. It was found lying on the inner coffin in Tomb no. 1 at Mawangdui in Changsa – the tomb of the Lady Dai. Her grave, which was excavated between 1972 and 1974, had been sealed with insulating layers of charcoal and white clay to maintain a stable internal environment and prevent the ingress of damp. The result was that its contents remained remarkably intact, including the body of the Marquesa herself, which now lies eerily preserved, dressed in her original white gown, in a case in the Provincial Museum of Hunan. Lying stretched out in a similar case in an adjacent room is this silken banner. It's difficult to see properly, partly due to the low level of lighting, while deterioration of the silk has probably caused some darkening of the background. What can be said with confidence is that the blues and whites have lost their brilliance, though some of the reds still glow. The effect of the whole must originally have been a great deal brighter. It's worth trying to imagine what the painting looked like when it was freshly painted, because this has a bearing on its meaning. The likelihood is that it was carried in front of the funeral procession before being laid on the coffin in the grave. In the open air this delicate silk hanging would have stirred in the slightest breeze, and the figures painted on it would have appeared to come alive and move, perhaps anticipating Lady Dai's actions after death.

Two bamboo strips found in the grave are inscribed with the characters ʄei ɣi. These are thought to relate to this painted banner, though their meaning is ambiguous. These words could refer to the woven cloth traditionally used to cover coffins, to the grass mat and cloth hung over a door, to a magical "flying cloak", or to all three. The last meaning suits the banner's function most closely, for most scholars agree that it was placed on Lady Dai's coffin for a reason: it wrapped round her soul and lifted it to heaven. Hence its lightness, and the wispy beauty of its imagery.

No one is certain of the meaning of each part of the banner – the ritual symbolism of this age is lost – but it is probable that the base of it shows the monsters of the deep, which live in the ocean under the world. A giant with hairy armpits stands above them, holding up the flat plane of the Earth, on which priests sit, burning offerings for Lady Dai's soul. The birds and dragons of the air float above the roof of their shrine, their tails intertwined through a bi disc – a flat circle of jade with a round central aperture, possibly symbolizing the stars. Lady Dai herself walks with a stick on the flat roof of the clouds, and asks two men, proffering gifts, the way to heaven. Above the roof of the sky is heaven itself; a toad and a hare sit in the moon, while a black raven perches in the sun. Between them, at the very top of the banner, is coiled a humanoid deity with a serpent's tail. The exquisite delicacy and confidence of the brushwork and the intricate, absorbing asymmetry of its composition make this one of the rare treasures of world art, though its precise meaning will probably always remain hidden.

Flying Horse of Gansu

Artist unknown

Bronze | 34.5 x 45.6cm | c.200 CE | Gansu Provincial Museum, Lanzhou, China

W hen the Flying Horse of Gansu was discovered in 1969, it instantly became famous across China. Adopted as the national symbol of tourism, colossal versions of it were cast to grace many public squares, and its quality soon became hidden by its familiarity: a great work of art turned into an overblown trademark. Outside China, however, it is still very little known. The real sculpture is surprisingly small, rather like the Trundholm Chariot (see p.55). Nobody knows for certain what it signified. It was found in the tomb of General Zhang of Zhang Ye, along with 99 other small bronze statues of horses and chariots. But all of these had a practical function: they were the general's retinue in the afterlife. The Flying Horse alone seems to have been purely symbolic. It leaps across the sky on the back of a swallow whose head swivels round to look up at the horse in surprise. "Who is this treading so lightly on my back?" the swallow seems to say. It's a beautiful, poetic conception – a horse lighter and faster than a bird. But if it is a poetic image, what does it depict? Something that flies faster than a swallow? Time? As soon as you are aware of a moment, it's gone. Or light? No matter how far away a fire is lit, you see it instantly. This isn't so with sound; you hear the thump a little after the drum is struck. Lightning travels faster than thunder. Could this horse represent time and light?

The Flying Horse is now tarnished and earthbound. Originally it must have been polished and it would have shone like gold – fluidity made permanent. There was, perhaps, another reason for this colour. The Han Dynasty, which ruled China from 202 BCE to 220 CE – equivalent in scope to the Roman Empire on the other side of the world – owed its success to keeping the troublesome hordes at its boundaries at bay. The Great Wall was crucial and so was the army, equipped before any other with crossbows. But the fierce nomadic tribes of Mongolia and Scythia fought on horseback. The Chinese needed horses to defeat them, and they fought wars to get the best horses they could find. These belonged to the Wu-Sun tribe of Kazakhstan, who were red-haired and blue-eyed, and believed that they became horses in the afterlife. They bred beasts famed for their stamina and speed: Akhal-Teke horses, the oldest thoroughbreds in the world, and now the national emblem of Turkmenistan. They are remarkable not just for their strength and grace but for their colour – a golden, metallic sheen.

Where could these horses have come from but heaven? Weren't they the celestial horses of Chinese mythology, which could cover a thousand kilometres by day and eight hundred by night, and sweated blood? What more fitting beast could there be to carry the general's soul back to his fatherland in heaven? Such a function would account for the sculptor's inspiration. Every centimetre of the modelling adds to the overall impression of lightsome strength, effort and speed. In all sculptures of horses at least one hoof usually drags. Here everything is on tiptoe. The poise of the outstretched front leg and the arch of the neck indicate take-off: art about to uplift the soul.

Tomb of the Diver

Artist unknown

Fresco on limestone | 5th century BCE |
National Archaeological Museum, Paestum, Italy

T he paintings of Ancient Greece are one of the lost glories of world art. The names of many great painters have survived in contemporary texts, for instance Agatharcus, who specialized in illusionistic scenery; Apollodorus, renowned for his effects of light and shade; and Apelles, famed for his portraiture. Many fanciful stories were told about them to illustrate their genius, particularly in verisimilitude. In one tale, Parrhasius challenged Zeuxis to a competition. He produced a painting of a bunch of grapes so realistic that birds tried to peck at it. Zeuxis, in response, invited his rival to draw aside a curtain to look at his work, but when Parrhasius tried to do so he realized that the curtain itself was a painting, and admitted defeat. Parrhasius had fooled animals; Zeuxis had deceived man.

The majority of Ancient Greek paintings were on walls, many apparently of great size, but some were painted on panel or cloth. It is possible that the Erectheion, on the Acropolis in Athens, was built to show portable works of art – the world's first picture gallery. The subjects of these pictures were mainly religious and triumphal: they brought to life the antics of the gods, or were commissioned to commemorate victories on the battlefield and in the sports arena. But it was thought that no original painting survived from these times until 1968, when a small stone-box coffin, the Tomb of the Diver, was discovered in a cemetery in the Greek city of Paestum in southern Italy. The paint inside looked fresh, but it dated from 480–470 BCE,

the high point of Greek culture, the time of Aeschylus, Pericles and Socrates. It was, almost certainly, by the hand of a provincial painter, working far from the cultural centre of Athens, but its quality is such as to give us some inkling of what the world has lost.

What is surprising about the *Tomb of the Diver* is the sureness, grace and utter simplicity of its execution. It was painted using the exacting technique of true fresco, in which the images are created by brushing pigments suspended in water on to sections of damp plaster. This necessitates working fast – the plaster dries within a few hours – and making no mistakes. Its advantages are that the colours glow with absorbed, reflected light, like a sheet of frosted glass, and remain fresh, because they become part of the wall and don't flake off or fade with time. The scene on this coffin lid is a gloriously simple evocation: two feathery trees, a diving platform, a horizon of water and a little naked diver, wonderfully caught in profile, with his eyes open and his genitals drooping, as they would. His dive is symbolic of the soul entering the next world. The diving platform probably represents the Pillars of Hercules that stood at the end of the known world. If so, the pool is Oceanus, the sea that was believed to surround the world.

For the Ancient Greeks, the afterlife didn't mean sizzling hellfire or endless hymn-singing, but simply a continuation, for eternity, of what one most enjoyed doing in this life. These activities are also shown in this delightful tomb (two words that seem contradictory to us but apparently weren't to the Ancient Greeks). The

north and south walls show young men lying together on day beds at a *sumposion* – a drinking party (the modern word symposium, sadly, has a drier meaning). On the north wall an older, bearded man fondles a handsome, rosy-cheeked youth. His fingers show he is tickling the young man's hair. The youth lies beside him, playing the lyre with his left hand while his right indicates something in the distance, suggesting that he is reciting, or perhaps singing, a story to his friend as they gaze into each other's eyes. They both rest their elbows on differently patterned, surprisingly modern-looking, cushions. On the day bed next to them, young men are playing *kottabos* – a popular Ancient Greek game with erotic overtones that consisted of flicking the dregs of your wine from the bottom of your cup in an attempt to hit a moving, usually floating target. The goods found in the grave were sparse: just a lyre and a few unguent bottles which presumably originally contained scented body oils. What else would you need to take with you for such an afterlife?

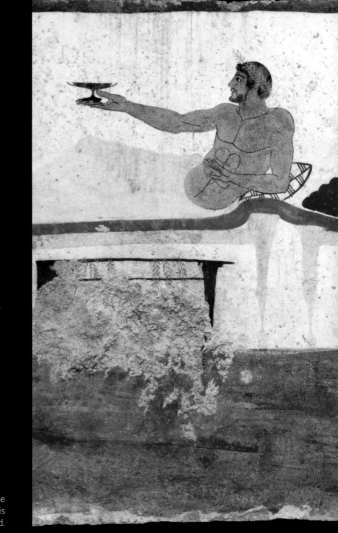

The side wall of this small tomb was barely longer than the corpse it contained. Friends lounge alongside the deceased, sharing his pleasures in the next world.

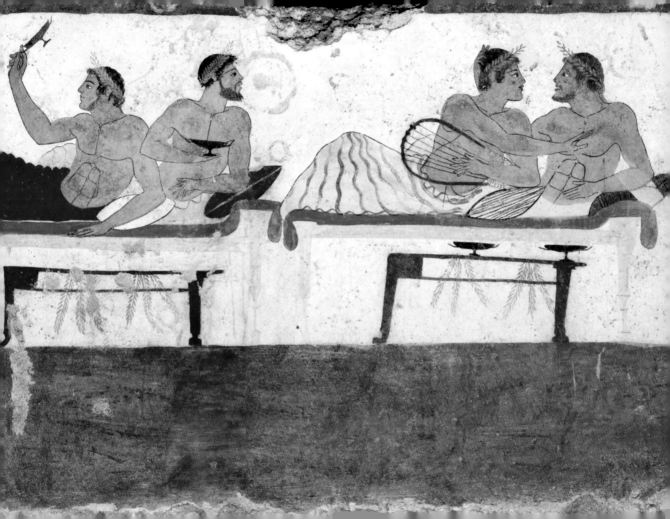

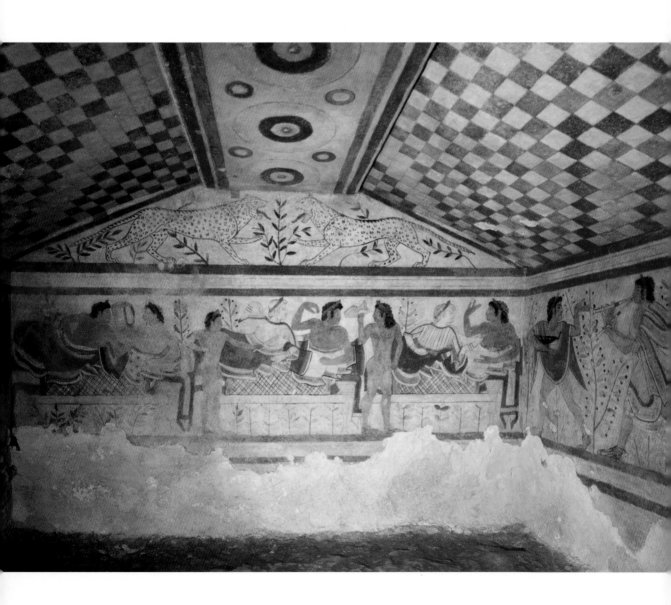

Tomb of the Leopards

Artist unknown

Fresco | 5th century BCE | Tarquinia, Italy

T he Etruscans have been swathed in mystery since their culture began to be rediscovered in the eighteenth century. They seemed to answer a human yearning for a mysterious ancestry redolent of secret knowledge. Though mentioned by the Ancient Romans, little was known about them. They were an independent people, with their own language and beliefs, who inhabited central and northern Italy a millennium before the Romans; they provided Rome with its first kings, but their culture was gradually absorbed and finally obliterated by the emergent materialistic empire. Some of their language survived, freakishly, because a length of linen used to wrap an Egyptian mummy was found to be covered with an Etruscan text dating from the second century BCE. There's a widespread belief that the language has remained untranslated, though in fact most of it is now understood. The text is a list of prayers to be recited throughout the year. The Etruscans built their houses, halls and temples out of wood, so none now remain: all we have is their tombs. About six thousand have been unearthed, almost all undecorated. Many were robbed in antiquity and now lie bare.

In the mid-nineteenth century, however, a handful of painted tombs were discovered, and these fired a new wave of Etruscan fever. D.H. Lawrence's 1927 book about them, *Etruscan Places*, passionately evoked a race of dark, muscle-bound, naked men and elegantly robed, pale-fleshed women. He wrote lyrically about how they touched each other, and mourned the decline of physical contact in modern society. The sensuality of these people, and what he thought was their mystic response to creation, were what most appealed to him. In several graves, men and women are shown lying side by side, propped up on pillows, and often the man is handing the woman an egg. For Lawrence, this was "the egg of resurrection, within which the germ sleeps as the soul sleeps in the tomb, before it breaks the shell and emerges again."

The Villa Giulia in Rome, the greatest treasury of Etruscan artefacts, houses a remarkable life-size funerary monument – an amazing survival in brittle terracotta. An extremely elegant couple lie on a couch, half raised up, smiling, their eyes alert. His hand rests gently on her shoulder, his elegant long fingers open – surely they too once held a fragile egg. This degree of sophistication was, however, unusual in the art of the Etruscans, a loose collective of boisterous peasant clans linked by a common language. By the sixth century some of them were already much influenced by the Greeks. The *Tomb of the Leopards* is a colourful country cousin of the *Tomb of the Diver* (see p.60). It's still worth going to the bleak open hilltop at Tarquinia where the largest group of painted tombs have been found, even though few are now open, having deteriorated greatly after decades of exposure. Narrow stairs lead you down into room-sized chambers, like painted tents underground. The colours are startling as are the bold roof patterns. These local Etruscans were a noisy lot. They loved drinking and dancing to the sound of the double flute and lyre, and had no intention of stopping when they died. Standing in the empty field, you can easily imagine them singing and laughing below, loving life – not mysterious at all.

Portrait of Two Brothers

Artist unknown

Distemper and encaustic on wood| 61cm diameter |
2nd century CE | Egyptian Museum, Cairo, Egypt

P ortraits must have been a familiar sight in Ancient Greece, hanging in courts, offices and the homes of the better-off. But not one survives. Roman culture developed from the Greek, and included a fondness for painted likenesses, but apart from a few from Pompeii, virtually no Roman portrait paintings have come down to us either. In Egypt, however, an unlikely confluence of cultures preserved this great classical tradition for posterity. Under Roman rule, the upper Nile valley became an extraordinary social melting pot. People descended on it from all over the empire, attracted by the wealth of its cities, the fertility of its land and its hot, equable climate. Egypt was the Southern California of the Roman world. The emperor Hadrian built the city of Antinoöpolis there, close to where his beloved Antinoös had drowned in 130 CE. And it was in the necropolis of this city and those of nearby towns in the Fayum basin that a remarkable buried treasure was discovered.

A strange funerary practice had evolved that was an amalgam of Roman and Egyptian beliefs. The bodies of the dead were mummified, but rather than covering the heads with masks, painted portraits were placed there – vivid, realistic faces peering out through windows in the bandages. Nearly a thousand of these have been found over the last four centuries, a few scattered in the world's museums, but most in private hands. Cut from their wrappings and sold, these portraits were eminently collectable. Unfortunately, the bodies were discarded and with them all the context of their lives so that, on the whole, we know very little about who these people were, except that they had all adopted Roman

ways. We can tell this by their simple clothes, un-showy as the law decreed, and the style of their hair, which was always brushed away to reveal their faces. Even more remarkable is their distinct individuality. Like the Chimu pottery heads (see p.69) and the Chinese Terracotta Warriors, the painted mummy portraits of Fayum wipe time away and show how similar we are to our ancestors. People must have wanted to preserve their personality in death. Most of these portraits are painted in the encaustic technique, using pigment mixed with hot beeswax – a sticky and highly intractable medium. The artists had to work fast. Sometimes they painted directly on to the bandages covering the face – memories of the living being beneath. But mostly the portraits were painted on boards, in some cases perhaps from life.

The similarity between these two men has led experts to think they were brothers, but the difference in their skin colour suggests a more distant relationship. They could have been lovers; homosexual partnerships were honoured in the military. The golden statuettes in the background indicate that both were heroes; they might have died together on the same battlefield. What's remarkable is the way the artist, with a few confident strokes, has been able to capture their different personalities. The dark, almost smiling, look of the man on the left gives his face a slightly dreamy air, while the pin-point lights in the eyes of the other, and the hint of a scowl on his lips, suggest a more pugnacious temperament. Both could kill without a second thought. The swastika was a symbol widespread throughout the ancient world, generally signifying good luck, for eternity.

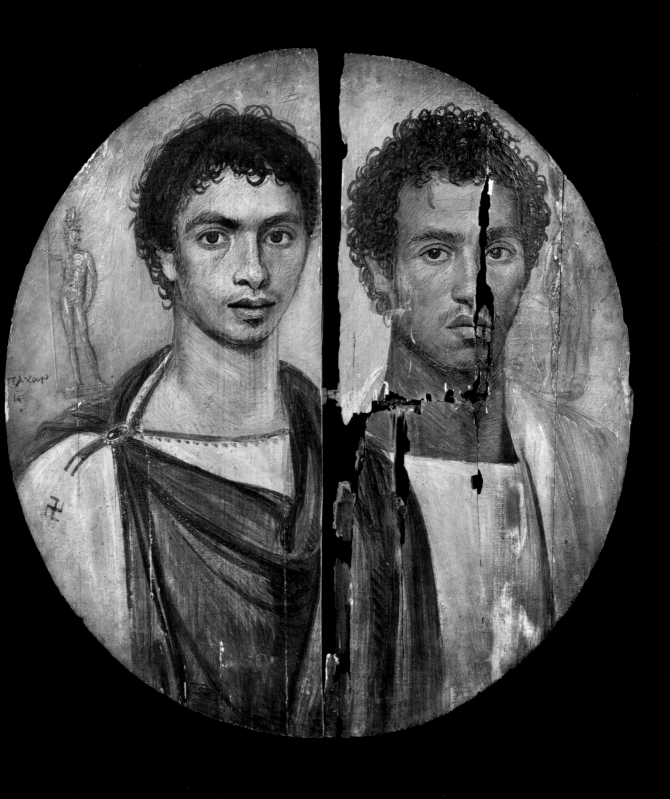

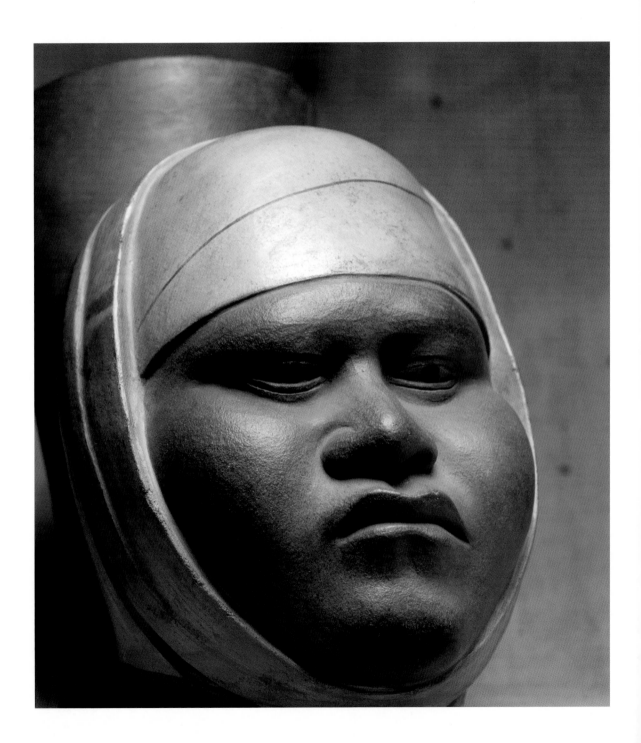

Moche Vessel in the Form of a Head

Artist unknown

Fired clay | 28cm | c.400 CE | Private collection

W alking through the storerooms of the Museo Rafael Larco Herrera in Lima is one of the world's great artistic experiences. Due to the enlightened policy of the museum, these rooms are not hidden but open to the public. Inside are some forty thousand complete pottery artefacts from ancient pre-Columbian Peruvian cultures, the most extraordinary of which are the Moche portrait vessels: row upon row of faces looking down at you from the distant past, brightly painted and exquisitely modelled. What's most surprising is that they all look so different – a vast assembly of powerful characters. The overall effect is similar to that of seeing the Terracotta Warriors in situ in Xi'an. Looking into the eyes of each of these ceramic faces, we sense we are seeing a unique individual, someone with their own past and future, each a story waiting to be told. This is a remarkable artistic and imaginative achievement, all the more so because both the Chinese and the Moche potters based their heads on standard moulds. Seven thousand distinct Chinese warriors were created from eight basic physiognomies! The Moche used more, possibly over a hundred. But it's what these artists did to the given face types that matters: here the sculptor has puffed out the cheeks, sunk in the eyes and slightly curled back the upper lip so precisely that you feel a real person is before you.

We know very little about the Moche. Their culture flourished from about 100 to 800 CE along the river valleys of northern Peru. They had no writing but, like the Ancient Egyptians, developed elaborate irrigation systems, and built colossal pyramids, out of mud brick.

The remains of their buildings, from mud and rush hovels to adobe palaces, suggest a highly stratified society. Skeletal remains indicate that human sacrifice was practised, mostly of young men. Many had their throats cut, and their blood may have been collected, possibly for consumption, while some appear to have been deliberately stripped of their flesh and others covered with mud. All of this indicates that such sacrifices were associated with rebirth.

The ceramics found in Moche tombs are almost invariably representational shaped pots. Some take the form of maize cobs, sweet potatoes, or ulluchu, a fruit used as an anti-coagulant. Others are modelled with scenes of people going about their daily business: farming, fishing or making love. The Museo Rafael Larco Herrera has a whole wing dedicated to pots embellished with all manner of sexual acts. Every plant or activity was a vehicle for conveying life-giving juices. Most important were the vessels formed as portrait heads. No one knows what these pots contained (possibly some sort of corn alcohol) or how they were used. They've been found broken in dumps, while those placed in tombs show signs of wear and were not made specifically for the afterlife. The portraits are of men only, sometimes boys, and occasionally show the same man at different ages. My own interpretation is that these vessels were communal drinking cups, passed round on special occasions, celebrating heroes. Each time the cup was tilted, the hero's face looked up at the stars, from whence his spirit had come. Then as the liquor poured, his spirit flowed into the community. And the essence of his spirit was his individuality.

Golden Bronzes of Pergola

Artist unknown

Gilded bronze | 1st century BCE | Museo dei Bronzi Dorati, Pergola, Italy

I n 1946, in the sparsely populated Marche region of Italy, two farmers digging a ditch near the little town of Pergola unearthed a neatly stacked pile of moulded sheets of gilded bronze, in which they discerned arms, hooves and two horse's heads. They were the remains of a Roman statuary group that had been purposefully broken down, squashed and hidden, presumably by thieves. About half was missing, suggesting that the loot had been divided, and this is almost certainly lost for ever; metal was extremely valuable, and could easily be melted down and reused, which is why hardly any metal sculptures remain from ancient times except those lost at sea.

The Pergola fragments were sent for restoration to Florence, where the larger sections were reassembled and returned to the Marche, to be exhibited in the Archaeological Museum in the district capital, Ancona. But the troubles of the statuary were not yet over. The pieces still in Florence survived the flood in 1966, though they were buried in mud, while those in Ancona narrowly survived the earthquake of 1972, which seriously damaged the rest of the museum. In 1974, it was decided to reassemble the whole group, in Florence, a process which took until 1988. On its way back to Ancona, the group was exhibited briefly in Pergola as a courtesy. But when the exhibition was over, the locals wouldn't let the statues go, bricking up the doors and manning a twenty-four-hour watch. Eventually the government stepped in and allocated the finds to Pergola, where they now reside in a new museum opened in 1999 – a heartening tale of the margins trumping the centre.

Pergola was never central, even in Roman times, which makes the survival of this group all the more poignant. It was almost certainly buried close to its original location; it would have been too difficult and risky to move the loot far. The almost life-sized group probably graced a nearby road, the remains of which have been found. The simple garments and lack of ornament suggest that the statues celebrated local people, at a time when Rome was still a true republic and people wore uniform clothing. It can be dated to about 50–30 BCE.

The double-tiered lacing on the rider's beautifully modelled boots and the equestrian ring on the woman's finger are the only modest indications that these people were high ranking, though not exceptionally so. The rider, who wears a toga, not armour, raises his arm just below head height. This gesture meant peace had been restored. The medallion on his horse's head shows Mars, the god of war, reclining, naked and at ease. Such tiny clues tell us that a battle has just been won. This statuary is a celebration, therefore, of the resumption of normality. The man is serious and determined but not in any way heroic. Two women walked beside the horses. The one that has survived has an old, troubled face, with a slightly lopsided expression – a realistic portrait, perhaps of the rider's mother. She lifts her hand from under her gathered robe and raises a finger as if about to say something. This is a speaking likeness from far-off times. There must have been thousands of statues like this dotted across the Roman Republic, art praising modest individuals who had made and kept life good.

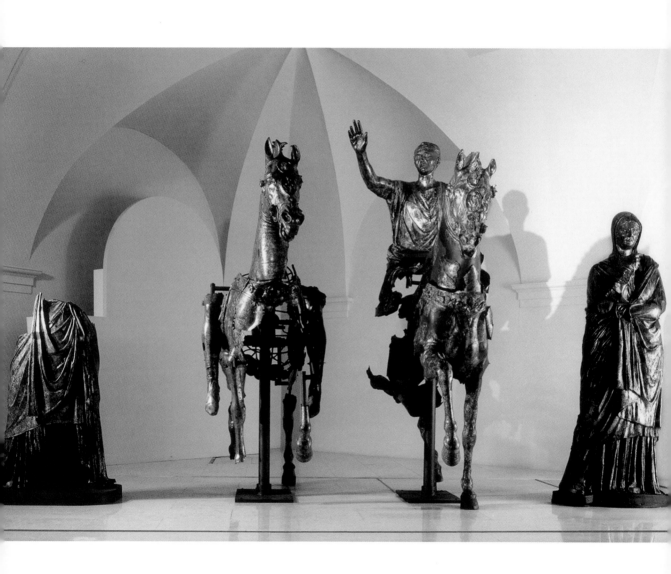

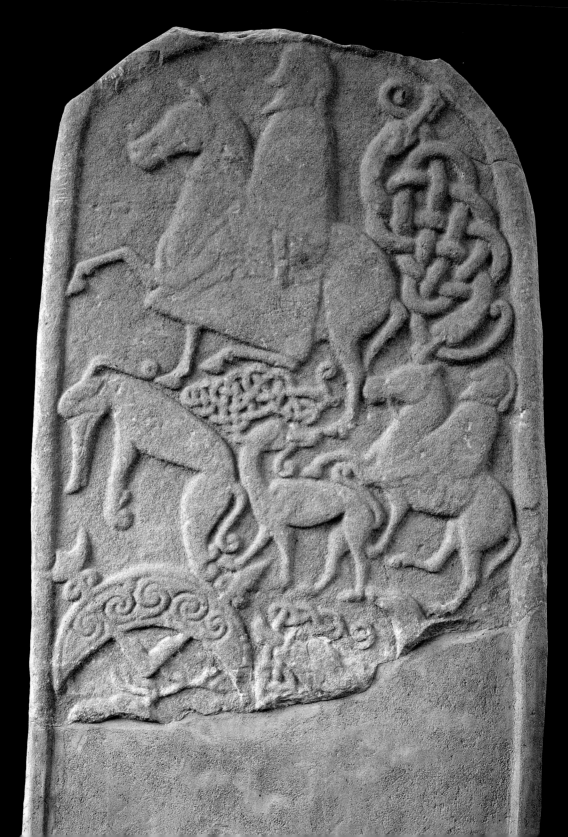

Pictish Stone

Artist unknown

Sandstone | 8th–9th century CE | 152cm high |
Sculptured Stone Museum, Meigle, Scotland

T he earliest art of the world was tribal. It emerged among family clans, who were hunter-gatherers, farmers or both. They might trade with or raid their neighbours, but at heart they were territorial. Even when they migrated, they did so within set terrains. We now have a romantic notion of our early ancestors travelling great distances, exploring virgin lands. Undoubtedly they sometimes did this, for their sense of curiosity must have been as strong as, if not stronger than ours is today. But these lands were dangerous, inhabited by hungry beasts and hostile men. When they ventured forth, their aim was generally to return. The majority of people were (and still are) home-based; their deepest longing was to live and die where they were born. Art was the expression of this sense of belonging. Its mainspring was community identity; as the community grew stronger, so did the art. Some tribes came to dominate, through marriage and bargaining, war and guile, and increasingly marked their presence within their lands. Hardly any of these tribal signposts have been left standing. They were the first things to be swept away as kingdoms, then nations, then empires took over, just as today when a business is absorbed by a larger company, its logo and other branding are immediately ditched. The sculpted Pictish stones of Scotland are rare survivors from early tribal times. These stones didn't mark graves, but stood in the open, by old roads, probably indicating clan boundaries. Several are still in their original positions, though these are often much worn by wind and weather. Some were reused as building material, and occasionally these have survived in crisper condition. The choicest are to be found in the tiny Meigle Museum.

The clean-shaven Romans contemptuously called these barbaric people "Picts" because they painted their bodies. It probably wasn't just painting, but tattooing. The recent excavation of a fifth-century BCE grave at Pazyryk, in the Altai Mountains of Mongolia, yielded the deep-frozen and remarkably preserved body of a chieftain whose skin was elaborately tattooed with intricate patterns of knots and curls. The Maori people of New Zealand tattooed themselves up till modern times; engravings from the eighteenth century show the elaborate abstract patterns that covered their faces, each one unique and probably indicating birth signs and secret spiritual influences from the individual's ancestry. Body painting is one of the great lost treasures of world art, and it was everywhere.

It's likely that the Picts, a northern people, were masters of tattooing. Their stones would have been lasting expressions of these designs, declaring family identity. The significance of many of the symbols on them is now totally lost, for instance the so-called "Pictish beast" with its hangdog beak, Rip van Winkle hat and curlicue feet – the celestial offspring of a sea horse and a dolphin – and the equally omnipresent and mysterious sickle moon pierced by a broken, flaming spear. On the other side of this stone is a carved cross, packed with coiled knots and surrounded by more strange beasts. The Picts continued to identify with their origins even after they adopted Christianity in the sixth century CE. Their art remains all the more intriguing for its mysteriousness, which was probably intentional in the first place, made to declare secret allegiance to a clan and keep outsiders out.

Oseberg Ship Burial

Artist unknown

Oak | c.850 CE | Viking Ship Museum, Oslo, Norway

Norse leaders were buried in ships hidden under mounds of earth, most of which were looted in antiquity. In England, the burial at Sutton Hoo (c.625 CE) survived intact. The helmet, facemask and jewellery found there, probably of Scandinavian design, amazed a world that had dubbed that era the Dark Ages. The later Oseberg burial had been broken into, but only the metal goods were taken. The boat was found complete, by far the most beautiful Viking ship to have survived, with immaculately bent timbers bowing out in midship and rising at either end in soaring curves. Where was it going in the afterlife? The remains of fourteen horses, three dogs and, surprisingly, a peacock were found in it, alongside two skeletons: one of an arthritic woman in her mid-sixties, dressed in fine clothes, the other of a woman aged about 25, wearing a coarse blue dress and veil. Her broken collarbone at first suggested that she had been ritually killed, but then it was discovered that this injury had begun to heal before her death. No one knows for sure who they were. A favoured speculation is that the older woman is Queen Asar, celebrated in the Ynglinge clan saga. She was wooed by Harald the Hunter, but when her father, the king, rejected his suit, Harald killed him and carried her off. A year later she had Harald murdered by her servant, returned home with her newborn son and ruled for twenty years.

Three elaborately carved sledges and a cart, the front of which is shown here, were found in the boat. The front axle of the cart was, strangely, fixed to the chassis, preventing the wheels from turning. The cart could only have travelled in a straight line. Was that the shortest way to heaven? An eyewitness account of a Norse funeral in 921 CE survives in the writings of Ibn Fadlan, an ambassador from Baghdad to the Volga Bulgars. He describes a ceremony which included the ritual rape and subsequent sacrifice of a girl, before the boat and corpses were set ablaze. One man said to him during the proceedings: "You Arabs are a foolish lot – because you take those whom you hold in highest esteem and throw them under the earth. Whereas we burn them in the fire so that they enter paradise immediately." Perhaps the need to get to heaven quickly was a paramount requirement when the Norse buried their dead. If so, that would explain the boat, the horses, dogs, cart and sledges – all necessary for a speedy journey.

The carvings on the cart have eluded full interpretation. This detail might show a demon being killed in a snake pit, then a popular means of execution from Norway to China. Traces of paint indicate that the gaps between the lines were painted in light grey, with dark grey on top. These lines would have seemed to writhe when the shadows shifted across the lighter background, as the cart sped to its destination. In Norse mythology the bridge to heaven, which was the rainbow, Bifrost, was guarded by Heimdall, who could hear grass growing and leaves falling, and could see to the end of the world. You had to be swift to get past him. But he would surely have given a helping hand to anyone bringing him a peacock.

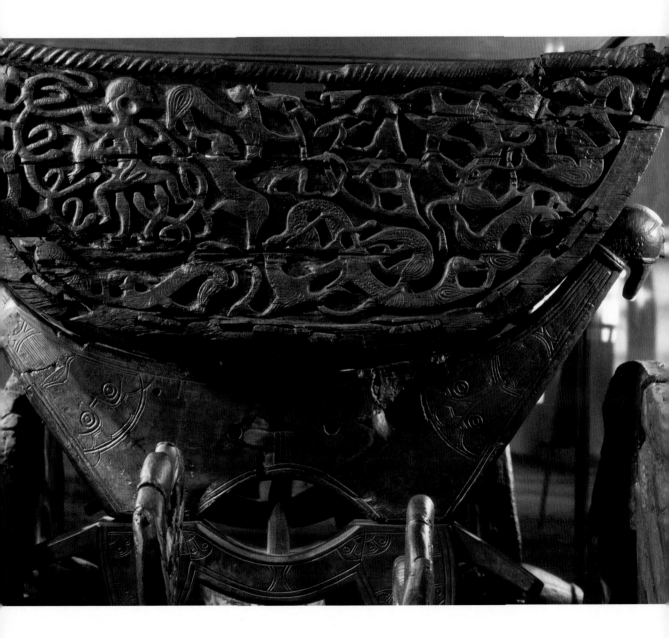

Kula Canoe

Artist unknown

Painted wood and cowrie shells | 580 x 120cm |
South Australian Museum, Adelaide, Australia

P apua New Guinea is the last great
stronghold of traditional tribal cultures,
though these are increasingly under threat
from mining and logging industries. Tailing
off into the Pacific Ocean on the far eastern tip of the
mainland is the scattered – and in places uncharted
– Massim archipelago. Boats, like this trading canoe
from the Trobriand island of Kitava, can still be
seen, dragged up on to the beaches, next to stacks of
ebony trunks and the huge machinery of the timber
companies. The local people sell logging rights, but still
today channel much of their wealth into their complex
ancient system of gift-giving, for which the Kula canoes
are built.

The prows of these canoes are intentionally dazzling
and mysterious. The participants in the Kula ritual sail
for hundreds of miles round a circuit of eighteen of the
Massim islands, handing over gifts to select individuals
and receiving them in exchange. The gifts are symbolic:
red shell necklaces and white shell armbands,
perhaps suggestive of the sun and moon. The red are
traditionally transferred in a clockwise direction, the
white anticlockwise. All of these treasures are distinct
and have names; they are associated with the spirits of
ancestors. The more splendid they are and the more
closely linked to powerful men, the more humbly they
are given, with exaggerated displays of false modesty:
"Oh really, it's nothing." These gifts do not become
the property of the receiver, he is only their temporary
guardian; his responsibility then is to pass them on to
someone else with an even greater display of humility.
Over the centuries an elaborate network has been woven
across the seas, of status-giving and indebtedness,
of friendships sealed and loyalties bound, forever in
danger, of course, of breaking or being betrayed. Special
boats are built for these annual rounds, and decorated,
as everything in this culture is, with magic signs and
visual spells. Their meaning is hidden and surely
deliberately ambiguous. These decorations are the same
as the patterns on the strange shields the men carry in
harvest moon dances; they are about identity, fortifying
initiates and bewildering outsiders.

Dazzling is also a way of hiding – it temporarily
disarms a potential foe. The aggressors in this case
might be witches, the spirits of the sea, many of them
emanations from living women, who were believed to
prey across the waves and stir up storms. The sea is also
the source of children, according to a widespread belief
still current in these islands. When people die, their
spirits (called *baloma*) go to the island of Tuma where,
as reflections of their former selves, they have a good
time while they grow even older, finally shrivelling and
shrinking to the size of babies. They then enter the
waves, shed their loose skin and turn into embryos,
waiting for a woman spirit to pick them up and place
them in a vacant womb from which they will emerge.
This is believed to account for the wrinkled appearance
of the newborn, the frequent resemblance of babies to
distant forebears, and the fact that intercourse does not
invariably result in pregnancy. Sex for these people is
only a way of opening the womb, in preparation for a
spirit delivery. And it was on Tuma, the isle of the dead,
that the most precious giant cowries, which decorate
the Kula canoes, were to be found.

The Comedy of Death

Rodolphe Bresdin

Lithograph | 30 x 23cm | 1854 | Bibliothèque nationale, Paris, France

Rodolphe Bresdin (1822–85) was the son of a tanner who learnt engraving, a poor man's trade. As a youth he had artistic aspirations and haunted the Bohemian districts of Paris. Here wannabe young artists and writers from wealthy backgrounds rubbed shoulders with actors, singers and Gypsies (who were thought to come from Bohemia – hence the name) and picked up grisettes – poor young girls from the country who could only afford to dress in grey cloth – to keep as cheap mistresses. Bresdin became a well-known character in this shady milieu, a bearded visionary fond of taking his pet white rabbit for a walk. When he was only 23, the art critic Champfleury wrote a short story about him. Bresdin became Chien-Caillou, the son of a tanner, turned engraver, who fell in love with a grisette who vanished one day because she couldn't pay the rent. Chien-Caillou died heartbroken after searching for her in vain. Rodolphe Bresdin was ultimately the inspiration for Rodolfo in Puccini's opera La Bohème.

Bresdin became obsessed by a dream of another life where he would be freed from soul-crippling labour and released to live and work surrounded by nature in all her savage splendour. He imagined a primeval existence where life and death existed in an inextricable, regenerative relationship. He drew this world on paper, obsessively and minutely. Many of his prints are no bigger than calling-cards. Bosch, Dürer and Grünewald hovered in the background of his imagination, but his vision became entirely his own. He believed he'd find this raw state in reality in the New World, and emigrated briefly to Canada, only to return all the poorer. He became increasingly embittered and introspective. Gloom spread its wings over his work. In The Comedy of Death a Christ-like figure in the background points to a heavenly light appearing through umbilical clouds, but such eternal bliss is far, far away from the hellish world below. The huddled figure in the cave is surely Bresdin himself. His shining cranium, cradling his dreams, is the only beacon in the surrounding utter darkness. The splayed old man to the left, perhaps already dead or facing death, could be another depiction of himself, or a prediction of his fate, a corpse on the point of being absorbed back into the rotting undergrowth from which it came. A withered root whispers in his ear. The tree-tops above branch skeletons. There's no question about whose domain we're in. This is the kingdom of Death. No wonder Bresdin turned in on himself. His art was hidden by his own dark vision.

Though Bresdin had a few admirers, including his sometime pupil Odilon Redon and the poet Baudelaire, hardly any of his work sold. He died in abject poverty, nearly blind, forgotten by the art world, estranged from his wife and seven children, and living in a garret above a cowshed, where he eked out an existence by selling vegetables grown on a small plot of land. His vision was expressed through minute strokes of black and white, in the new medium of lithography, which enabled his drawings to be printed to an extraordinary standard of resolution. The joy and tension that went into their making can only be appreciated in the originals; the detail is lost in reduced reproduction. Sadly the few works of his that survive mostly languish in museum storerooms.

My Destiny

Victor Hugo

Ink, gouache and wash | 17 x 26cm | 1857 | Maison de Victor Hugo, Paris, France

W alking into the home of Victor Hugo (1802–85) on Guernsey is like entering his mind. You are encased in a dark cave of shadows, faces, gargoyles, gnarled branches – quite impossible to photograph. Slowly you begin to make it out. The hall has been lined with old oak furniture, cut up and reassembled to make a wall, a canopy, a stair. You can see chairs, bedposts and panelling, primitively and deeply carved with leaves, eyes, noses and jutting chins, all dark brown, peering through the gloom. The bits and pieces which Hugo used to decorate his house were local handicraft, gleaned from second-hand furniture shops and bric-a-brac sales; nothing was expensive or precious, so it could be sawn up with impunity. The effect of its assembly is of riotous play, perhaps a bit on the dark side, but too lively and odd to be oppressive. It is a hidden world of creative zaniness, and there is nowhere else quite like it.

Hauteville House was the first home Hugo actually owned, and he decorated it exactly as he wanted, despite what his more conventional wife and family thought. He lived there from 1855 to 1870 as an exile from France, driven out because of his political activism and radical views. He was one of several victims of the shock waves of reaction that continually buffeted France after the Revolution. Hugo was a staunch republican, a believer in the freedom of the press, the abolition of the death penalty and the creation of nation-states as a necessary step towards building his dream of a United States of Europe. He enjoyed living in Guernsey because he could work there without

political and social distractions, though more and more visitors came, and his correspondence was vast and international. He extended his charity work, providing free lunches for dozens of poor children. He wrote standing up at a desk in the lantern room he had built at the top of the house, facing the distant coast of France, every day from before dawn till well after dusk. There would be short breaks for meals, perhaps a game with the family, a song or charade, and, every evening without fail, his "constitutional" – a visit to his mistress Juliette Drouet, whom he'd installed in a house nearby. The interior he created for her – in bizarre chinoiserie packed with visual puns on his name – is preserved in the Victor Hugo House in Paris.

It was in Hauteville House that Hugo wrote the final version of Les Misérables. But its extraordinary environment was only one manifestation of his visual creativity. He was also a great artist, but of the four thousand or more works he produced, privately for himself and friends, hardly any are ever seen, not even in his house in Paris which has by far the largest collection. These paintings are dark fantasies, of ruined towers, ships in storms and corpses swinging on the gallows. They began with him just playing, not with old bits of furniture, but with ink, blotting, scraping and dragging until some kink hooked his imagination and an image flowered, resonant with feeling. Here he's caught a wave, the pulling under and crashing over, and the white spume drifting – the feeling of being dragged through life, which he, as a believer in divinity, called his destiny.

Last Supper
Andrea del Castagno

Fresco | c.1447 | Cenacolo di Sant'Apollonia, Florence, Italy

I n Italian Renaissance cities art was everywhere – in the street, round the corner, through a door. You can still get a sensation of this cultural omnipresence in Florence, though only a fragmentary patchwork remains of what the city was like in its heyday. Its treasures include many world-famous works, but they're so plentiful that some real gems are still little known. On a back street, a couple of minutes' walk from the Accademia Gallery (with its permanent queue thronging to see Michelangelo's *David*), is a doorway very few tourists enter, though anyone is free to do so. A few steps find you in a great hall, once the refectory of a convent. A colossal painting fills the whole west wall. The upper part is, sadly, damaged, but the lower is almost pristine, except that the dark floral drapes and grass would originally have been green. The scene shows the Last Supper, then a popular subject for the dining halls of religious communities. It was painted for a closed order of Benedictine nuns and wasn't "rediscovered" until 1861, after the convent had been secularized.

Hardly anything is known about Andrea del Castagno (c.1421–57). His surname derives from his village of origin, in the Mugello region, not far from Florence. He earned the nickname "Andreino degli Impiccati" (Hanged-Men Andy) after his first public commission, for a fresco (long gone) on the exterior of the Palazzo del Podestà in Florence, showing the dangling upside-down corpses of rebels who were defeated at the battle of Anghiari (see p.249). Andrea was well enough

known in his time to be included by Vasari in his book of artists' lives, but a lot of what Vasari wrote about him was pure fiction, including the claim that he jealously murdered his supposed rival Domenico Veneziano, who in fact died after him. Even much of the Sant'Apollonia sequence, his major surviving work, is difficult to see. You need binoculars to appreciate the scenes painted above the Last Supper. The Resurrection (on the left) is the best preserved section. A soldier looks up in wonder as Christ rises from the tomb, bathed in light. It is as beautiful a conception as the similar, much more famous version by Piero della Francesca, which was clearly inspired by it.

The vividness of the scene below comes as a surprise. The white tablecloth, perfectly realized with its delicate pattern and light creases, hangs as though suspended in space. Most striking is the representation of the panels of cut and polished stone set in marble frames above the heads of Christ and the Apostles. No one in Castagno's day had any idea how rocks had been formed, or how old they really were. It was assumed that they had been made at the time of the Creation, in an instant and relatively recently. Being by the hand of God, their forms and colours had to have a divine significance. Though it's difficult to be certain of the type of stones represented here, the two panels on the viewer's left seem to be varieties of porphyry, a stone whose use in Imperial Rome was the exclusive province of the emperor. Its presence sets the historical date of this scene from Christ's mission. Of the two panels on the right, the innermost looks very like *corallina*

di *Spagna*, while its neighbour probably represents lapis lazuli, a semi-precious stone from what is now Afghanistan which was the source of the precious pigment ultramarine (whose name means "beyond the sea"). This could be taken to imply that the apostles would carry Christ's message to the ends of the Earth (Spain was then believed to be the country with the most westerly point in the known world). The bluish pink veined panel to the right of centre is very like *granito della colonna*, so called by Italian stonemasons because it was believed to have been used to make the column to which Christ was tied during his flagellation. The other central panel, directly above Christ and Judas, is the most dramatic. It almost certainly represents agate, then regarded as a wonder of nature for its storm-lightning intermingling of brilliant colours. Here nature echoes the drama going on beneath. The heads of Judas and Christ are vividly contrasted: one of dark, evil introspection; the other of light, loving care. Andrea seems to have painted the moment when, according to St John's gospel, Satan entered into Judas. Sin was believed to have been inherent in creation since the Fall of Man.

A few streets away from the Cenacolo, the Museo dell'Opificio delle Pietre Dure has a fascinating display of samples of a huge range of decorative stone, together with the tools used in the traditional craft of cutting and polishing them – another hidden treasure of this unique city.

The painted creases in the tablecloth are visible, but the glass vessels have almost disappeared. The floral cloth, hanging, behind the figures, was originally green.

·S·IOHANNES ANDREAS ·S·BART...

4 Hidden by Hate

Religious belief has been a great maker and destroyer of art. Thousands of divine images disappeared when gods became singular. Initially there was resistance to the idea of monotheism, and the world's first wave of iconoclasm swept across Akhenaten's Egypt after he'd declared his faith in a single god, the sun. The Ancient Egyptians were having none of it and obliterated his new capital and everything in it. Since then, the world has witnessed tsunamis of destruction, usually waves of revenge against oppression but sometimes just changes in religion, when the most visible symbols of the previous authority – its works of art – were mowed down. The Kailash Temple, in its glory one of the greatest works of art ever created, only survived destruction by Muslim invaders because it was cut out of a mountain. It proved impossible to eradicate it completely. Hate is as blind as love. It's extraordinary that medieval stonemasons couldn't see the beauty of the carving on the *Young Man of Mozia* when they chucked him in a ditch to use in foundation rubble. The world has cleared away almost as much art as it has made. Northern Christians swept their own house clean when Protestants declared images were ungodly. Countless sculptures were hacked off cathedral walls, but fortunately in Germany some altarpieces were simply closed up. So putting some artworks in the doghouse, like the intricate carvings of Riemenschneider, became a way of preserving them. In the twentieth century, when hatred turned on race, art became its witness, nowhere more powerfully than in the unforgettable paintings of Felix Nussbaum.

Fragment of a Royal Woman's Face

Artist unknown

Jasper | 13 x 12.5 x 11.5cm |c.1352–1336 BCE |
Metropolitan Museum of Art, New York, USA

F ragment though it is, this is possibly the greatest carving ever made of a woman's lips – at the same time a beautiful simplification and yet convincingly realistic. There is no actual line which separates the skin on a person's lips from that of their face, though lipstick can make it appear so. We like to emphasize our mouths; they, along with our eyes, are our main vehicles for communication and, ultimately, invitations to love and sex. Ancient Egyptian make-up made much use of eyeliners and lip-liners. Here the lips, including their pointed ends, are encased in a single contour, as if the mouth were floating on the face, like a leaf in water. It is the precise undercut carving of this line that creates the glorious impression of a pout, as if these lips were shaping up to kiss. The waving seam along their parting has been so sensitively delineated that it is difficult to believe you are looking at stone chiselled by hand. This is no ordinary stone, either, but an exceptionally large, extremely rare hunk of yellow jasper. A groove in the back suggests that only the head of the figure was made in this precious material; the rest of her body was probably cut out of more common, but still valued alabaster.

The effect of the complete sculpture must have been extraordinary, with a face like the sun rising over a pale sea. Such an analogy might have been intended since, though the woman's identity is unknown, the exquisite craftsmanship and rareness of material suggest a royal personage, perhaps one of the pharaoh's queens or daughters. As a recipient of the pharaoh's love and

seed, this woman would have been imbued with the life-giving essence of the sun for, though no one knows for certain where this fragment came from, everything indicates that it was created during the reign of Akhenaten (1353–1336 BCE), when he reformed Egyptian religion and introduced the concept of a single god, the sun, who was his father. And one of the main reasons for thinking that the head dates from this time is that it has been smashed to bits.

It is almost impossible to imagine today how anyone could willingly destroy such a wonderful sculpture. If those were her lips, imagine her eyes! How could they have inspired the fear and loathing that cracked her face apart, and left a desert of scars? The explanation lies in the fact that this wasn't a work of art in the way we understand the phrase today. The hours of loving workmanship that went into it were nothing in comparison to the power it contained of the sun-god pharaoh. The world's first known monotheistic faith, which perhaps encouraged Judaism, and thence Christianity and Islam, resulted in the world's first known wave of iconoclasm. Armana, the great new city Akhenaten built to his god, was systematically razed to the ground in c. 1334 BCE. All that remains is debris stretching for miles under drifting sand. A handful of fragments – these lips, a wall tile showing a cow wading through papyruses, a floor painting of ducks swimming among lotuses – indicate what glories there must have been. The world's first and possibly greatest flowering of realistic art, inspired by a belief that the beauties of nature are god-given, was hidden forever, by hate.

Kailash Temple

Artists unknown

Basalt | 770–870 CE | Ellora, India

Vandalized by Muslims who spread across northern India in the thirteenth century, the Kailash Temple was then systematically ravaged on the orders of Aurangzeb (1618–1707). Fortunately it was so vast that enough remains to enable one to recreate in one's mind what was once one of the greatest works of art the world has ever seen. The whole colossal structure, standing 33 metres high, was cut out of a mountain side. It is not a building, but a sculpture of a temple. It took four generations of masons to carve it, from 770 to 870 CE, working from the cliff-top down. They must have visualized it in its entirety before the first chisel stroke was made, since working in reverse left no room for a slip.

This was an immense labour of love, carried out by people who knew they wouldn't live to see their work completed. The complexity and sheer effort of realizing this monumental structure is bewildering to the modern mind, not least in the confidence it demonstrates about the future. But then its masons were creating an image of a mountain that would last from the beginning to the end of creation. Mount Kailash is a real mountain in the Himalayas, still worshipped by Hindus as the home of Lord Shiva, the god of creation and destruction. It was the divine axis between heaven and Earth, where the Milky Way fell down from heaven to form the Holy Ganges. Thousands of pilgrims go there every year to circuit its base and worship at its shrines.

The carved Kailash temple at Ellora is an image of the whole cosmos. It's topped by a vast opening lotus flower on which four huge lions pace, guarding the four celestial gates to the east, west, south and north. The upper storeys of the temple depict heaven, the abode of the gods. Beneath this is the sky through which *devatas* – the angels of Hinduism – dance and fly. Most are, sadly, much mutilated, but a few on higher, inaccessible storeys are still full-limbed and decked with floral garlands and flowing robes. They are among the most frolicsome and lightsome angelic beings ever created. Below them is the terrestrial zone, where humans live. Here the gods appear from time to time to perform miracles, make love and generally get up to mischief. This whole towering edifice of earth, sky and heaven is carried on the backs of colossal elephants that face you at ground level. Their great ears ripple delicately in the breeze as their huge feet pad through the waters under the world, while their trunks pluck lotus flowers. No elephants were ever so beautifully carved as these – though sadly so many have been vandalized that only tantalizing glimpses of their glory remain.

The whole structure was originally painted, but almost all the plaster has fallen away through neglect and natural deterioration, or been deliberately chipped off. The effect when it was brightly coloured must have been extraordinary. The whole mountain must once have flowed with energy and excitement. From the paddling elephants at its base to the lions prowling on the lotus flower at its zenith, it is perhaps the greatest single conception anywhere of the glorious fecundity of creation.

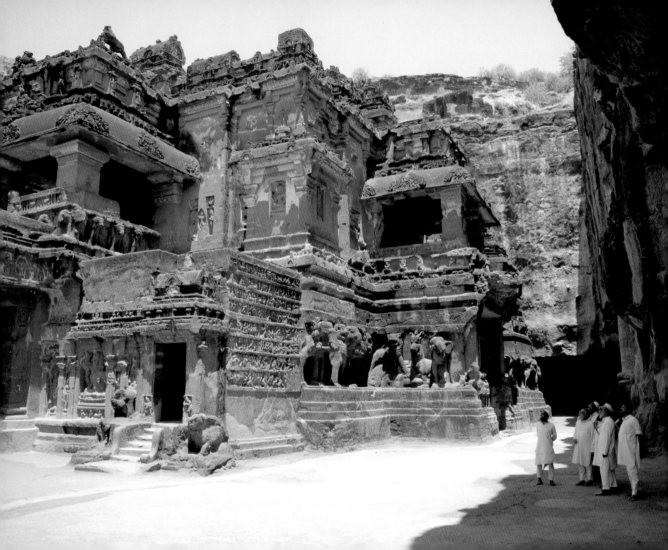

Jayavarman VII in Meditation

Artist unknown

Sandstone | 135cm | c.1200|
National Museum of Cambodia, Phnom Penh, Cambodia

This doesn't look like the portrait of an old soldier, but then it wasn't supposed to. It depicts a man who became king when he was over fifty after decades spent expelling invaders, and who then proceeded to expand his frontiers, during a reign that lasted a further thirty years, until he ruled over the largest empire the Khmer people had ever known. The statue shows the other side of the king's nature – his avowed Buddhism. It's a portrait of his inner spirit, his eternal youthfulness, the soul of goodness that drove him to conquer all for the sake of his people. He had hundreds of such statues exhibited in prominent places throughout the empire, accompanied by inscriptions which stated: "He suffered from his people's sufferings more than he did from his own." Jayavarman VII was as obsessive a builder as he was a soldier, erecting new temples in a land that was already packed with them. These sacred sites were essentially places to pray for the souls of the departed and the living. Each was serviced by resident priests and choruses of dancing girls in their hundreds. In 1186 he built a temple dedicated to his mother, and five years later one to his father; then he started work on his own temple at Angkor Thom, enclosed within three kilometres of eight-metre high walls. This wasn't a show of self-aggrandizement, but a centre for sending goodness to his people.

The Khmer sculptors were outstanding for their ability to carve spiritual power. This figure's closed eyes make you aware that he is meditating, his gaze turned inward. The lids are veils which reveal something you don't usually see: the domes of the eyes. Khmer sculptors were intensely aware of the swell of inner forms, in cheek and shoulder, chest and stomach – here fractionally extended to suggest the held intake of breath called *prana*, the epitome of spiritual power. How they managed to cut such subtle curves in stone is a wonder. They were undoubtedly influenced by the artists of India, the source of both of their religions, Hinduism and Buddhism, just as the Indians themselves had been influenced by the sculptors of Greece and Rome. The latter might have inspired the Khmer carvers directly, for Roman coins have been found dating from the earliest period of Cambodian history, showing that contact was probable and trade likely. But Khmer art is essentially home-grown, the flower of their faith. When it changed, trouble came. Soon after Jayavarman died, in about 1218, Hinduism was swept back, and most of his statues were wilfully destroyed.

This statue has been reassembled, almost certainly from different sculptures. The tragic subsequent history of the region has seen the destruction of much of its cultural past, by vandalism, theft and decay. When the French ran the country they took a few sculptures back home – wonderful things, though hacked about. But at least they saved them from the ravages of the brutal Khmer Rouge, the ruling party from 1975 to 1979, who outlawed religion and civilization in their gruesome, forced return of the people to an imaginary, idyllic peasantry. The Guimet Museum in Paris and the National Museum in Phnom Penh contain virtually all that's left from one of the world's great sculptural traditions. The countless fragments on the temples themselves are sadly almost all now decayed.

Coatlicue

Artist unknown

Stone | 270cm | 14th–15th century CE |
National Museum of Anthropology, Mexico City, Mexico

This colossal stone statue has a history of being hidden. At some time after the Spaniards invaded Mexico in 1519, Coatlicue was buried under the main square of the city, perhaps by Aztecs who wanted to save and preserve her powerful presence, or perhaps by the conquerors themselves because they couldn't stand her face. She was discovered by chance in 1790 and put on show, but when people started to light candles to her, the authorities again banished her underground. Dug up to be cast in 1803, she was then hastily buried once more, and only finally exposed twenty years later. Even now, in the sterile surroundings of the National Museum of Anthropology, stripped of all her religious context, visitors turn away from her with an involuntary shudder. Human eyes were not meant to see such ferocious, naked power. This carving can fairly lay claim to be the most terrifying image ever created by mankind.

The probability is that she was also hidden in Aztec times. Her gaze might have meant instant death to non-initiates, for Coatlicue was the earth goddess who not only gave birth to, but also killed all living creatures. Her tale is an enchanting one. One day a beautiful rainbow feather started to dance in the air beside her. She caught it and tucked it into her bosom. The cheeky feather took advantage of this intimacy, and Coatlicue became pregnant – with the sun. Her daughter Coyolxauhqui, the moon, and four hundred sons, the stars, were jealous and threatened to kill their mother, complaining that the heavens were crowded enough already. The sun, hearing these threats, leapt from

Coatlicue's womb, and hacked Coyolxuahqui to pieces. So the moon died every month, and her dismembered image lay at the foot of the sacrificial steps of all major Aztec temples. Death and life were inextricably intertwined in Aztec faith. In times of drought, plague or famine, or after battles were lost, elite Eagle Warriors were chosen to be sacrificed so that their warm blood could ascend to heaven to appease the angry gods. The invading Christians were horrified by these "barbaric" practices, even though their own god had been sacrificed as a man, and their religious history was full of martyrs who had met hideously gruesome ends.

The full significance of this complex carving has been lost, and must only ever have been known to a few, but we can sense something of its meaning from the imaginative art that has gone into its making. The writhing rattlesnakes which form Coatlicue's head and shoulders, with their rattles that turn into penis heads and cobs of corn in her belt and skirt, and the skull and severed hands that hang before her breasts, all combine to create an image of the irresistible forces of creation and destruction. Two huge snakes, their teeth bared, clash head-on to create her massive face. Their eyes become the two eyes that see you, and their jaws lock together to create a terrifying grin. Two become one. What more powerful image is there of the magnetic force central to our existence? It's the force we experience in the pull of sex, and during the agonies of loving, giving birth and dying – which, as scientists have now discovered, binds the twin coils of DNA together when life begins.

Kandariya Mahadeva Temple

Artists unknown

Sandstone | 12th century CE | Khajuraho, India

The temples of Khajuraho are one of the wonders of world art. They were built by the Chandela, once among the most powerful families in India. Contemporary reports claim that silver palms flanked the gates of their fabulously wealthy walled capital, Kharjuravahataka, meaning City of Date Palms. Over eighty temples rose in the countryside around it, the majority Hindu, a few Jain, almost all of them built between 950 and 1050 CE. The city was repeatedly attacked by Muslims during the thirteenth century, and ravaged finally in 1310; most of the surrounding temples were destroyed. Mysteriously, the Muslims left 25 standing; perhaps they'd been bought off, for they were more interested in loot than destruction. The Chandela were then reduced to village chiefs and their temples disappeared into the forest, eventually to be rediscovered by a British army captain, T.S. Burt, in 1838. He considered them very fine, but defiled by "extremely indecent and offensive sculptures". Propriety kept them hidden until the 1960s. Now they're becoming increasingly famous in the West, but primarily as erotica rather than as great works of art.

Some Hindus find this sexual interest offensive and have begun to promote the notion that the sexual scenes are there to make worshippers leave their worldly desires on the outside before entering the temple, whose interior is free from erotic imagery. This is misleading, for these temples' exteriors, unlike those of churches and mosques, are as important as their interiors. Pilgrims first walk round them, barefoot, in prayer. All of the temples at Khajuraho represent either Mount Meru, the mountain that Hindus believed stood at the centre of the world or, as is the case with the Kandariya Mahadeva Temple, Mount Kailash (see p.90) in the Himalayas, home of Lord Shiva. Each temple can be read both as a mountain rising to a peak and as a phallus swelling to its maximum extent. At the same time, they are images of mystical elevation, through cloud-hung, demon-infested spirit levels, up past the sun, moon and stars (represented by the ribbed crown), up even higher, past the sacred umbrellas (sometimes interpreted as upturned lotus flowers) representing divine wellbeing cascading down to the Earth, higher even than that, up to the very peak of existence. This is the Kalasha vase, where the mystic essence of one's being merges with divinity.

The interior of these temples consists of a dark inner passage resembling a cave in a mountain or a woman's womb. Pilgrims entering them journey back in time to before their birth, and forward beyond their death. In the depths of the temple, they exchange eye contact with the god, and so receive divine blessing, but they cannot enter the inner sanctum. All they can do is walk along the dark passage that goes round it, as they walked round the outside of the temple, saying prayers. Intimacy and distance are integral to Hindu worship, as they are in courtship preceding love. Directly below the Kalasha vase on top of the Kandariya Mahadeva

Temple, deep inside its sanctuary, stands a lingam, a carved marble phallus representing Shiva's erection. Sex is intrinsic to the meaning of these temples, inside and out. They are a glorious, late manifestation of that very ancient seam in Indian belief that praised sexual intercourse as the greatest joy of life. For Hindus this pleasure is not merely sensual but religious, for the act of lovemaking repeats and celebrates the creation of the world, which began when the Lord Brahma created Kama, the god of desire.

In the Hindu Vedas, Kama is described as a youth with well-rounded calves and thighs, a narrow waist and broad chest, a ruddy, healthy complexion, black wavy hair and eyes like lotus petals. His fragrance filled the heavens and his breath was as sweet as a summer breeze. He carried a bow with arrows that were tipped with flowers – for their piercing was soft and the pain they brought bore fruit. All the gods were alarmed by Kama's birth, for they knew that none of them could escape his arrows, including Lord Shiva himself. But what would happen when Shiva – who existed before Creation began, who was timeless and limitless, the pure essence of joy – became inflamed by desire?

This is the moment that the sculptors of Khajuraho have tried to capture, when Shiva fell in love with the beautiful Parvati, whose face, as the poets of the Vedas wrote, shone like the moon and whose breasts were firm and pointed like lotus buds. The sculpture on these temples shows Shiva and Parvati consummating their marriage, in different positions of rapturous love-making while their attendants, stimulated but unable to leave their posts, masturbate. So desire spreads out through creation and finds its perfect expression here in arching, aching limbs carved in stone.

One of dozens of panels depicting love-making – all different – high up on the walls of the Kandariya Mahadeva Temple.

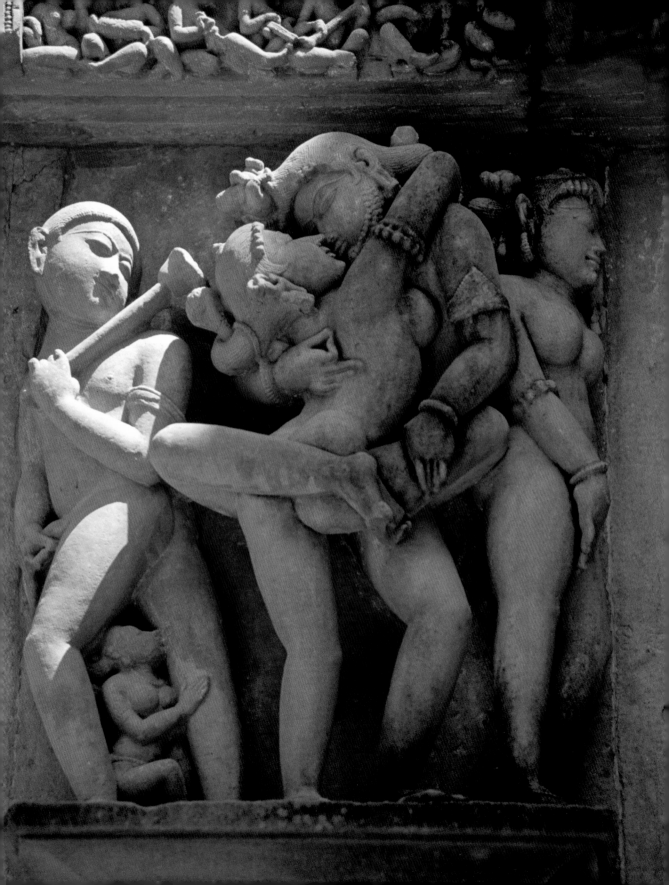

Young Man of Mozia

Artist unknown

Marble | 181cm high | c.440 BCE |
Whitaker Museum, San Pantaleo, Sicily, Italy

The Young Man of Mozia was found in 1979 under a buried stone wall on a small island just off the coast of Sicily. The statue was lying face up as part of the foundations, just one in a row of large boulders, no more valued than the rest. Though the art of one culture sometimes only survives in the building material of the next, it still seems extraordinary that a sculpture of such refinement could have been used in this way. But the builders who did so, almost certainly Christian, evidently saw nothing of merit in this pagan relic. Their blindness to its quality is almost as amazing as the clarity of vision of the sculptor who carved it. The fact that human minds are capable of seeing things so differently helps to explain why one culture so often wipes out the art of a preceding one, even when it is aesthetically and technically outstanding.

It's arguable that the greatest flowering of visual art the world has ever known occurred in Greece in the fifth century BCE. And yet hardly any of it survives: virtually no paintings (see p.60), a handful of bronzes (see p.8) and only a tiny fraction of the marble sculptures which once existed. Freestanding carvings like the Young Man of Mozia are extremely rare. Most of those that we see in museums are later Roman copies, made in emulation of famous originals. These few remains give one the impression that art was a rare commodity in Ancient Greece, but the reverse was the case. Art was all around, on the wall, along the street, in offices, workplaces and people's houses, in the public baths, gardens and squares and, above all, in temples and sports arenas. And the quality of workmanship was, on the surviving evidence, quite remarkable, the product of an exceptional culture which was at once communal and individual, co-operative and competitive, questioning, undogmatic and realistic. Art flourished in this sensuous and intellectual atmosphere.

The Young Man of Mozia might look exceptional to us, but the probability is that he was ordinary. The swell of flesh over the band across his chest and the folds caused by the pressure of his hand are miracles of stone-cutting. Every pleat in his clinging garment follows its own contour across his body. Not one line is slavishly echoed; every inch is individually observed. Yet no detail looks finicky; everything adds to the grandeur of the overall effect. This is partly due to the easy grace of the young man's pose, and his magnificent physique.

No one knows who he was; he has none of the telling attributes of a god. The most likely explanation is that he was the victor in a contest, perhaps in some sport that required him to wear a leather harness of the type indicated. Arenas in those times were ringed with statues of athletes, erected by the men themselves, or their male lovers or families, most usually as a thanksgiving to the god who had helped them win. Statues like this now face us in museums, but originally they would have faced altars, permanent stand-ins for the athletes in case the gods dropped by. The Greeks would more often have seen their backsides – a pleasurable view for many in a society where the love of youths by older men was generally accepted (see p.141).

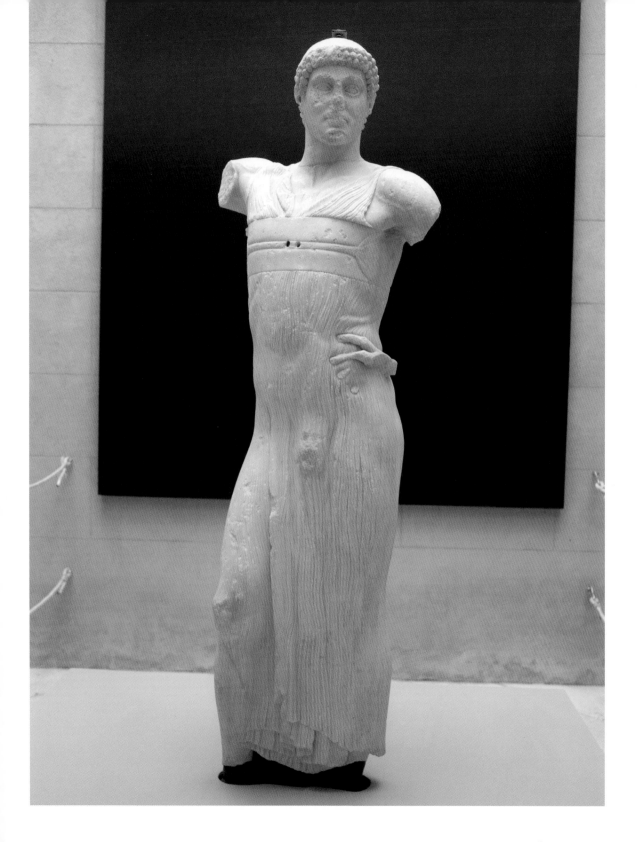

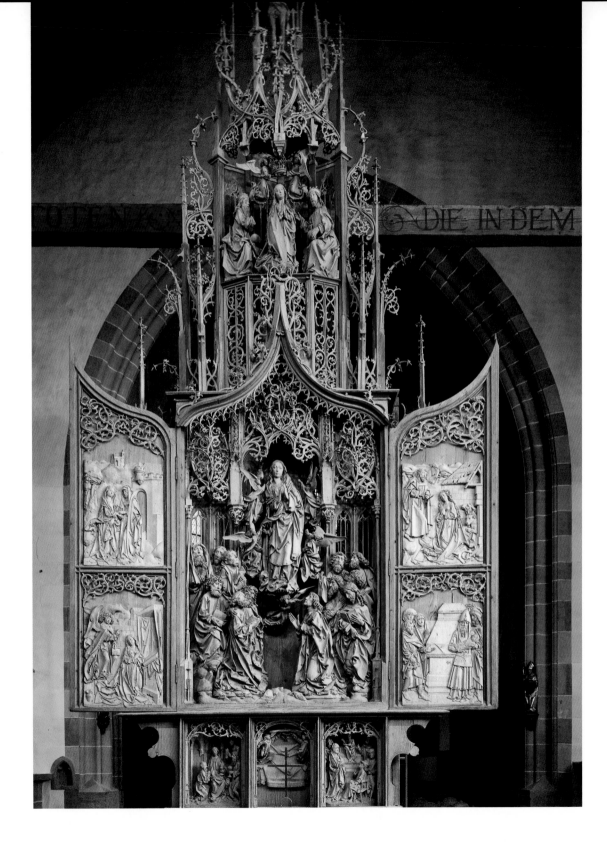

Marienaltar

Tilman Riemenschneider

Limewood | 900cm high | c.1505–10 | Herrgottskirche, Creglingen, Germany

The first sight of the Marienaltar in the modest church at Creglingen is breathtaking. It is thought that the altarpiece's unusual position in the middle of the nave marks the spot where, in 1384, a farmer ploughing his field found a miraculous host. At ten metres high, it towers above you as you come in, its top almost touching the height of the barrel-vaulted ceiling. It's as if a tree has come to life before your eyes, opened its trunk wide and become temporarily inhabited by angels. Filigree branches reach out and twist into the air, while others turn inwards and tie knots of extraordinary intricacy. The whole vegetative world has been brought into the church in praise of God. And it's all made of wood: light limewood, untouched by paint or age, as if it had just been carved. The reason for its freshness is that it was covered up soon after it was made; its wings were closed and it remained sealed from the world until 1832. This was a consequence of a change of doctrine. When the Reformation swept through Germany, Martin Luther demanded an end to the selling of indulgences, the glorification of Mary and the worship of saints. Christianity had to return to the sacred text; images were *verboten*. Although Luther later softened his attitude, the Creglingen altarpiece remained unacceptable and was shut away. And so this masterpiece of the High Renaissance, created by Tilman Riemenschneider (c.1460–1531), a

contemporary of Dürer, Michelangelo and Bosch, survived intact.

Almost all wood carvings of this time were painted and gilded, including Riemenschneider's earlier work. The Creglingen altarpiece probably looks more naked now than it did originally, because at some stage after it was reopened it was vigorously cleaned. (A lot of dust must have crept in over the centuries.) It's likely that Riemenschneider originally toned down the bare wood with a honey-coloured glaze, brushed the eyebrows and pupils with dark pigment and tinted the lips red, for these delicate touches are found on his other sculptures of this period. But it's a mystery why he began to leave them virtually bare. It can't have been just for economic reasons, though it would certainly have been cheaper not to paint them. Perhaps his austerity was partly in sympathy with the growing desire for clerical humility, dramatically expressed by Luther's demands.

The rawness might also have been symbolic. The whole altarpiece is conceived as a tree, perhaps the Tree of Knowledge from which Adam and Eve ate the fruit and so brought sin into the world. The Virgin Mary (whom Catholics regarded as the New Eve) rises through the tree, and near the top is crowned in heaven, under the figure of Christ who stands aloft. He is depicted as the Man of Sorrows who saved mankind from original sin. The central panel (see p.105) shows the Virgin after her death rising bodily to

heaven, lifted by angels. The one underneath tilts as he carries her feet hidden in swirls of drapery. The whole ensemble is a remarkable encapsulation in wood of spiritual elevation, culminating in the slightly parted hands of the Virgin raised in prayer. Beneath her, at the very centre of the altarpiece there is an empty space, in which only the flame-like grains of bare wood are visible. Does this represent the Cross, the tree on which Jesus was crucified? It could well be so, because in the panel underneath it two angels hold up an empty cloth in front of which the monstrance – the receptacle containing the consecrated bread that was regarded as Christ's actual body – would have been displayed. Such elaborate symbolism was popular in

the Renaissance, but its power is dramatically increased by Riemenschneider's ability to convey an extraordinary range of feelings. The Apostles, who attended the Virgin's death and witnessed her assumption into heaven, are each delineated with different characters and expressions. On the left, the beardless, plump Philip, looking like a prosperous local merchant, gazes up in rapt admiration. Just below him Bartholomew looks down, lost in thought, the book in his hands falling open, his mouth slightly ajar and tongue protruding between his teeth as if he's about to speak, but is silenced by wonder. Only a visit to the church enables one to appreciate Riemenschneider's carving in all its intricate subtlety.

The central panel of the Marienaltar shows the Virgin Mary's Assumption taking place inside a church with its own glazed lancet windows.

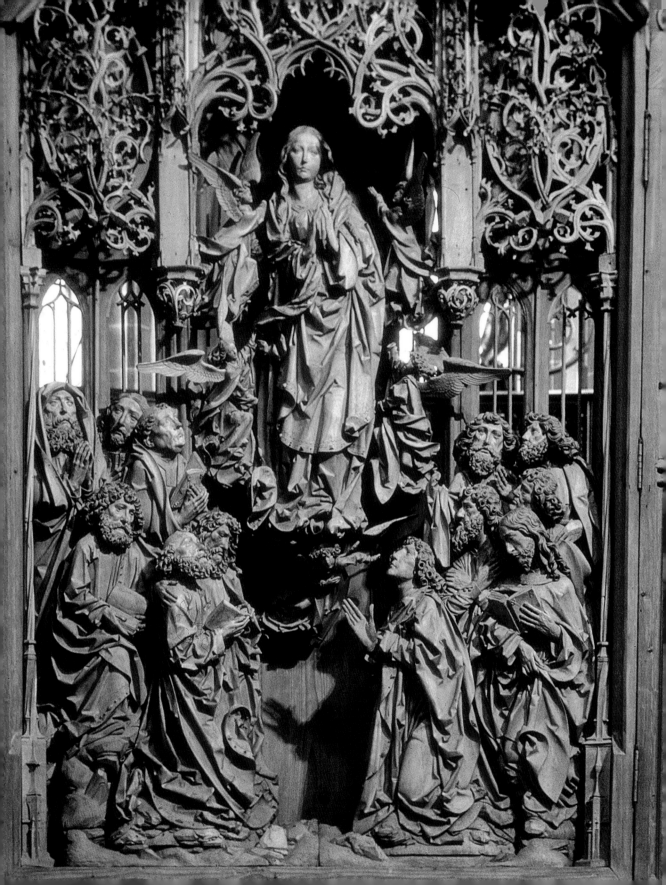

Urnes Stave Church

Artist unknown

Portal and panel in north wall| 290cm high |
c.1050–70 | Luster in Sogn, Norway

O n the grassy slopes of the isolated fjords and valleys of Norway is a group of ancient wooden churches, built of split logs rising in tiers under steeply pitched roofs. Their gables, most of which have long since deteriorated, once ended in elegant, uplifted dragon heads with elongated open jaws and long tongues curling up into the sky, as if to lap up rain and lightning. The likelihood is that these stave churches echoed the form of much older temples dedicated to the gods of trees, mountains and tempestuous skies, celebrated in the Norse sagas and worshipped by the Vikings, though none of these pagan buildings survive.

Urnes is the oldest of them, built around 1130 on the foundations of two earlier churches which appear, from the evidence of burials, to have been Christian from the start. There is no indication here of pagan temples being converted for Christian use. Though Urnes Church lacks the splendid roof dragons, it does have a remarkable group of earlier carved panels inset into its north wall, including a strange keyhole doorway which was sealed up and could no longer be used. It's a mystery why these carvings were incorporated into a Christian church. Its builders couldn't have been short of wood: the fjords were bedecked with forests. The incoming Christians must have destroyed all the "pagan" temples – but they kept these haunting images.

We don't know for certain what these carvings mean. The most convincing explanation for the elegantly stepping horse, and the intertwining branches laced with devouring beasts and serpents, is that the carving represents Yggdrasil, the sacred tree of Norse legend, which stood at the centre of the world. Its branches touched the sky and its roots reached down to the waters under the Earth. Yggdrasil was continually being threatened by four stags which came from the north, south, east and west and nibbled its leaves, but it was protected by beautiful damsels, the Norns or Fates, who kept it watered day and night so that it was always green. Yggdrasil means "Odin's horse", for the world tree also had the honour of having the steed of the supreme god tied to it. And it was on this tree that Odin sacrificed himself to bring life back to the world. This might explain the incorporation of these panels into a Christian church. Christians consciously grafted their faith on to older popular beliefs, arguing that these foreshadowed the true path, which was revealed with the coming of Christ. All religions have grown out of others, as their art often shows, though many like to claim they started from a clean slate.

What's surprising about these carvings is their sophistication. They are extremely deeply cut, almost three-dimensional – except for the keyhole door, which must surely have been left intentionally shadowy, like a reflection in a pool of a world beyond. At first glance the design appears to be symmetrical, but in fact everything in it is individual, lopsided, off-centre. In this it is an exquisite rendering of the working of nature: everything is dependent on everything else, all things feed off one another, and yet, within this unrelenting cycle, there is a degree of freedom of movement and expression. Life and death are entwined together to create a wonderfully jointed and disjointed pattern.

Self-Portrait with Jewish Identity Card

Felix Nussbaum Oil on canvas | 56 x 49cm | c.1943 | Felix Nussbaum Museum, Osnabrück, Germany

T he collection in the Felix Nussbaum Museum begins with the artist's early work. His self-portrait beams out at you: a fresh-faced, confident young man, smiling under a splendid green felt hat. It wouldn't occur to anyone to wonder if he were Jewish. By the early twentieth century, most Jews were fully integrated into modern European society. Then the Nazis came to power in Germany and systematic persecution began. Nussbaum's last self-portrait shows him drawn and old, though he was barely forty. He has painted himself low down in the canvas, backed into a corner against a high grey wall. He lifts his collar to show the yellow star all Jews were forced to wear. In his other hand he holds his Jewish pass – his passport to extermination. Over the wall is what at first looks like normal life. But is it? Sunlight catches the upper mullions of a window, but those below look like prison bars. One branch of a tree bursts into blossom, but the main trunk beside it has been cruelly lopped off and so have all its side branches. Their white sawn-off ends gaze up at the threatening sky, like small blind eyes. There is a disc of light, too, in Nussbaum's own eye, a faint grey reflection without a spark of hope. Its pallor emphasizes the pitch blackness of his pupil, which stares back at us with a piercing directness.

Nussbaum's early paintings flowered in a normal world; they're happy-go-lucky still lifes and townscapes, portraits of friends and of his young wife, boldly drawn in blazing colours. His work began to sell well in Berlin, and in 1933 he won a scholarship to Rome. Then Joseph Goebbels, the new Minister of Propaganda, announced the main themes Nazi artists should focus on: celebration of the Fatherland, the Aryan race and heroism. Nussbaum's paintings darkened. An underpass under a road becomes a hell mouth; boats are no longer for joyrides but a means of getting out. He escaped to Brussels with his wife, Felka Platek, in 1937. A self-portrait behind a smiling mask was a poignant goodbye to art as praise. From then on all he could do was warn.

In 1939 Nussbaum was arrested as an enemy alien and sent to prison. He watched a tree being cut down in the courtyard to prevent the prisoners climbing it to escape. This is the tree in his self-portrait. While being transported to Germany, he managed to jump trains and get back to Brussels where he went into hiding with his wife. From 1942 they lived in a cramped attic, secretly supported by friends. The space was too small to work in but Nussbaum had to keep painting, so, risking his life daily, he went to work in the cellar of a sympathetic art dealer. There he painted harrowing visions of men carrying empty coffins, trapped crowds and a great *Triumph of Death* in which Goebbels-faced skeletons dance and play while kites with weeping faces fly overhead. He and his wife were discovered in July 1944 and immediately dispatched to Auschwitz, where they were killed. His paintings survived. If they'd been seen, they would have been destroyed. After the war, his cousin Auguste Moses-Nussbaum tirelessly brought his life's work together, charting a pitiless and unforgettable journey from normality down into hell.

Head of Idia, the Queen Mother

Artist unknown

Brass and iron | 41cm high |
Early 16th century CE | The British Museum, London, England

A t the end of the nineteenth century, the Oba, the divine king of Benin, was so powerful that British colonialists had to negotiate trade deals on his terms, not theirs. In December 1896, Lieutenant Phillips of the British Navy, the Acting Consul General, led a small unofficial force into the kingdom of Benin (now part of modern Nigeria) to confront the Oba, but the attempt was resisted and three British officers were killed. Outraged, the British launched a punitive expedition to avenge what their press called the "Benin Massacre". An army of over a thousand men swept through the country destroying and burning monuments, shrines and palaces, seizing all the brass and ivory goods they could find, to cover the cost of the expedition. This loot, containing nearly three thousand artistic treasures, was sold at auction in Paris, and the finest group, which included the head of Idia (opposite), went to the British Museum.

The Portuguese had been more successful in their dealings with the Oba. They began trading with the kingdom in 1486, and succeeded in establishing a fruitful partnership which enabled the Oba to grow considerably in power and prestige. When Benin metalwork first became known in Europe, it was assumed that these works of art must have been imported. Such sophisticated casting couldn't have been done by natives in the jungle! But we know now that the art of Benin was a comparatively late manifestation of a more ancient tradition which had flowered at least three hundred years earlier in the neighbouring kingdom of Ife.

Sculpture was integral to West African culture, and the region's metalwork was much more naturalistic than its carvings in wood. Trees were the source of spirits, whereas metal was flesh made permanent. Only royals could be cast in brass. This head is believed to be a portrait of Queen Idia, perhaps shown at the young age at which she gave birth to the future Oba Esigie (c.1504–50). Oba Esigie began the tradition of making a cult of his royal mother, possibly influenced by the Catholic Portuguese traders who worshipped the Virgin Mary, the eternally youthful mother of their god. Idia, the Queen Mother, lived in a palace apart and wasn't allowed to see her son, but she sent him advice, medicines and spells, and even at one stage raised an army to support him. Shrines were erected in her honour, and this bust probably graced one of them.

A net of coral beads, with tassels, contains the queen's heaped-up hair. Scarification marks decorate her brows on either side of two inset iron bands, that perhaps symbolize the power of royal thought. But what most attracts is the gloriously simplified, moon-like curve: the peaked hair complementing the rounded, uplifted chin, the pert nose and pursed lips, offset by large, respectfully lowered eyes that are inset with iron, so that they glow with light. This wonderful work of art doesn't seem so far removed from the royal Egyptian head illustrated on p.88, nor was it in fact. Western historians have isolated sub-Saharan Africa, and treated the art of Ancient Egypt as belonging to Europe, rather than Africa. But many trade routes crossed and by-passed the desert, and the sculpture of Benin is the rightful heir of Egypian art.

Many of these unique treasures, including the wonderful brass plaques which used to decorate the pillars of Benin palaces, must be returned to Nigeria. However, five contemporary casts of this head exist, one of them in the National Museum at Lagos, and so Queen Idia could legitimately remain in Britain as an advocate for African art in the West. But the ugly tale of how she got there must also be told.

5 Hidden by Convention

Art and society sit most comfortably together when art praises what convention approves. Then paintings are framed in gold and sculptures stand high on plinths. But when artists go against the grain, their works are often hidden, ignored or censored. There are many realities of life that, at different times and for different reasons, are brushed under the carpet by polite society, such as war, death, sex, crime, sickness and inequalities of wealth, gender, class and race. In some ages, when the ruling classes were especially elevated, artists were restricted to showing pretty faces and noble profiles performing charades in silk-hung rooms and shady gardens. Themes differ little across the courts of Europe, India and China, though the make-up changes, and the myths. When an artist steps out of line and observes life as a whole, as Goya did throughout his career, his unconventional works remain unknown, to be uncovered by a later generation. Occasionally high society acknowledges an uncomfortable reality, as in the phenomenon of fifteenth- and sixteenth-century "cadaver" tombs, in which an effigy representing the living person was contrasted with one showing his or her decomposing body. The depiction of sex was another difficult subject for art to confront openly, although in the closed society of Japan during the Edo period erotic prints of great artistic sophistication, called *shunga*, were widely available. In nineteenth-century Europe a more hypocritical attitude prevailed, and a painting like Courbet's *The Origin of the World* could only be viewed within the closed confines of a private collection.

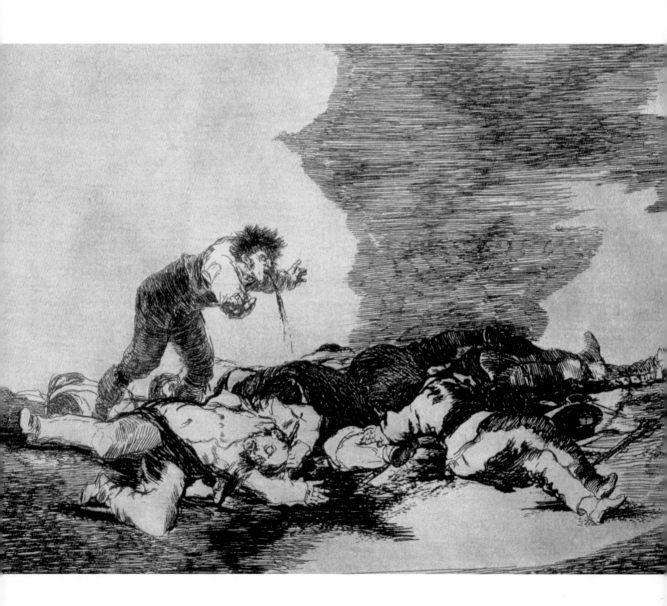

The Disasters of War

Francisco Goya

Etching and aquatint | 16 x 23cm | 1810–12 |
Worcester Art Museum, Worcester, Massachusetts, USA

Some artists produce works in secret. Around 1810, when he was in his early sixties, Francisco Goya (1740–1828) began a series of eighty etchings about the horror of war, which were never made public in his lifetime. He must have thought they would have been too shocking, but it's a wonder that he made them at all. Evidently he felt he had to, for he travelled to many battle sites during Spain's war with France, and remembered what he saw. What he couldn't get out of his mind was the human suffering war produced – whichever side you were on. This was what made his work so radical. He was, after all, the official painter to the Spanish court, so he clearly had to be on the side of Spain. He couldn't say all war was wrong, but this is what he did in his art, keeping it hidden. His great condemnation of war only surfaced in 1863, long after his death.

The series takes one on a relentless journey around a battlefield, mostly in the immediate aftermath of horrendous cruelties, the terrible suffering of the victims transfixed on their just-dead faces. Plate 12, entitled "This is what you were born for" (see opposite), is one of the quieter scenes. It shows a man, his arms outstretched, about to stumble headlong on to a heap of bodies. A dark cloud, like the shadow of a bat, rises from them. Is this their stench? Is this what makes the man throw up? Or is he spewing blood, internally bleeding from a bayonet thrust, yet another victim about to be added to the pile? As in most of these images, Goya gives little context. There is no horizon, as if the scene were happening in a cave of isolation,

lifted out of ordinary life by the horror of the action, held forever in the artist's vivid memory. But this isn't just stark reportage; the scene is imbued with sympathy. It's partly the way Goya has composed the heap in incoherent patches of lights and darks; the eye tries to unravel the jumble of limbs, hands and feet, and as it does feelings for the individual victims are aroused. But it's also due to the tenderness of Goya's lines. The features and fingers of the dead soldier in the foreground are delicately rendered, as if he were asleep.

Etching is a miraculous medium, capable of capturing the finest lines. A copper plate is first coated with wax. This is drawn through to reveal metal lines. Next the waxed plate is lowered into a bath of acid which bites into the exposed metal. Lines which are to print light are "stopped out" with more wax, while those which are to print darker are etched more deeply. After several "bites" of acid, the plate is covered with ink and then wiped clean, so that the ink only remains in the bitten lines. A damp sheet of paper is then forced under great pressure to pick up the ink in these indentations. This is what makes etching different: the fine lines are raised, and can draw feelings with the tingling precision of a fingernail running across flesh. That's why Goya's prints need to be seen. But they're almost all hidden in boxes in museum print-room stores. There are approximately five hundred sets of The Disasters of War, enough to be shown permanently around the world. Then Goya's motivation for making them would be fulfilled: to warn us against making light of war.

Gassed

John Singer Sargent

Oil on canvas | 230 x 610cm | 1918 |
Imperial War Museum, London, England

Born in Florence to well-off American parents, Sargent's early ambition was to be an artist. He trained in Paris, where he learned from the Impressionists, and proved so deft that he could paint anything he wanted. He began his career producing portraits of the very rich. The tip of his brush danced across the canvas, catching the light in their eyes, reflections in chandeliers, mirrors and glasses, and the shimmer of their satin dresses in the dark cavernous halls of their country houses. In the process he caught their characters, chinks in their armour of elegance – acknowledging their individuality while never for a second disrupting the overall effect.

Sargent was soon in demand wherever he went – Paris, London, Rome – and most of all when he returned home. America was hungry for European high culture, so he decided to give it to them. He became a painter of allegories, for libraries, museums and universities. Gone were the dashing strokes and spontaneous touches. Instead he methodically coloured in carefully drawn outlines, erecting edifices of high seriousness which reveal little genuine feeling. His *Entering the War*, painted for Harvard University, shows ranks of idealized soldiers clasping the hands of three female presonifications, one helmeted as Britain, one swooning, characterizing Belgium, and the third, cradling a baby, representing France. But the real war produced something very different.

In 1918 Sargent was invited by the British prime minister Lloyd George to serve as an official war artist on the western front. The idea was that he should produce a great painting for a proposed Hall of Remembrance, on the theme of the collaboration between British and American troops. He agreed to go, but wondered about it in a letter to a friend: "I have never seen anything the least horrible – outside my studio." He had painted watercolours throughout his career: two thousand survive, quick notes of sights that caught his eye – a couple in a gondola, a girl dozing under a parasol, naked men bathing – each one dashed off with staggering fluidity. Now he sketched soldiers idling by a bombed chateau, peasants cutting hay near a crashed plane, a heap of rubble that had been a sugar factory.

Eventually he came across his subject, not a triumphal one but "a harrowing sight, a field full of gassed and blindfolded men". He sketched furiously, and worked on the canvas during the winter of 1918–19. The quotations from the art of the past, from Greek friezes, Renaissance frescoes, Tintoretto and Breughel, were no longer forced, but natural, resonant echoes which augmented his profound sympathy for men who had lost that most precious sense, their sight. Two lines are being led to the dressing station indicated by the guy ropes on the right, where the sun is setting. A full moon is rising. Another ball is visible in the sunlit distance, where a game of football is being played.

Gassed is an epic painting without pretension, one of the great works of art of the early twentieth century, although it's rarely rated as such. In the end the Memorial Hall was never built; the picture ended up on the staircase of the Imperial War Museum and has only recently beem moved to a gallery of its own.

Hiroshima Panels

Iri Maruki and Toshi Maruki

Sumi ink on papaer | 1.8 x 7.2m | 1950–82 |
Maruki Gallery, Higashi-Matsuyama, Saitama, Japan

I ri Maruki (1901–95), the son of a peasant farmer, was born just outside Hiroshima in 1901. By the 1930s, he had earned a reputation as a traditional "ink and water" painter of landscapes, flowers and animals, noted for working freely on a large scale. Toshi Akamatsu (1912–2000) was born in Hokkaido in 1912, the daughter of a Buddhist cleric. She learnt Western-style figurative oil painting and became fascinated by Surrealism. The couple married in 1941 and settled in Tokyo, but kept their artistic ambitions fiercely distinct. During the war nobody wanted to buy art, and they survived on a subsistence diet of potatoes. On 6 August they heard that a terrible bomb had gone off in Hiroshima – no one knew its nature – and Iri (followed days later by Toshi) rushed down to find out if his parents, family and friends had survived, and to see if he could do anything to help. They found themselves in a hell. Most of their friends had been killed outright. Iri's father, who lived far from the centre of the blast, died slowly over six months. His mother just survived.

Iri and Toshi spent their days carrying the injured, cremating bodies, searching for food and building makeshift shelters, amidst flies, maggots and the stench of death. The atmosphere was eerily quiet. Victims, disfigured and naked, wandered about with their arms outstretched to ease the burns, their skin peeling off like rags. There were piles of corpses, stacked so their faces looked inward. Fires burst out at random, burning the dead and the still-living. A cloud of dust hung over the city. It rained poisonous sludge, and though it was August the days were dark and cold.

People sheltered in the blasted bamboo groves around the city, and died slowly among the bending branches. Toshi made a stew out of a half-baked pumpkin she found – no one knew then about radiation sickness – and soon after began to excrete blood. She lost weight and contracted TB. When they thought they'd done all they could, they returned to Tokyo to try to get on with their careers.

All information about the atomic bombs dropped on Japan was censored by the government; it was thought this would disrupt the smoothness of the Allied occupation. Everyone was encouraged to be positive and forward-looking. Iri tried to paint nature's beauty, and Toshi "faces bright with peace", but they realized that they couldn't. They had to paint what they had seen, and they needed to work together to give each other strength. In 1948, they began drawing their memories. They painted their first eight-panel mural, *Ghosts* – naked victims with outstretched hands and shredding skin – and exhibited it in Tokyo in 1950. Some visitors thought it was exaggerated propaganda, but one who'd lost his daughter in Hiroshima said it was simply true and encouraged Toshi, who was in the gallery at the time, to continue. "These are our paintings," he said.

The Murakis painted a total of fifteen harrowing murals about the aftermath of the atomic bomb, including *Rescue* (1954), illustrated here. As an anti-war statement they rank among the greatest cycle of paintings in the twentieth century, but they are hardly ever mentioned in the histories of modern art, even though they shock and are genuinely new.

Newgate: Committed for Trial

Frank Holl
Oil on canvas | 152.3 x 210.7cm | 1878 | Royal Holloway, University of London, Egham, England

R oyal Holloway College contains an artistic time capsule. The 77 paintings that grace its walls were acquired by its founder Thomas Holloway in the two years from 1881 until a few months before he died, in 1883. It was a women's college at a time when such a notion was comparatively new, and Holloway hoped that its students, exclusively from the middle and upper-middle classes, would be elevated by the sight of the pictures he chose. Just what he thought they would gain by looking at Edwin Long's *Babylonian Marriage Market*, in which a row of discreetly clad but decidedly buxom damsels wait to be inspected by a crowd of lustful, bearded men, is difficult to say. Many of the pictures were simple idylls – cows in fields, churches nestling in vales. But a few were vividly harrowing, illustrating aspects of Victorian life that would normally have been hidden from the eyes of respectable girls.

Thomas Holloway was born in 1800, the son of a baker. He made his fortune selling his patented Pills and Potions, the exact ingredients of which were never revealed during his lifetime. He traded around the world, taking advantage of London's burgeoning international port, marketing his products in every language he could from Arabic to Chinese. Like many self-made men, he had cash flow problems initially, and spent some time in a debtors' prison. It was perhaps this experience that made him buy *Newgate:*

Committed for Trial by Frank Holl (1845–88). The picture was based on a scene Holl had once witnessed on a visit to Newgate prison. He told a friend that he would never forget the impression made on him by the sight of the "cage". This was a room in the gaol where prisoners on trial were allowed to see visitors and talk to them through a double row of bars. The space in between was patrolled by a warden. With masterly understatement, by pushing the protagonists to the side and leaving so much empty space front of stage, Holl has painted the gap that opens with guilt. Two prisoners are awaiting judgement. The artist doesn't take sides or make it clear who is right or wrong. Is the man on the left's look of wide-eyed innocence deceptive? The weary pose of his wife suggests that it is; she's heard it all before. The prisoner on the right is clearly desperate, and his wife's clenched hands show that she shares his anguish. The whole story is told through the play of light.

Van Gogh, who spent some time in London, compared Holl to Rembrandt. While Rembrandt was "sublime", he wrote to his brother, he felt "the moderns" to be "more personal and intimate". Holl, in his opinion, painted what George Eliot wrote. But the rich didn't want such incisive realism on their walls, and Holl had to paint portraits to make a living. It took a man like Thomas Holloway, who had suffered hard times, to recognize his rare insight.

Capitalist Dinner

Diego Rivera

Fresco | 207 x 160cm | c.1926–27 | Ministry of Education, Mexico City, Mexico

D iego Rivera (1886–1957) was in his time probably the most famous living artist in the world, more so than Picasso and Matisse. He was not only popular with the masses, but perceived to be great by connoisseurs. The Museum of Modern Art in New York honoured him with a retrospective in 1931. But since then his fame has declined, a victim of the ascendancy of abstraction over representation and the outlawing of any art that supported Communism. More recently, his reputation has suffered further with the ascendance of that of his wife, Frida Kahlo, whose tortured canvases are now widely thought to be more resonant of human feeling than the acres covered by her spouse. By comparison, Rivera's art is monumental, and nowadays we are averse to artistic monuments and, by inference, to artistic greatness, particularly if it is male. We are drawn more to personal anguish and general gloom, and this has tended to overshadow Rivera's glorious assurance.

Rivera consciously rejected modernism and "bourgeois individualism". He was well aware of Cubism, and moved in Picasso's circle when he lived in Paris from 1908 to 1921. But that was not the direction he wanted to take. Instead he travelled to Italy, where he studied the murals of Giotto, Masaccio and Mantegna. In 1922 he was called home. A new Mexican national government had been formed after a decade of civil war, and the minister of education, José Vasconcelos, had a vision of mass cultural elevation in which Rivera could play a part. Along with other Mexican artists, he was invited to paint murals on key public buildings. Fired with hope, Rivera grafted what he'd learnt in Paris and Italy on to the indigenous art of the Mexican people, which he declared to be "the most wholesome spiritual expression in the world and our greatest treasure… because it belongs collectively to the people."

What distinguishes the Mexican murals from most socialist realist art in countries like Russia and China is that the movement was led by artists, not politicians. It doesn't have the ghastly hollow ring of a jolly mask covering what was really going on. Mexican murals were always heartfelt. Reduced in scale in books, they tend to look congested and heavy, but in reality they're rich and glow with warmth. It's not easy to animate walls; what has to be got right is the clarity of form. Rivera's genius lay in his ability to draw forms and create spaces with sureness, strength and humanity, even when he was being censorious. Capitalist Dinner might look like political tub-thumping, but it shows a widespread human truth, beautifully observed. Rich and poor are both there: the hungry child and his spoilt, unhappy counterpart; the master with his eyes closed to say a prayer but also shut to the reality of his situation, his knife and fork held in readiness, for either consumption or defence. The faces of the family are turned inwards, each with their own reasons for not seeing the world outside, and a masterpiece of piggish indifference is portrayed at the front, with her double chin, bull neck, and tightly girdled waist. Social commentary can still be contained within the embrace of painting.

Lamentation over the Dead Christ

Niccolò dell'Arca

Painted terracotta | 150cm high | c.1463 | Santa Maria della Vita, Bologna, Italy

This tableau was commissioned for Santa Maria della Vita when the church was attached to a hospital. It shows the dead Christ surrounded by mourners (see overleaf). The group originally stood at the entrance to the wards, comforting the sick and their visitors, reminding them that no suffering they might undergo could equal that of their saviour's. This harrowing work of art had a similar function to Grünewald's great altarpiece in Colmar (see p.37), which patients prayed to before going into the operating theatre. There must have been many life-size tableaux like this in churches at the time, but hardly any survive because almost all of them were made, cheaply, of clay. They were a natural extension of the theatricality of church ceremonies, more permanent renditions of the dramatic presentations of Biblical scenes, the *quadri viventi*, or living paintings, that are still staged in Italy today by local people dressed in period costumes.

Terracotta – the word means baked earth – is an extremely brittle medium which is easily cracked and chipped, especially when worked on this scale. Most terracottas must have been destroyed when they were moved during building repairs and alteration. This set has been repositioned at least three times within the church. Its original configuration has been lost and there were almost certainly more figures, but the wonder is that it exists at all. Its exceptional quality might have helped to ensure its survival. The figures were originally painted, and must have looked even more realistic, but what bowls one over is the tide of emotion that surges through them.

Christ lies in front utterly at peace, his head resting on a fine cushion. His flesh when painted might have been tinted with the warmth of life, for his body has been modelled in such a relaxed pose that it suggests he is not dead but sleeping. The lack of breath emphasizes his stillness. It is this unnatural quiet that triggers and so powerfully contrasts with the grief that grips the mourners gathered round him. Mary Magdalene, on the left, clutches at her garments; the agitated folds of fabric amplify her agony. The Virgin Mary, standing beside her, wrings her hands, consumed by a rising surge of sorrow that finds no outlet in her silent cry and tight-shut eyes. The young St John the Evangelist, next to them, is an extraordinary creation. He doesn't know what to do with his hands; he tucks one away and clamps the other to his chin. He is huddled up, contained, withdrawn. His pained expression, furrowed brow and writhing hair all indicate the turmoil of feeling he is suffering within.

On the right of the group are two unidentified figures, not so intimately connected with Christ, who represent the wider reach of humanity. They are lashed by tempests of grief. Their flying draperies are a *tour de force* of expression in the medium of clay. The last figure, on the far left, middle-aged and bearded, is kneeling, but turning away from the rest of the group and towards the observer. He is certainly a portrait, perhaps of the patron who commissioned the work, here probably playing the role of Nicodemus, who paid for Christ's burial. He looks straight at you with a challenging, proud expression, so genuine that you feel certain you are looking at a real individual from the fifteenth century.

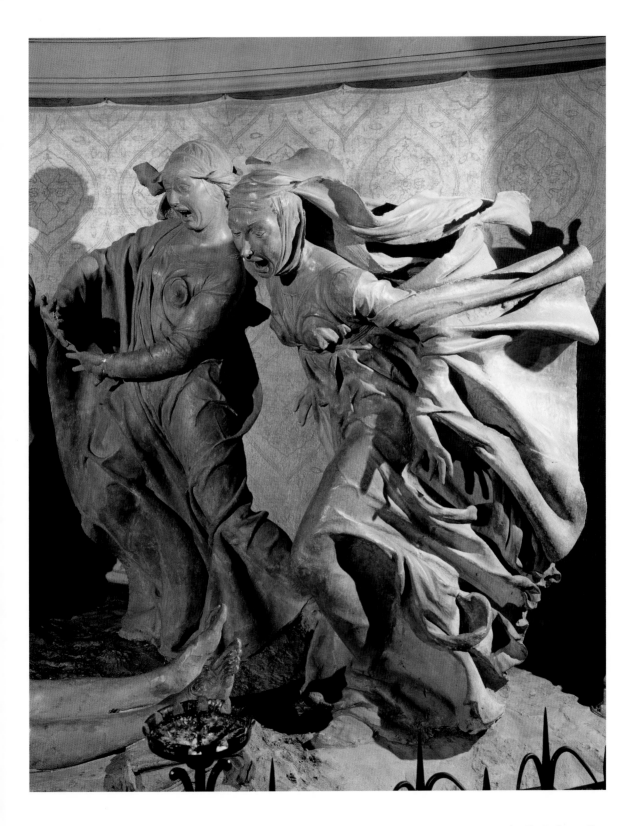

Hardly any other sculptures by Niccolò dell'Arca (c.1440–94) survive, and we know virtually nothing about his life. He must have been experienced in terracotta; this group is too brilliantly assured to be a one-off. The choice of medium may have been symbolic: God had created mankind out of clay in his own image, but we had sinned and our mortal bodies were now cursed with suffering. Medieval clerics loved such associations. But its use was also practical and economical: Bologna had no stone, but deep fields of clay. Nevertheless, dell'Arca was also a fluent stone-carver, when the money was forthcoming. His most important commission for the Bolognese was the monumental lid for the marble shrine containing the body of St Dominic, known as the Arca di S. Domenico, from which his nickname derives. The figures for this were completed after his death by the nineteen-year-old Michelangelo. Niccolò had earned a reputation in Bologna not only as an outstanding artist but as a wilful eccentric. An exceptional pen-portrait of him survives, written by a contemporary, Fra Girolamo Borselli, a monk at S. Domenico who must have seen him at work, and recorded: "He was fanciful and uncivilized… and so boorish and wild he drove everybody off." Niccolò might, then, have been an important role model, not just artistically but personally, for the young Michelangelo.

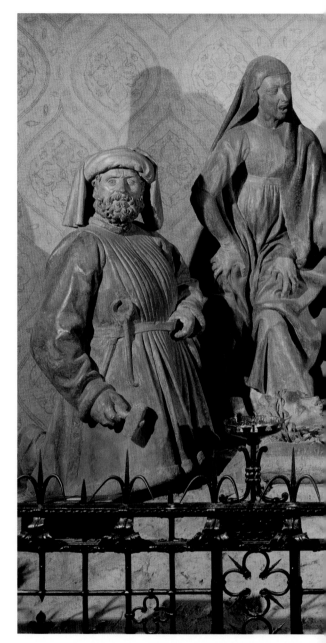

According to tradition, the kneeling figure of Nicodemus on the far left is thought to be a self-portrait.

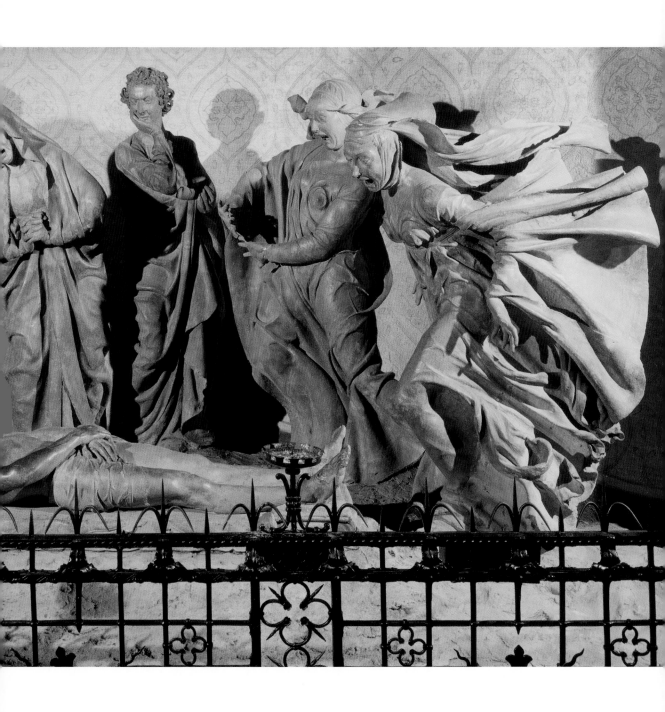

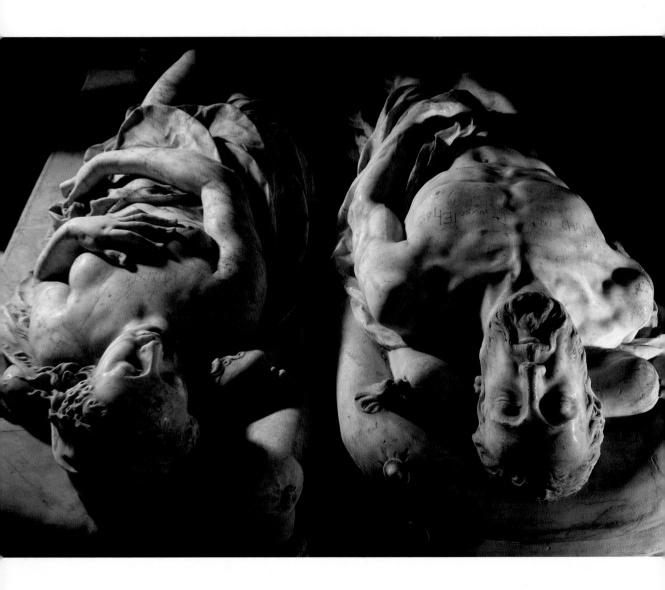

Tomb of Henri II & Catherine de Médicis

Germain Pilon

Marble | 1563–70 | Basilica of St-Denis, Saint-Denis, France

T he preparation of a body for a funeral used to involve a public show. Poor Christians laid out their dead in cottages, the rich in cathedral naves. The corpses of the great were carried through the streets, a practice still followed in some countries. This was partly a legal requirement, proving the individual really was dead – vital evidence when so much depended on inheritance. But it was also a way of coping with emotional parting. Mourners came to see and touch, pay their last respects and pray for the souls of the dead. A strange version of this ritual emerged last century in Communist countries, where the bodies of Lenin and Mao still lie in state, regularly rouged and refreshed, as if, though clearly inanimate, they could never die. Their followers don't think it ghoulish to stare at them. Most of us in the West, however, now feel uncomfortable looking at corpses – a reversal of Victorian attitudes, when mourning was public and sex private. Funerals now celebrate life, and death is hardly mentioned. One consequence is that funerary arts have been overlooked.

The Basilica of St-Denis contains the tombs of nearly every king and queen of France, the most striking of which are the so-called "cadaver" tombs of the late fifteenth and sixteenth centuries. As you enter the cathedral's rear chapel you are faced with a pair of starkly normal bare feet, with skewed big toes, sticking out at the edge of a tomb. They are the extremities of the recumbent, naked body of François I, gloriously cut out of cadaverous white marble. Unfortunately a barrier now prevents you walking round the bier to view the rest of his body, though mourners would have done

so, but as you step back there is the king himself as if alive, kneeling in prayer on top of his tomb. The tomb of Henri II (François' successor) and his wife Catherine de Médicis is rather easier to see. Another two-tier construction, it was commissioned by Catherine in 1559 after her husband's early death in a joust, but while she was very much alive. The *tour-de-force* brilliance of the handling gives the lower carvings, with their thrown-back heads, a truly haunting quality.

Very little is known about Germain Pilon (c.1537–90). He became Sculptor Royal in 1568, specializing in tombs, and his early pieces are in the flouncy manner of fashionable Italians, such as Primaticcio (who may have been responsible for the overall plan of the tomb). But the stark realism of the royal corpses must have been done to order. What were the French royals trying to prove by having themselves depicted in this way? Was this an expression of growing nervousness? Rebellion was seething among the lower orders, partly stimulated by the new Protestant faith in the north, which held that the word of God was more important than the flesh of man, and abhorred the presence of images in churches. Perhaps the kings and queens of France, two centuries before the Revolution, wanted to show that they were just like everyone else beneath their finery. Their bodies, like everyone's, had been made in God's image, and that was nothing to be ashamed of. These monuments showed that they, like us, would stand naked before their maker. The stripped cadaver was not just a reminder of death but also a declaration of hope, and of the fate that awaits us all – a much more urgent concern than possible political upheaval.

Head of Henry VII's Funeral Effigy

Artist unknown Painted plaster and wood | 35.5cm high | 1509 |Westminster Abbey Museum, London, England

T he museum in the undercroft in Westminster Abbey contains a unique survival – the only major relic of a practice that was widespread across Europe during the later Middle Ages and the Renaissance. In those days churches were crowded not only with worshippers but with life-size likenesses of the dead. Their heads and hands were made of painted wood or plaster and, later, wax. Their bodies were wood, or canvas stuffed with straw, and they were dressed in the clothes they wore in life. Either standing by their graves, or lying on them, they were startlingly macabre presences, as if the corpses in the tombs had sprung back to life.

Almost all of these figures have now gone. Of those that survived most were swept away by later, tidier religious ideas which viewed these manikins as barbaric intercessors between mankind and God. But a remarkable clutch of these effigies still exists in Westminster Abbey, where many of the English royal family are buried. Having restored its monarchy, after a brief revolution in the seventeenth century, no citizen of England cared to defile the image of a king. The practice of making life-size replicas of the dead was even maintained for Oliver Cromwell, the leader of Britain's short-lived republic. Nothing remains of this figure, which stood with a sceptre in its hand and a crown on its head, lit by five hundred candles. Unfortunately, several of the abbey's effigies were damaged beyond repair when the building was hit by incendiary bombs during World War II, and water was used to put out the fires. Some survived even this, such as the speaking likeness of Charles II, still wearing his monogrammed underpants. Sadly, of Henry VII only the head remains – but what a face!

We don't know who carved and painted this portrait of the tough administrator king who imposed peace on England after the Wars of the Roses and established the long-running Tudor dynasty. It was presumably made within days of his death, probably based on his actual features or his death mask. It's been suggested that the drooping of the left side of his mouth indicates the contortion of his fatal stroke, but other portraits painted from life have a similar slightly lopsided expression. What comes over most strongly is how alive he looks. Rarely, if ever, does a face stare back at us so vividly from the past. It originally had a wig of real hair – there are traces of it at the side – and the figure was fully dressed. It was carried lying on his coffin through the streets so everyone could see that the king was actually dead. But it was believed that, being a king, Henry was in part divine, and would in any event be resurrected in the flesh, fully dressed, his eyes open, facing up to heaven, ready to face his God. Such lively realism is a rare achievement.

The head has been attributed to Pietro Torrigiano (1472–1528), who had come over to England to create Henry's sepulchral monument. But what little remains of Torrigiano's work – much of it was smashed during the English Revolution – generally lacks an interest in individual characterization. A bust of Henry in the Victoria and Albert Museum, now attributed to him, has the king's features but depicts him as a powerful ruler, not a quizzical thinker. Torrigiano was a feisty fellow; he reputedly broke Michelangelo's nose after the latter made a slighting remark about his work. The chances are that Henry VII's unforgettable face was the creation of a more humble funeral effigy-maker whose other works have been totally lost.

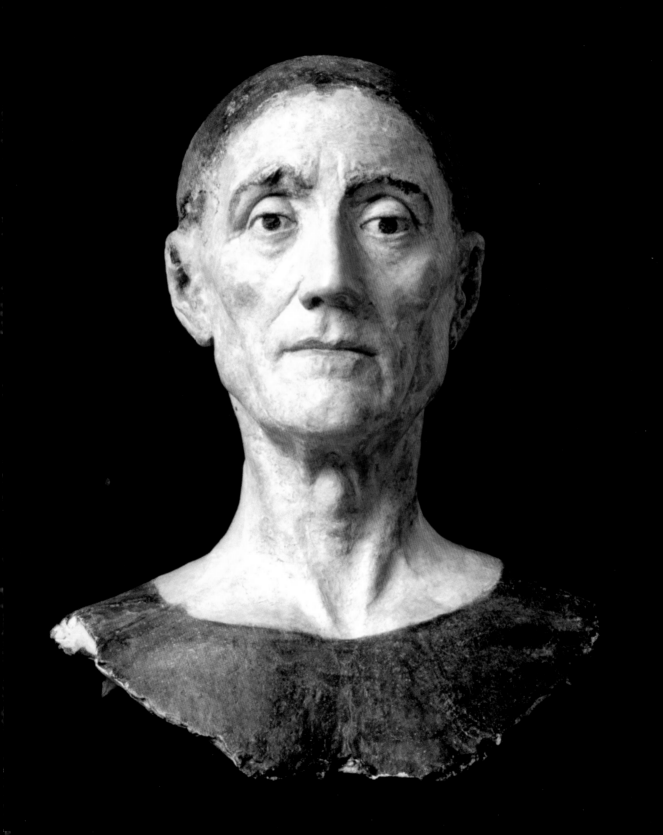

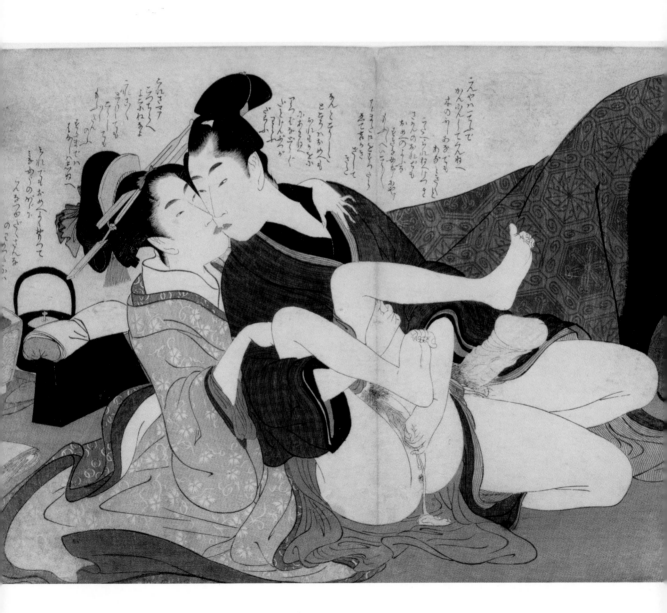

Prelude to Desire

Utamaro Kitagawa

Woodcut | 37.9 x 25.5cm | 1799 | Museé Guimet, Paris, France

J apan cut itself off from external corrupting influences for over two centuries. From 1639 to 1853, no foreigner was allowed to enter the country, nor any Japanese to leave, on penalty of death. Life went on as if the rest of the world didn't exist, an extraordinary survival of an ancient culture, but a culture that didn't stagnate. An open attitude to sex was part of this heritage. Ancient fertility cults, which were once widespread around the world, survived into this period. Colossal wooden phalluses carved out of tree trunks were prayed to in temples, and forks in roads, like the fork in a man, were usually marked by a large, erect penis carved from a standing stone. Sex wasn't hidden but was openly celebrated as an essential and most enjoyable fact of life.

The Japanese enjoyed their pleasures to the full and codified them precisely, intensely aware – as their poets and mystics were always reminding them – that no enjoyment lasts forever. They evolved elaborate menus that sustained the edge of the appetite without satiating it too soon. They watched cherry trees blossom each spring, from the first bursting buds to the finale when the ground beneath the trees was carpeted in pink. Their erotic paintings and prints were called *shunga*, a word which literally means spring. They were expert at sustaining sexual enjoyment. As illustrated books of poems and as albums of prints, *shunga* celebrated all the stages in lovemaking, from first glances to mutual arousal, clutched anguish and exhausted consummation. Such works were avidly collected by all levels of society, men and women alike, and often given as presents at weddings. The burgeoning class of wealthy merchants and craftsmen, who frequented the courtesan districts in the major towns, vied with one another to commission erotica from the leading artists of the day. All the famous artists of the period produced *shunga*. No one considered for a moment that these might be shameful, let alone pornographic. Nor were these prints in any way sexual manuals; there were plenty of those cheaply available. *Shunga* were high art, supreme expressions of the transience of pleasure.

Utamaro (1753–1806) was one of the greatest artists of his day, celebrated for his depictions of beautiful women. One famous print shows a young girl from the back exposing the nape of her neck, the elegant sweep of her cheek caught in a mirror. Utamaro was a master of the sensuous, taut contour. He produced over two thousand prints including many *shunga*, which were usually published in series.

The one opposite is from a set of twelve, entitled *Prelude to Desire*, which depicts various moments of exquisite pleasure enjoyed by different couples: from a casual first grope, fully dressed, to full-throttled in *flagrante*, with most of their clothes thrown off. Every stage of sexual delight was regarded as legitimate subject matter for art, though in other cultures the mere mention of them would have been embarrassing if not outright taboo. Here both partners are in an advanced state of arousal, the woman's toes curl in pleasure, her tongue begins to explore her lover's cheek, while his penis throbs with expectancy, and the eyes of both begin to close, while all around the robes swirl as their inner senses swoon.

The Origin of the World

Gustave Courbet

Oil on canvas | 46 x 55cm | 1866 |Museé d'Orsay, Paris, France

The Origin of the World was painted to be hidden. It was commissioned by a rich Muslim, Khahil Bey, the Ottoman ambassador to France, for his private collection of erotica. The painting has remained hidden for most of its existence, and was for a time kept in a double frame under a snow scene. Even when the psychoanalyst Jacques Lacan bought it in 1955, he had André Masson paint a rather lame surrealistic version of it on a covering panel, the symbolic language of unconscious dreams evidently being more presentable than naked reality! The painting remained in private hands until it was acquired by the Musée d'Orsay and put on public display in 1995. It's still difficult to look at the painting because of the feeling of being a voyeur, with other people watching you. Male genitalia have been aired in Western art for centuries, but those of females have always been covered up. Perhaps by painting this picture Gustave Courbet (1819–77) was questioning the logic of this inequality but, if so, it was a personal meditation, for this was a private commission, never meant to be seen in public. That would have been a step too far, even for Courbet, despite his ambition to challenge all conventions and lead the life of a savage in polite society. He was, he declared, a slave to no school, faith or rule, except that of the freedom to face reality.

Khahil Bey probably specified the subject, because it is exceptional even in Courbet's adventurous oeuvre. Some commentators have interpreted the image as misogynistic, a headless woman laid out like a slab of meat. But the addition of a face would totally change the subject of the picture; her expression would become central, suggesting her motive for posing in this way. Headless, the image becomes general, and perhaps goes some way to explaining its cryptic title. The picture's subject is not just the focus of a sexually aroused man's interest, but also the source of his and everyone's existence – the origin of everything. It's also a beautiful painting. The light on the silken skin is delicious, and the sagging flesh, within shaded contours, adds sumptuousness. A subtle visual rhythm recedes from the vagina, placed off-centre, to the light-catching navel and further back to the aroused nipple. The pubic hair, in its patchy irregularity, contrasts vividly with the surrounding pallor, like dark anthers in a bed of petals. The sexual function of flowers had ten only recently been discovered, and Courbet is possibly seeing women in these terms.

There has been much speculation about the model. The favoured candidate is Joanna Hiffernan, the painter Whistler's mistress, who posed draped in white, standing on a polar bear skin, for his painting Symphony in White No.1. The drawback to this theory is that she was a redhead. Perhaps Courbet darkened the colour of her hair to disguise her identity, though he didn't when he used her for one of the models in his sumptuously seductive lesbian painting, Les Dormeuses. We do know that Whistler and Courbet's friendship fell apart about this time, and the row could have been over Joanna. Whistler, moreover, was jittery during this period: his pious mother was coming to stay. His portrait of her – the epitome of ageing propriety – became one of the most popular paintings in the world, while Courbet's alternative view of motherhood remained buried in secrecy.

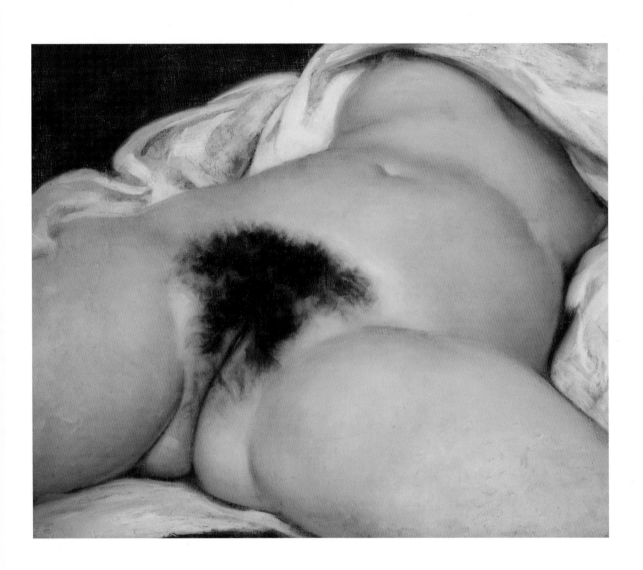

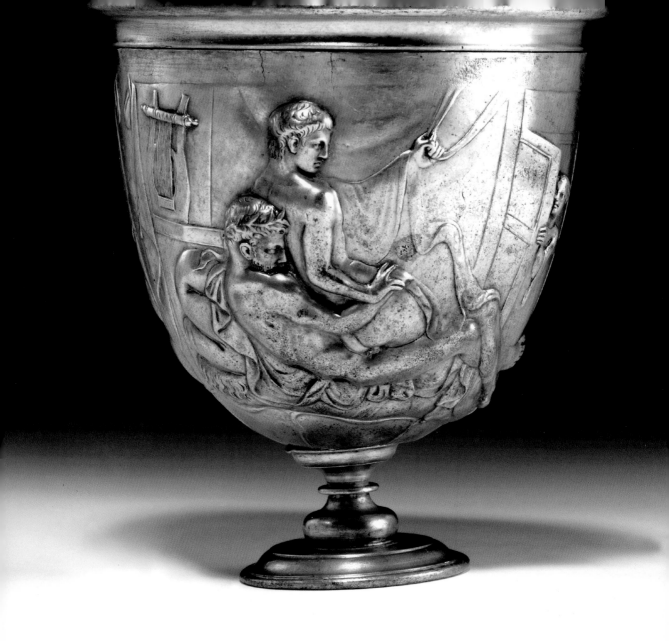

The Warren Cup

Artist unknown

Silver | 9.9cm in diameter| 1st century CE |British Museum, London, England

E dward Perry Warren (1860–1928) was an American of independent means who settled in the charming English town of Lewes, where he devoted his life to collecting art and promoting homosexuality. After the conviction of Oscar Wilde in 1895, Warren increasingly had to pursue his cause behind the closed front doors of Lewes House, with his lover John Marshall, known as "Puppy", and their intimate circle. He assembled collections of literature and art which justified homosexuality in human life (though he also commissioned a version of Rodin's Kiss, now in the Tate Gallery – a powerful piece of heterosexual eroticism).

Among Warren's collection was a Roman silver drinking vessel decorated in low relief, now known as the Warren Cup. The cup's provenance is obscure, but tradition has it that it was found near Jerusalem with a hoard of coins which date it to the early first century CE. It's intriguing to think that the craftsman who made it could have seen Jesus of Nazareth. It probably remained buried for centuries – it almost certainly wouldn't have survived if it had been discovered much before the eighteenth century, when there emerged in Europe a growing coterie of homosexual intellectuals who clandestinely collected anything priapic, passing on prized objects almost as talismans. It was not until the 1980s that the cup was judged acceptable for public view, and in 1999 it was eventually acquired for the nation by the British Museum for £1.8m. It had taken 2000 years for it to "come out" once again – though it was probably never fully "out" from the beginning.

During the republican era in Rome, physical love between men was widely regarded as degenerate and "Greek", but it continued to be accepted as a normal practice among the upper classes and the military, and this continued into the imperial years. The emperors Nero and Hadrian openly had male lovers. The army had special units, famed for their bravery, formed by older men and their younger lovers, who emulated the feats of mythical heroes like Achilles and Patroclus. The Warren Cup could have been made for such a band. It was a communal drinking cup – it originally had two handles – passed round at private banquets. The Greeks accepted that some men fell in love with youths, though bisexuality was more widespread than homosexuality. Much was written about how male love was a stimulus to educating the young (though many writers, including Plato, thought it should remain platonic). It was customary for the older man to be the dominant partner, as is shown on both sides of the Warren Cup: here a bearded man penetrating a youth, on the other a youth coupling with a boy. Mature men were dominant, active, strong; youths, like women, foreigners and slaves, were passive, weak and naturally submissive. But youths had to be taught to be strong.

This cup was made by beating five thin sheets of silver, probably into a mould cast from an original carving of these two scenes. The sheets were then assembled round a thicker silver core that formed the inner surface of the bowl. Details, like the curls of hair, were finished off from the outside. There could have been several versions of this cup. Sexual desire is best expressed in art through rhythm, volume and line. The sense of movement is a key to the emotion. The only thing fixed and static in this exquisite modelling is the expressions on the faces. Had they betrayed feelings, the couplings could have become comic (especially because of the peeping Tom). But the overall effect of this depiction of clandestine activity is of serious, almost educational, intent.

Portrait of a Black Woman

Marie-Guillemine Benoist

Oil on canvas | 65 x 81cm | 1800 | Museé du Louvre, Paris, France

In a far corner of the Louvre's top floor there is a portrait that isn't the usual white face against a dim background; this one is dark on light. It's one of the very few black faces on the Louvre's walls, and even more surprisingly, it was painted by a woman, Marie-Guillemine Benoist (1768–1826). The painting was exhibited in the Paris Salon in 1800, to considerable acclaim, though the critic Jean-Baptiste Boutard was shocked that "a white, pretty hand … had created such a horror." It was then widely assumed that paler-skinned people were more civilized than darker people, who were thought to be closer to the earth and nature. This idea of "natives" perhaps explains why this woman's exposed breast passed without comment and why the painting was so admired, eventually being bought by Louis XVIII and given to the Louvre. Naked breasts were acceptable on goddesses and on idealized personifications of Liberty, Nature and the like (a convention which largely accounted for the popularity of such improving subjects), but a bared bosom on a picture of a real live woman would normally have caused a scandal. The model was most probably a servant whom Benoist had asked to sit for her on one of her dining chairs, draped in a blue cloth, her body wrapped in a length of freshly laundered white linen gathered with a red sash, the perfect ensemble of colours to offset her dark flesh. She is, primarily, a superb pictorial composition.

Feminist historians have claimed much more. They've seen this painting as a political statement, asserting women's freedom alongside that of blacks, a common theme among radical thinkers at that time. Though slavery had been abolished throughout French territories in 1794, after the Revolution, black people were still accorded only the minimum of rights, and their liberty was short-lived, for Napoleon reinstituted slavery shortly after this picture was first exhibited. Women still had virtually no rights. Benoist was exceptional in rising high in an overwhelmingly male profession, and had been trained by a pioneer of women painters, Elisabeth Vigée-Le Brun. Her other teacher was Jacques-Louis David, the doyen of Revolutionary artists, who encouraged women painters, though even he would not allow them into the life class to draw naked men. But Benoist was no radical. She came from a very well-connected political family and married a royalist lawyer.

The sitter for this portrait was probably a freed slave brought from Guadeloupe as a servant by Benoist's brother-in-law. The artist's interest in her was primarily visual and possibly sexual. One of her earliest pictures, *Between Virtue and Vice* (1791), shows a pretty young woman choosing the companionship of a handsome girl (Virtue) in preference to the arms of a handsome youth (Vice). This is standard allegorical painting, but the tenderness of the women's proximity could suggest a lesbian inclination. It is quite possible that Benoist cherished an unrequited passion for her black sitter. This would explain not only its intensity, which is exceptional in her work, but also the self-effacing look in the sitter's eyes, tinged with boredom and perhaps hostility. There is no glow of affection in her eyes, but lights edge along the contours of her lips and round her nipple. For whatever reason, Benoist has painted one of the most beautiful breasts in art.

6 Hidden by Art

Art can bury art. No one gave a second thought about plastering over the old sculpture on the cathedral at Autun in the eighteenth century. Those responsible regarded them as the primitive art of France's childhood – anyone could see that by the outsize heads. Such accusations of artistic naïvety have always been used to denigrate works that people don't approve of, whether it's to dismiss the work of earlier ages or different cultures as crude, disparage abstract art by suggesting a child of five could do it, or sneer at art that has a wide popular appeal. Many pundits of modern art argue that any art that the public enjoys can't be any good, and so an outstanding painter like Norman Rockwell is written out of the history of modern art simply for being popular. Similarly, certain genres – such as portraiture and flower painting – have always been taken less seriously than others, for no better reason than that they are primarily illustrative. The result is that many outstanding works of art, for example Audubon's watercolours of birds, or Redouté's flower paintings, have never had the aesthetic recognition they deserve. The same is true of the false distinction maintained by Western cultures between art and craft – the so-called fine arts versus the decorative arts. The supposed superiority of art over craft – head over hand – continues to be upheld, even though such superb masterworks as the Roman mosaic at Palestrina or the tapestries at Angers contain more artistic merit than the output of a great many "fine" artists.

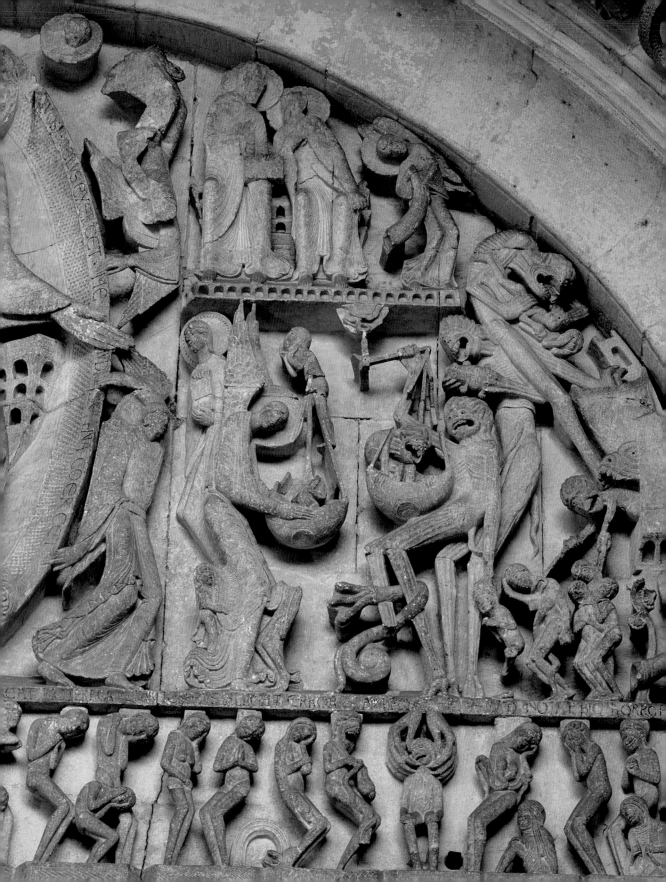

West Portal of Autun Cathedral

Gislebertus

Limestone | c.1120–1135 | Cathedral of St-Lazare, Autun, France

I n 1766 the canons of Autun Cathedral, who considered the twelfth-century sculptures in the arch above the main door embarrassingly "barbaric", decided to have them plastered over and bricked up. This was quicker and cheaper than removing them. Christ's head still protruded, however, as did all the sculptures around the rim, so these were lopped off to leave the surface level. Then in 1837, the Abbé Devoucoux came upon a reference to the sculptures in a fifteenth-century document. He had the bricks and plaster cut away and discovered the carvings underneath, more or less intact. Just over a century later, a sculpture in the nearby Musée Rolin was identified as the head of Christ and reunited with the body.

How could Christians have beheaded an image of their saviour, and concealed a work of art that was so expressive of their beliefs? In part it was a question of changing taste. The eighteenth-century clergy could only see these figures, with their big heads and hands and elongated bodies, as naïve and unsophisticated. But there was also a religious reason for their actions. Scientific study had begun to demonstrate that earthly suffering had natural causes: disease, disasters and famine weren't the inevitable results of God's wrath but could, with forethought, be relieved or even avoided. While the wages of sin were still death, warnings of hell-fire no longer carried the same weight. Christianity started to promote a more positive message, leap-frogging science with images of eternal bliss. The slapdash concealment of the Autun tympanum turned out to be fortuitous, however – it screened it from the eyes of the anti-religious militants of the French Revolution who roamed the country after 1792 ransacking churches. One of the greatest works of Christian art could easily have been lost in those turbulent times.

We know nothing about Gislebertus except his name. Boldly inscribed at the feet of Christ are the words GISLEBERTUS HOC FECIT – Gislebertus made this. Such a claim of authorship was virtually unprecedented at that time, when artists, like everyone else involved in building the great medieval churches, were God's anonymous journeymen. One senses, though, that this wasn't so much an assertion of artistic ownership as a declaration of personal commitment. Rarely has so much passion been poured into the cutting of stone. Down at the bottom, the damned go weak at the knees. How they regret their sinful lives! One little figure crouches as he feels two great claws close around his neck – the nightmare of people who lived in fear of bears. They could have imagined the pitiful cries of this fool who didn't take care. Skeletal hoofed demons shriek as they rake in the fallen, while the souls next in line are weighed. The Devil didn't just have the best tunes, but the best scenes.

But Gislebertus was also glorious in his depiction of virtue. St Michael, lifting a soul from the scales, is a flowing, elongated, image of kindly goodness. A tiny saved soul hides in his robes and looks at the damned with troubled bewilderment, amazed that anyone could have been so short-sighted. Gislebertus was a supreme carver of expressions – looks of abject fear, demonic hatred, limitless love and eye-opening wonder. These figures' eyes were originally studded with blue glass beads, a few of which remain, and the whole tympanum would have been brightly painted.

Voltaire Naked

Jean-Baptiste Pigalle

Marble | 150cm high | 1776 | Musée du Louvre, Paris, France

Amidst all the pompous marble statuary in the Louvre is an artistic gem which is easily missed. Importuned by all the great and good elevated on plinths, with jutting jaws, pouting lips and furrowed brows, you could easily let your eyes glaze over, like the stone ones all around. But if you do, you're likely to miss something extraordinary. At first the figure seems just the same, a purified reputation puffed in stone, but looking more closely you realize it's different. This man is naked rather than nude and, even more surprisingly, he's old. A fold of paper covers his genitals, but the rest of him is starkly bare. His breasts sag in folds above his sunken ribs, and creases trail across his stomach. His legs and arms are gaunt and veined; you can almost feel the looseness of the skin on them. Round his back, the flesh hangs from his buttocks and ripples out on to the seat. But then you notice that his eyes are not vacant like those all around him, but burn with a quizzical, fiery intelligence; they blaze with brightness, though they're only rings carved in stone. And then the whole face comes into focus, the craggy jaw, the ironic, curling smile, all too candid and life-worn to be a caricature.

There is something symbolic about Voltaire sitting there, among all the pomp and glory of the eighteenth century. He was part of the rumbling, bubbling lava under the smooth surface of the Establishment – presaging the volcano that would erupt, soon after his death, in the French Revolution. Most of the dozens of pamphlets, plays and satires that Voltaire wrote were published anonymously, to keep their author out of trouble. But still the finger was pointed (for no one else wrote like him), with the result that he was repeatedly put in prison and sent into exile, from where he could write undistracted. Dipping into Voltaire's mind is like taking a cold shower in clammy weather. His thoughts on baptism: "Men, who are always guided by their senses, easily imagine that what washes the body also washes the soul." On equality: "What does a dog owe to a dog, and a horse to a horse? Nothing, no animal depends on his like; but man having received the ray of divinity called *reason*, what is the result? Slavery throughout almost the whole world."

This statue, commissioned by a circle of Voltaire's admirers, including the great encyclopaedist Denis Diderot, was at that time a unique tribute to a living person not of noble blood. Its sculptor Jean-Baptiste Pigalle (1714–85), a close friend of Diderot, was dedicated to reviving the realistic, republican style of classical sculpture, which Voltaire admired for "veiling nothing". The portrait was ridiculed not just for putting a lowly mortal on a pedestal but, even more, for showing him as he was, flabby skin and all. It's a remarkable depiction of a real person, stripped naked by the eye of the artist rather than dressed up in the robes of art. Voltaire wrote to Pigalle with "gratitude and admiration" for "listening to his own voice", adding, with typical self-deprecating candour, that his figure "would not inspire any disreputable ideas in the ladies".

MONSIEUR DE VOLTAIRE. PAR LES GENS DE LETTRES
SES COMPATRIOTES, ET SES CONTEMPORAINS. 1776.

Head of Julius Caesar

Artist unknown

Marble | 32cm high | c.50 BCE | Graeco-Roman Museum, Alexandria, Egypt

J ulius Caesar was lionized during his life and worshipped as a god after his death. Art was the main vehicle for this elevation. Sculptors morphed his features into those of a superhuman hero: he acquired a chiselled jaw, straight nose, full lips and a prominent, clear brow. Nothing could get in the way of such a man. So art, in time, buried the real face of Caesar. But art could also show him as he really was, as it might be doing here. We will probably never know for certain if this is an authentic portrait of Julius Caesar. Countless busts were made of him, and went on being made virtually up until our own times. And whenever an old bust of an unknown man in a toga was dug up it was assumed to be a portrait of Julius Caesar, because he was the only Ancient Roman most people had heard of. This happened as recently as 2008, when an antique portrait head was found in river silt near Arles, a city founded by Caesar in 46 BCE. Despite its squashed features and expression of permanent panic, its finders immediately claimed it was a true portrait of Caesar, and pictures of the discovery were beamed around the world. The face of the real Julius Caesar has proved extremely elusive, but of the several busts generally held to record his true appearance, this one, despite its rather rough execution, seems to have the most authenticity – not least because its expression is sufficiently calculating.

One of the Romans' greatest contributions to world art was their realistic portraiture. It is one of the least considered wonders of world art, but its cause is not helped by the hundreds of neoclassical imitations, now in museums, showing European leaders dressed in mock antique robes. Most of these reveal little more than self-importance, whereas genuine Roman busts always repay a closer look. The Romans were fascinated by individuality. Their understanding of human nature was perhaps the main reason why their vast empire was sustained so successfully and for so long. Official reports by governors are often full of amusing and telling character assessments. The Romans delighted in analysing personalities in writing and in art.

It's very difficult to put one's finger on what precisely makes this head look so alive. It's something to do with the slightly asymmetrical set of the smallish mouth, suggesting sensuous determination, while the clearly arching brows seem to reveal intelligent awareness combined with arrogant contempt. These are feelings more hinted at than laboured, created by subtle inflections of the sculptor's hand. Another reason to think this bust might well be a genuine portrait is that the later depictions of Caesar as a god exaggerate these same features: the lofty brow, the jutting lower lip and jaw. But these were conventional attributes of gods and heroes well before his time. Caesar's career marked the watershed between the Roman republic and its dictatorship. Cicero suspected Caesar's ambitions, but mused: "When I see his hair so perfectly arranged, and when I see him scratching his head with a single finger, I change my mind. It seems inconceivable that anything as terrible as the overthrow of the Roman constitution could ever occur to this man." This is the portrait of a man who could scratch his head. Later portraits of Julius Caesar Imperator reveal no shadow of self-doubt.

Nile Mosaic

Artist unknown

Mosaic| c.100 BCE | Museo Nazionale Archeologico Prenestino, Palestrina, Italy

Only the Romans made hard-wearing art you were meant to walk on. Mosaics had been known in Mesopotamia 2000 years before, but it was the Romans who saw their potential for picture-making. The Greeks were apparently fond of floor paintings but, hardly surprisingly, none survive. The Romans thought paintings were for walls, and that floors demanded mosaics. That made sense, for mosaics were durable and could survive under water, which was important, as the Romans were very fond of baths. They loved the idea of art you could look down upon, but then they liked being in the picture and in the swim. Mosaics were a wonderful expression of the Romans' hedonism.

Virtually no Ancient Roman ceilings now exist (they tended to fall in) apart from some tantalizing fragments in the Golden House of Nero. But floors did survive, and many have been discovered, particularly along the North African coast. Some are simply and beautifully tiled, for Romans cared for their feet. Hundreds are more elaborately decorated, though the people who walked on them could never have appreciated their total effect. When these mosaics are redisplayed in museums they're often shown upright, attached to a wall. That is not the way to appreciate a Roman mosaic – they're meant to be explored bit by bit around your feet, as you would discover a sea bed you're paddling through. The analogy is apt, because many Roman mosaics were mostly meant to be seen under water, in baths or flooded by spill-offs from channelled streams and fountains. The colours of the tesserae (the hundreds of minute tiles that make up a mosaic) must then have glowed, as pebbles shine when wet. Now they are mostly dry and dusty, a pale shadow of their former glory.

One of the finest mosaics to survive virtually complete can be seen in Palestrina, a small town south of Rome. It decorated the terrace of one of the largest sanctuaries in the Roman Empire, dedicated to Fortuna and the sea god Poseidon. The site had been worshipped earlier as the source of a sacred spring, and it's probable that holy water was still piped to ripple over the sanctuary's mosaics in Roman times. "Cool Praeneste", as it was called, was a popular spot for Romans to escape the summer heat, and the emperors Tiberius, Hadrian and Marcus Aurelius all built villas in the surrounding hills.

The sanctuary sported two great mosaics, one of the sea, writhing with fish and sea monsters, dedicated to Poseidon, and one of the Nile dedicated to Fortuna, who was perhaps already at that time associated with the Egyptian goddess Isis. The Nile mosaic shows the river flowing from its source in the mountains, where black men shoot birds and lions roam, then follows its course down to the flooded delta where hippos speared by hunters roar in pain, and an angry crocodile, hiding in the rushes, lashes its tail. Water flows everywhere, around the lintels of houses and temples (both Egyptian and Roman), inundating papyrus and lotus beds, and lapping at the feet of men and women banqueting under a shady palisade of vines. The sensation of rippling liveliness is produced by bands of fractured tesserae. The Romans created a new art form by making the most of the limitations of the technique, but this achievement has tended to be downgraded, for who can take seriously art which is under their feet?

Apocalypse Tapestries

Hennequin de Bruges

Wool | 550 x 1370cm | 1373–82 | Château d'Angers, Angers, France.

In the Middle Ages, grand occasions were enhanced with sculptures, painted scenery and tapestries. This art was mostly ephemeral, and little survives. The Apocalypse Tapestries, exceptionally, give us an idea of what the medieval era was like when putting on a show. At 137 metres long and 5.5 metres high, the series is at once all-encompassing and overwhelming, even though only 70 of the original 90 tapestries survive intact. It's amazing that any do at all. Commissioned in 1373 by Louis of Anjou, they may have been woven to embellish the recently restored Angers castle. Louis bequeathed them to his son Louis II, who used them as decorations at his wedding to Yolande of Aragon. It might seem strange to mark a wedding with scenes of the end of the world, but this was 1400, and the turn of each century brought Christians nearer to the Second Coming and the Last Judgement.

The tapestries were then bequeathed to Angers Cathedral, where they were brought out during great festivals to fill the congregation with fear and trembling. By the 1760s everything medieval was deemed barbaric (see p.147), and the cathedral council ordered the tapestries to be sold. They failed to find a bidder, and so came to be used instead to protect the orange trees in the greenhouses from winter frosts. There, luckily, they escaped the attentions of the iconoclasts of the French Revolution, who despised all churches and their art. Had the cloth included gold and silver thread they would undoubtedly have been burnt, as many tapestries were, to extract the metal. But the Angers set survived to be repaired and eventually reconstituted, not greatly the worse for wear. They're not even very badly faded, as is the case with most of the few tapestries that exist from this date. The blues and red are still vividly strong, though the yellows, greens and flesh tones have largely gone. When the backing was removed in 1981, these colours shone out in shocking brilliance.

The tapestries tell the story of the final days of creation, as written down in Revelation, the last book of the New Testament. Each scene had its own caption – like a vast comic strip – but these have all been lost. The scene illustrated here shows the second angel of the Apocalypse blowing his trumpet "…and as it were a great mountain burning with fire was cast into the sea: and the third part of the sea became blood. And the third part of the creatures which were in the sea, and had life, died; and the third part of the ships were destroyed."

The work was designed by Hennequin de Bruges, and woven by a vast team of weavers overseen by Nicolas Bataille. The backgrounds were alternately blue and red – a brilliant chequerboard effect. The aim was for grandeur and simplicity. There was boldness, too, in the detail. Tapestry is made of horizontal threads, the weft, woven over a support of vertical threads, or warp. The picture is created by an accumulation of woven patches of weft on warp – a sort of suspended jigsaw. The designers of the Angers tapestry have made the most of this limitation. The shape of every detail, however small, is clearly seen, adding to the impact and urgent rhythm of the whole – the clam-like clouds, tongues of flame and knobbly waves coiling like octopuses' arms create the effect of an engulfing calamity, against a backdrop of falling fire.

San Rocco Carvings

Francesco Pianta

Walnut | 1657–58 | Scuola Grande di San Rocco, Venice, Italy

Venice, that most luminous of cities, contains some of the world's gloomiest interiors. It's as if its inhabitants, weary of pink and white marble and reflections in green water, yearned for forests, caves, wood and earth. One of the darkest interiors is in the Scuola Grande di San Rocco. You stumble on its doorstep into pitch blackness. Inside, when your eyes have recovered, you discover light condensed to searching rays, beams slashing through storm-laden skies, splashing on rocks and pools and on the backs of saints contorted in the throes of martyrdom or exultation. This is the fabulous cycle of paintings by Tintoretto, completed in 1588 and culminating in an immense Crucifixion caught at that moment when night descended on the vault of heaven.

Darkness for Venetians wasn't just a respite from the sun's glare, a retreat from heat into a shady glade; it was a moral journey into the evil recesses of the soul, a torchlit, vital search through the vales of fear. The Scuola Grande di San Rocco was, after all, dedicated to salvation from the plague. The Venetian *scuole* were charitable societies formed to do God's work in the world. By 1400, there were about four hundred of them, raising funds for different causes. Some grew very rich, especially the Scuola Grande di San Rocco, which attracted great bequests after a sequence of plagues decimated the city. Its patron, St Roch (1295–1327), was a French nobleman who devoted himself to the care of the sick, and was miraculously cured of the plague with the aid of his dog, which brought him his daily bread. The Scuola had managed to secure his mortal remains, and they built a church to house them with a magnificent meeting hall next door, emblazoned with pictures by one of their members, Jacopo Tintoretto. But they also had to have somewhere to sit.

Francesco Pianta (c.1632–92) was descended from a long line of woodcarvers, and lived and worked in the family's old carpentry shop. An inventory of its contents was made on his death, listing all his tools and stacks of wood, and pieces of unfinished furniture, mainly for churches. The house was also full of paintings and devotional sculptures, and an extensive library of historical and religious works, Latin classics and poetry. Two books in particular, *De humana physiognomonia* (1586) by Giovanni Battista della Porta and *Iconologia* (1593) by Cesare Ripa, inspired the carvings that graced the seats for the honourable members of the Scuola. Until recently you had to peer at them through the gloom under the great paintings, but now they've been lit so that visitors can appreciate them.

Each carving is an exquisite mystery in dark walnut, a fantasy that flows out of a consummate craftsman's chisel, inspired by twists and knots in the timber, the playful juxtaposition of real things with patterns, flotsam caught in waves of wood. Here Anger – winged, blindfolded and with tensed muscles – flanks a bookcase stacked with old leather volumes so delicately carved you want to pull them out and feel their worn calf bindings. On the other side stands a cloaked figure. His lantern gives the clue that he works, secretly, at night, and his wing-heeled shoe shows he's fleet of foot. This mystery man is a spy, or a personification of Curiosity. The other carvings include bizarre depictions of Honour, Avarice, Scandal, Knowledge and Ignorance, plus a sumptuous posthumous portrait of Tintoretto, one craftsman's tribute to another. Rarely has wood been wrought so imaginatively and with such vigorous finesse.

George Nevill, 3rd Baron Bergavenny

Hans Holbein

Chalk on paper | 27 x 24cm | c.1526–27 | Wilton House, Wiltshire, England

D uring his short life, Hans Holbein (c.1497–1543) painted vast mural cycles and allegorical tableaux, as well as designing stained-glass windows, armour and jewellery. But almost all of this immense output has been lost. His fame now rests on his portraits, particularly on his image of Henry VIII, whose thrusting codpiece displays the motivation for his split with the Pope – he had to have a son, no matter how many wives needed to be divorced. Holbein's portraits never look posed; Henry must have stood like that. One can imagine Holbein saying "hold it!" and whipping out his pencil. And he had to whip, for a king wouldn't wait.

Here Holbein has a slightly easier sitter, the distinguished Baron Bergavenny, drawn shortly before his death in 1535. The Baron was a wily ex-soldier and courtier. He began as a favourite of King Henry VII (see p.134) but had to weave adroitly through the intrigues of Henry VIII's court. He was imprisoned on suspicion of treason, but later pardoned, and ended his life in comparative tranquillity. This troubled career is caught in the set of his mouth. With just one line, Holbein captures with absolute precision the baron's self-restrained, pugnacious determination. He has also caught his look: the way the pupils merge into the tips of the eyelashes gives the impression of an alert but wary intelligence. Holbein probably drew this sketch in less than an hour, with a searching sensitivity and breathtaking confidence. Occasionally he turned his drawings into paintings – this one was used as the basis for a miniature – but many were executed for their own sake. He seems to have sketched all the time out of sheer enjoyment.

The amazing thing is that any of these sketches survive. They weren't valued as finished works of art during his lifetime, but a few of his subjects held on to them and they were preserved by their descendants. Remarkably, the British Royal Collection has no fewer than eighty-five, almost all drawings of lords and ladies about the court, a few done for paintings but also many one-offs. These sketches, perhaps gathered together by an enthusiast, only survived by chance, handed down in a bundle – more as curiosities than works of art – through a sequence of royal and aristocratic collections in Europe and then back to Britain again. They were eventually rediscovered during the reign of George II, lying at the back of an old bureau in Kensington Palace, where they had apparently been left and forgotten. Most great drawings by artists in the past were simply not kept.

We now realize that drawings can reveal artists at their most intimate and inspired, and yet they are extremely difficult to see. The Royal Collection hardly ever shows its Holbein drawings. They argue that "due to their vulnerability to the damaging effects of light, old master drawings cannot be on permanent display". Of course, with properly managed controls of environmental conditions, they could be. In any case, the Royal Collection has so many Holbein drawings that it could easily ring the changes if it wanted to. Holbein showed what great things can be achieved with the simplest of means – just pencil lines on paper. People need to be able to see these wonderful survivals.

Study of a Cabbage Rose with Tulips

Pierre-Joseph Redouté

Watercolour on vellum | 36.8 x 26.7cm | 1802 | Private collection

The paintings of Pierre-Joseph Redouté (1759–1840) are not often equated with those of David or Ingres, or even the English horse painter Stubbs, but like them he was one of the great artists of the European Enlightenment. The trouble is that he painted only flowers, and flower painting has long been considered a minor art. In Islamic countries, flowers symbolized the presence of divinity on Earth, and the most powerful rulers of Persia and India were depicted holding a rose in their hand. In Christian Europe, the rose and the lily both symbolized purity,especially that of the Virgin Mary, so flowers came to be associated mainly with women. Flower painting enjoyed a brief eminence in seventeenth-century Protestant Holland, when elaborate floral arrangements became vehicles for clandestine statements of Catholic belief, but after that flowers in art were reduced to decorative bouquets, the perfect subject matter for women amateur artists on wet afternoons.

The Enlightenment, however, inspired a special type of flower painting. This was the great age of classification, when taxonomists like Linnaeus listed every living thing in God's creation. Scientists travelled everywhere searching for new species and, since it was the era before photography, took artists with them to record their discoveries. Redouté accompanied such a research party to Egypt, but for the most part he stayed in Paris painting the remarkable specimens that were sent from around the world to the Royal Gardens. Queen Marie Antoinette, who collected roses, made him her official court artist. After the Revolution, the Royal Gardens were incorporated into the new Museum of Natural History. Redouté then became the favourite painter of Napoleon's wife, the Empress Josephine, whose passion was for lilies. A painter of flowers could sail serenely through those turbulent times: his art was seen to be in the cause of science, which was sacrosanct to the new republicans. But it's partly for that reason that Redouté's art has been devalued ever since, and viewed as mere botanical illustration.

It's true that he was an illustrator, who, over his long career, delineated in minute detail the distinct features of over two thousand species, most of which were engraved for reference books. But these engravings were merely the economic foundation, not the ambition of his work. If they had been, he would never have lavished such care on the originals, which are built up in brushstrokes much too subtle to be reproduced. Redouté's life's work was nothing less than a hymn of praise to the beauty of flowers. He was a master of transparency and reflection, the two conditions of light that are essential to our appreciation of the quality of foliage and petals. No one has ever painted the padded delicacy of a leaf more surely, or evoked more powerfully the opening softness and strength of a flower, encompassing a concentrated pool of colour. Redouté's stems reveal his power, curving in space, so delicate yet able to sustain any weight. He was called in his time "the Raphael of Flowers", and his designs compare favourably with that master's Madonnas, similarly turned and held in space in an eternal stillness. The hushed wonder that pervades Redouté's work can only be appreciated fully in front of his original watercolours. Sadly, the majority of those that remain in public hands are hidden away in the reference collections of botanical gardens, in particular the Jardin des Plantes in Paris, which has over five hundred, hardly any of which are ever shown.

P. J. Redouté pinx 1802

Black-billed Cuckoo

John James Audubon

Watercolour and graphite on paper | 68.6 x 89 cm | 1822 | New York Historical Society, New York, USA

John James Audubon (1785–1851) is now famous. His portrait hangs in the White House, and his monumental work, *Birds of America*, is one of the most valuable books in the world. His life story – emigration from France as a young man, failed business enterprises, bankruptcy and imprisonment, followed by triumphant recovery thanks to his single-minded vision – has become emblematic of the story of the young American nation. But his fame was hard won, and, in his adoptive country, largely posthumous. His great book wasn't even published in America but in Britain. His art appealed to cultivated Europeans because it dramatically evoked the forests of the wild, untamed New World. Americans took longer to appreciate the beauties on their doorstep, and only started to do so seriously when they began to realize they were in danger of losing them. In 1820, when Audubon began his great, self-appointed task of painting all the birds of America, the woods were full of their songs. It didn't occur to him or anyone else at that time that many species would soon become rare, and several extinct. No one had any compunction about shooting birds, including Audubon, who did so in order to study them closely. (Binoculars only became widely available in the 1850s.) There were already many bird painters, but they presented their subjects stuffed and mounted on a perch, never on the wing. Audubon's originality was to show birds hunting, fighting and displaying, as you would see them in the wild. This required not only hours of intense and patient observation, but exceptional powers of creation.

Audubon could capture any action, from an eagle swooping on a startled hare to a hummingbird sipping at a flower. His paintings of birds should properly be called portraits, because he was so responsive to their distinctive natures. And he made their habitats dance to their tunes. He knew the black-billed cuckoo loved to hunt for insects in *Magnolia grandiflora*, so he painted this pair darting between its branches, well camouflaged among its shining leaves and blossoms (painted here by his long-term, talented assistant Joseph Mason). The bird on the left twists its head sharply to snap at a beetle. The design of the image, with the perfect positioning of the black tips of their beaks, expresses the precise beauty of birds' lives – their fitness for purpose.

Audubon's ornithological knowledge influenced Darwin, who as a student in Edinburgh attended a lecture by him. But his paintings aren't scientific illustrations; they're imaginative recreations of moments of life. Audubon deserves to rank among the world's great artists, not just because he was inspired by a radical vision of the value of natural life, but because he developed new skills to capture its full force. The engravings for his book are superb works of art in themselves, but his original watercolours are even more alive. Their deep colours glow and the forms are luminously suffused with what Audubon loved to call "the softness of plumage". These masterpieces of American painting are not to be found in the National Gallery of Art in Washington DC, nor in the American Museum of Natural History. Neither of these two institutions existed when Audubon's widow, desperate for cash, sold 435 of his original paintings to the New York Historical Society, where they are shown but all too seldom looked at.

Tapuya Woman
Albert Eckhout

Oil on canvas | 154 x 264cm | 1641 |
National Museum of Denmark, Copenhagen, Denmark

W e know virtually nothing about the Dutch artist Albert Eckhout (c.1610–65). He was born in Groningen, and had shown enough talent to be appointed official painter to Count Johan Maurits van Nassau-Siegen when he became governor of Dutch Brazil in 1637. Count Maurits, an exceptionally enlightened ruler, seized the opportunity to found an ideal society. He imposed peace, built forts, instituted political reforms and expanded cities, before being recalled in 1644, having already spent far too much. There was time, however, to instigate a programme of scientific research: his men collected the flora and fauna of the region, while his painters, Frans Post and Albert Eckhout, recorded their discoveries. Post painted the landscape and buildings, Eckhout the plants and animals – so vividly that you can almost smell the fruit, while his lizards look as if they're just about to dart away. And he displayed the same incisive objectivity and skill in his paintings of the local people.

The Europeans colonizers assumed that mankind was ordered in races, with themselves at the apex of the pyramid. Eckhout's task was to paint a series of portraits of the people ranged beneath them. These included a *mulato* man and *mameluca* woman, the mixed-race progeny of European and Brazilian parents, pale-skinned and dressed in European clothes. The local pure-bred natives only wore clothes from the waist down, but were evidently friendly to the Europeans and probably worked on their estates, for one is shown in the background of the woman's portrait. These people were slightly darker skinned than the *mulato* and *mameluca*. Then there were two portraits of a man and woman who had been transported from Africa and worked as slaves on the plantations. They were very dark-skinned, wore little clothing and carried traditional symbols of status from Africa, such as a fly-whisk and an exotic hat. Lastly Eckhout painted a Tapuya man and woman, a now extinct local tribal group. These were indigenous, cannibalistic people who had no settlements, but travelled and hunted, virtually naked, through the forests. Practising ritual tribal warfare, their men wore white bones through their cheeks after killing an enemy, and the women carried baskets filled with bits of humans, ready to be smoked, roasted and eaten. Reputedly, they also ate family members when they died, including stillborn babies, partly, it is thought, to ensure that their blood line remained in the family.

It's unlikely that Eckhout painted his Tapuya man and woman from life – these people were greatly feared. Instead he probably persuaded native Brazilians to pose for him, but contemporary accounts suggest that the appearances he gave them were authentic. It's only his model's slightly shamed expression that gives away the paid poser. Eckhout was too faithful an artist to disguise this look.

These remarkable paintings weren't thought to be art; their subjects didn't warrant that status. They were given by Count Maurits to the king of Denmark, who put them into his "cabinet of curiosities", which later formed the basis of the country's national museum. It's surprising to come across paintings of this size and quality in an ethnographic collection, but that makes the experience of walking into the Eckhout room all the more vivid. It's like entering a time capsule and meeting people who've long been hidden by history.

Shon-ka-ki-he-ga

George Catlin

Oil on canvas | 61 x 73.5cm | 1832 |
Smithsonian American Art Museum, Washington, DC, USA

L ike his older contemporary Audubon (see p.162), George Catlin (1796–1872) was one of America's most brilliant and original artists: a visionary not only in his choice of subject, but also in the superb technique he developed to express it. Both men's work went largely unrecognized in their lifetimes, and ended up not in art collections but in museums dedicated to the subjects they chose to paint, valued as historical records rather than as works of art. As a boy growing up in Pennsylvania, Catlin was inspired by tales of native American people and by occasional sightings of them. In 1830, when he was 34, he abandoned his dreary legal career, picked up his paints and headed West to devote his life to "rescuing from oblivion" the "primitive looks and customs" of the indigenous peoples of North America. Seven years followed during which he pursued his increasingly elusive goal, entranced by what he found. His memoirs describe the dangers, hostilities and immense difficulties he faced dragging his supplies and equipment through the wilderness, in search of the few remaining tribes who led traditional lives. The Indian Removal Act of 1830 and incursions by settlers had driven the tribes further west, while their numbers were being progressively decimated by introduced diseases like smallpox.

When Catlin found his subjects and persuaded them to pose for him – no easy task in itself – he had to work fast, developing in the process superbly economic painterly skills. With the minimum of means and a few deft flicks of the brush, he could capture the essence of a whole personality. And all of Catlin's faces, more than six hundred of them, are distinct individuals looking out at you from their varied life experiences. This portrait is of Shon-ka-ki-he-ga, head chief of the Grand Pawnees. Through the precise placing of the eyes, the subdued colouring of the whites, and the lights on the upper lids, Catlin has managed to capture a wariness in Shon-ka-ki-he-ga's expression combined with a slight weariness which never lets you forget that he is completely alert. Equally subtle is Catlin's depiction of the mouth, set askew by suffering and endurance, yet peculiarly playful, as if the great chief could be about to smile. This is portrait painting at its very finest.

In 1838, Catlin took his paintings and the artefacts he'd collected back to the East, and opened an Indian Gallery as a touring attraction. The next year he travelled with it to Europe, but the money he made didn't even cover his costs. He also failed, after repeated efforts, to persuade the government to acquire his gallery, despite the huge endowment it had recently accepted to fund the Smithsonian Institution for the preservation of America's past. In 1852, when Catlin was finally declared bankrupt, a Philadelphia industrialist, Joseph Harrison, paid his debts, acquiring the collection as security and storing it in his factory's boiler house. Catlin died in 1872, and after Harrison's death in 1879 the artist's widow gave his Indian Gallery to the Smithsonian, where it can still be seen, in a historical collection, though it is one of the greatest glories of American art.

Devil's Elbow, Rokeby Park

John Sell Cotman

Pencil and watercolour on paper |
35 x 45cm | 1806–07 |Castle Museum, Norwich, England

T urner's stupendous sunsets dominated English landscape painting two hundred years ago. Even Constable couldn't challenge him on his own terms, so an artist with as quiet a temperament as John Sell Cotman (1782–42) didn't stand a chance. His career was passed in the shade of Turner, whose turbulent effects he spent much of his time trying to emulate. But this, as Cotman knew, was contrary to his own artistic nature, and he became increasingly depressed. He was one of the world's great painters of shadows, but was doomed to be overshadowed by a brilliant star and by his own self-doubt. Few artists have ever made so much of so little as John Sell Cotman. There's nothing particularly picturesque about this tree-clad corner of a park: no romantic bridge, no distant view; even the trees themselves are unremarkable, indeterminate lopsided growths. It's just nature being natural, but somehow the picture is about everything. Its composition strikes a quiet chord that is at once utterly ordinary, and yet serenely beautiful.

John Sell Cotman was born in Norwich, the son of a well-to-do dealer in silks and lace. His artistic ambitions surfaced early, and at the age of sixteen he went to London to "breathe the air of art". He moved confidently into the circle of Girtin and Turner, the most radical young artists of the day, joining them in their sketching club evenings when they experimented with watercolour, a medium that until then had been largely disregarded. Cotman could match them in anything, but he wanted to find his own way. In 1803 he visited the Cholmeley family in Brandsby Hall in Yorkshire. He taught their four daughters drawing, sketched the surrounding countryside, and was enchanted with the place. He was invited back again in 1804 and 1805. These were the happiest and most productive times of his life, when he was working purely for himself, and had no money worries.

During Cotman's last stay at Brandsby he visited Rokeby Park, and the sketches he made there, in five short weeks, fed his life. Everything he saw was beautiful. He found the simplest means to express his exhilarating joy: washes of stained water on white paper. The cloud and water ripples here are the untouched paper. Substance, as insubstantial as light, is given form by the shadows around it. But these shadows too are rarefied – clear, layered pools of deepening dark. No darkness is allowed to get heavy. Only the edges give clarity, wonderfully precise but sensitively unassuming, as if left by a receding tide. Cotman painted with shadows, and composed sensations of peace with their elusive shades. But the public didn't like it, and he had a growing family to feed. He spent the rest of his life teaching, illustrating antiquarian texts and painting pictures, many in oil, in styles that sold – swashbuckling and Turneresque – all the while becoming more and more dispirited.

The Castle Museum in Norwich now houses several of these later commercial works. They do contain flashes of genius: the side of an old cottage, a windmill under a cloud, a boat hanging for a moment on a crystalline wave, all inspired by his old self-consuming blaze. But as is so often the case, his genius was buried by want of money. If only Cotman had had the financial means to do what he really wanted, like Constable and Cézanne, who knows what the world might have gained.

Panorama of Scheveningen

Hendrik Willem Mesdag

Oil on canvas | 140 x 1200cm | 1881 |
Panorama Mesdag, The Hague, The Netherlands

I t's a strange sensation, standing in the middle of a painting, but that is what you can do in The Hague, where a rare painted panorama survives. Panoramas were invented by Robert Barker (1739–1806), a self-taught portrait painter and miniaturist. While strolling on Calton Hill in Edinburgh, enjoying the magnificent views over the city, the Firth of Forth and the Highlands beyond, he had the splendid notion of painting the entire scene on a vast scale, in the round. After several trials, he opened his first panorama in Leicester Square, London. Visitors entered at ground level and climbed an inner staircase up to a central platform. There they found themselves surrounded by a circular painted backdrop. The top light source was cleverly concealed by a canopy, so the surrounding scene seemed bathed in its own luminance. The base of the painting was disguised by a realistic foreground: in the example in The Hague a real beach, littered with fishing baskets and tufts of real grass, runs seamlessly into the painted sand.

Arguably the most popular form of painting ever, panoramas attracted crowds in their thousands. They transported people to exotic places and even back in time – into the centre of Constantinople, the heart of the battle of Waterloo, or the Temple Mound in Jerusalem as Jesus was being led to Golgotha. Panoramas spread from Europe to America, Russia and China. From 1793 to 1864, the original Leicester Square Rotunda showed no fewer than 126 paintings. But by the new century, their heyday was over. One writer lamented in 1913: "Poor panorama, the joy of our grandparents: today it is the cinema that makes our nerves tingle."

The Panorama of Scheveningen is the oldest still in its original location. It's the work of Henrik Mesdag (1831–1915), who began as an amateur artist but at the age of 35 gave up his job in his father's bank to paint full time. He rapidly became well known as a marine painter, and in 1881 the Société Anonyme Belge des Panoramas commissioned him to paint a view of the beach at Scheveningen. Exhibited in The Hague, then at rotundas in Munich and Amsterdam, it was much admired but failed to make any money. So Mesdag bought it back and had it permanently installed in The Hague.

Mesdag's panorama was unusual because its purpose was aesthetic rather than narrative, which was the reason for both its failure and its survival. Few people wanted to marvel at an ordinary Dutch beach. But the light in it is still extraordinary – that lovely, quiet dawn light that was so popular in European landscape painting before the blaze of Impressionism. It is fascinating to find yourself surrounded by a painting. You seem to be in it, breathing its air. The illusion works so successfully because the painting takes off at the distance when near vision loses its edge. Your eyes search for details in the loosely sketched fishermen laying out their nets, the women on the balcony, the boats riding the waves, but you can't pin them down. Everything seems to float in a hazy light, and everything seems alive. Van Gogh, who painted at Scheveningen, is reputed to have commented that the only thing wrong with Mesdag's painting is that you didn't know it was a painting.

New Kids in the Neighborhood

Norman Rockwell

Oil on canvas | 91.5 x 146cm | 1967
The Norman Rockwell Museum, Stockbridge, Massachusetts, USA

Norman Rockwell (1894–1978) was the son of a New York textile worker who copied illustrations as a pastime and read Dickens to his family. Norman was skinny, and lived in fear of the rough kids of the Upper West Side. He learnt illustration as a trade and had his first cover accepted by the *Saturday Evening Post* when he was just 22. Cover illustrations were vital for magazine sales – they had to be eye-catching and have the power to draw you in. They were self-contained narratives, not illustrations of the articles inside. Rockwell became a consummate visual storyteller, famous for his impish street kids getting up to mischief. By the 1920s he was America's most popular living artist, and he sustained this position throughout his long life. He was always on the lookout for scenes that caught the essence of something that was happening more generally in society. One popular cover showed an old Mennonite woman and her grandson sitting primly in a café, heads bowed, saying grace, surrounded by indifferent, lounging workers. Another showed a businessman in a suit standing in front of a painting by Jackson Pollock. We can't see his face and are left to guess what he's thinking. Rockwell enjoyed painting the drips.

Rockwell broke with the Post in 1961 when the magazine refused to accept any work that suggested something could be wrong with America. Increasingly committed to the Civil Rights movement, Rockwell painted *New Kids in the Neighborhood* (also known as *Negro in the Suburbs*) for *Look* magazine to accompany a report about "white flight" – white people leaving residential districts as blacks moved in. The situation is beautifully articulated by the expressions on the faces, the planted feet, the unfenced grass, the pink dress – as glowing as in Manet's *Olympia* – and the line on the path just in front of the girl's polished shoes. The chasm that separates the kids is filled by the lorry back, the dog and cat (with a chain behind it). Every inch of this picture has been thought and felt.

Rockwell's work was ignored by the mainstream art world because it was thought to be merely illustration. Moreover, its popularity made it suspect – modern art was supposed to disturb the public, not bring them with it. Even his Civil Rights paintings failed to earn him a place in the modern pantheon. The trouble with modernism's reductive viewpoint was that it excluded so much of what art can be about. The old masters were all illustrators, mostly of the Bible, and no less great for that. Rockwell hoped he'd be able to lift such restrictions from contemporary art, though, as he admitted towards the end of his life, "I no longer believe I'll bring back the golden age of illustration. I realized long ago that I'll never be as good as Rembrandt" – while adding, "I think my work is improving. I start each work with the same high hopes". Rockwell was always a genuinely driven and emotional observer of life who, at his best, worked with intense concentration on a large scale. Sadly, there are virtually no Rockwells in public collections, though they were, in their time, far and away the favourite modern paintings of the American public. Almost all of them are now housed in his museum in Stockbridge, a collection bequeathed by the artist, where they provide visitors with an extraordinarily vivid survey of sixty years of American life.

Sonata of the Stars
Mikalojus Konstantinas Čiurlionis

Tempera on board | 62 x 73cm | 1908 | M.K. Čiurlionis
National Art Museum, Kaunas, Lithuania

T he son of a church organist from Varėna
in Lithuania, M.K. Čiurlionis (1875–1911)
began his artistic life as a musical prodigy.
He studied the piano in Warsaw and started to
compose, eventually writing 250 pieces, including long
symphonic hymns to the forests and the sea. But in 1903
he switched to art, briefly attending a drawing school,
before leaving and teaching himself. His aim was to
capture in images the exhilarating feelings he had tried
to express through music – his overpowering emotional
response to the wonder of being alive. He produced
a series of paintings which he called sonatas, evoking
spring and summer, the sun, the sea and the stars.
These were visualizations of what it would feel like to be
present at, say, the birth of a star, with all the feelings of
wonder and awe that such a moment would awaken.

Čiurlionis was fascinated by astronomy, and was
enchanted with the picture of the cosmos revealed in
a series of books, renowned for their illustrations, by
the French astronomer and intermittent spiritualist
Camille Flammarion. Christianity gained its foothold
in Lithuania much later than in any other European
country, and paganism survived until at least the
seventeenth century. The country's legends and
fairy tales still retain their hold on the Lithuanian
imagination, along with a traditional passion for song.
The art of Čiurlionis is characterized by a unique
mixture of Christian, folkloric and scientific imagery.

The decades between 1890 and 1910 saw an
extraordinary transformation of European art.
Theories about evolution, the subconscious and atoms
undermined the centuries-old Christian belief in the
divine origin of creation. Many young artists were
no longer content to paint the mere appearance of
things but felt that deeper, more vibrant truths could
be revealed in pure colours, shapes and rhythms on
canvas. Symbolism and Fauvism, Cubism, Futurism
and Suprematism, and later Surrealism were born
out of this maelstrom. The major cities of France,
Germany, Holland, Italy and Russia acted as magnets
to the artists who fomented these revolutions.
Čiurlionis, working in provincial cities after an
unsuccessful attempt to make his fortune in St
Petersburg, does not truly fit into any trend – his
imagination and practice were too idiosyncratic.

Like many artists of his time, Čiurlionis's work
tended towards abstraction and revealed a passion
for patterning. (Kandinsky, who saw his paintings in
1910, was much affected by them.) Čiurlionis wanted
to discover direct equivalents in visual art for musical
experience, and like other artists with similar interests
(including Kandinsky) he claimed to be a synaesthete:
able to see colours when he heard sounds and vice
versa. His search for these visual equivalents was
highly systematic. Many of his paintings are in sets
of three or four, corresponding to the movements

of musical compositions, especially sonatas. Often, a pattern appears in a painting, like a theme in music, and is then repeated in a transformed state, as in a set of musical variations.

The *Sonata of the Stars* is painted within a geometric framework that is reminiscent of a musical score. Only two of the planned four paintings were completed. *Andante* (see right) shows a winged angel walking slowly along a celestial belt in front of a pyramid of light, while a great coil of stars sweeps up from a white yolk hatching in the centre of a dark, low sphere. All the movement is from left to right, as if you're watching its slow pace from the quiet safety of a nearby orb. In *Allegro* (see p.174) the movement has swung round and swept you into it. You are no longer on the bank but in the swim, and everything has gained momentum. The angel is now leading you, or coming towards you. Once you sense the movement down this central path – the waves of energy all around and beneath you – you suddenly come alive with their erratic action, the depths in the picture gape and distant worlds are born. The painting also recalls the tremendous crescendo in one of Čiurlionis's musical compositions, *The Sea*.

Čiurlionis produced over three hundred paintings between 1904 and 1908. He never sold any, though the ones he gave his friends were cherished. In late 1909 he sank into a deep depression and spent the last two years of his life institutionalized in the Pustelnik hospital, near Warsaw, unable to paint. He died of pneumonia at the age of 35. It is a haunting experience to stand among his pictures, painted in delicate but ever more assured washes of tempera or water-based paint, on the cheapest of paper and card, all that the artist could afford. The M.K. Čiurlionis National Art Museum in Lithuania contains virtually the whole *oeuvre* of a painter long hailed a national hero but hardly known outside his native land.

Andante from Čiurlionis's *Sonata of the Stars*. Sadly, the rainbow colours of both paintings have now faded.

Houses in Riegsee

Gabriele Münter

Oil on canvas | 1920 | Private collection

To visit Munich's Städtische Galerie im Lenbachhaus is to witness a remarkable love affair. Two of its galleries are hung with small jewel-like landscapes, remarkably intense in colour, as if the mountains and skies in them, the trees, fields and clouds, the houses and roads, even the washing lines, had been viewed through a kaleidoscope of precious stones. The paintings are like fragments of medieval stained glass glowing on the walls. At first you assume that they're all by one person, but then you see the names of two separate artists: Gabriele Münter (1877–1962) and Wassily Kandinsky (1866–1944).

Münter and Kandinsky met in 1902, when she enrolled in his painting class in Munich. She was 25, he was 36 and married: a sophisticated, urbane Russian, trained in law, who had taken up art only six years earlier. They fell violently in love. After Kandinsky's tortuous divorce, told in the lovers' ecstatic, agonizing correspondence, the two were eventually united in 1904, and began painting together almost nonstop. Both had small private incomes. Unable to settle, they lived successively in Holland, France, Switzerland and Italy before finally moving to Murnau, just south of Munich in the Bavarian Alps, in 1908. Here they lived and breathed art; their shared ambition to produce paintings that represented nothing but their own integral meaning. Kandinsky's approach tended to be self-conscious, Münter's instinctive. He wrote to her when she was his student: "You are a hopeless pupil. All I can do is guard your talent and nurture it like a good gardener, to let nothing false creep in – you can only do what has grown within you (yourself)." To a large extent she led the way. She loved the local craft tradition of painting on glass – Madonnas and folk scenes in brilliant, shining colours with bold, black outlines – and did some herself. Then she made a breakthrough. "After a short period of agony, I took a great leap forward – from copying nature – in a more or less Impressionist style – to feeling for the content of things – abstracting – conveying an extract." Kandinsky built his theory of art on the paintings they did together and on their love for each other. For a while their work was almost indistinguishable, though Münter noted that "in my case it is largely or nearly always a smooth flow of lines – parallel – harmony – in your case it is the opposite, the lines collide and intersect in your work." In *Houses in Riegsee* the colours – the whites, yellows and scintillating blues – appear to project forward, singing, while the things they represent – walls, windows and washing – retreat into the background. Blacks are included not to give shaded substance to forms but to act like leaded bars in stained-glass windows, enhancing this dance of hues. The embracing curves are the homecoming of love.

Then in 1910, Kandinsky saw one of his paintings that had accidently been stacked upside down. It was incomprehensible as a representation but it surprised him with its "glowing inner radiance". Two years later he published his manifesto for abstract art, *Concerning the Spiritual in Art*. Münter's role was now forgotten and, in any case, Kandinsky's love had cooled. Separated when he was forced to leave Germany as an enemy alien at the outbreak of war in 1914, their relationship never recovered. Münter kept their Murnau paintings, and their letters, hiding them from the Nazis during World War II. On her eightieth birthday she gave them all to the Munich gallery where they can still be seen, a remarkable and moving testament to a love affair in art.

Untitled (Trains and Tunnels)

Martín Ramírez González

Pencil, crayon and watercolour on paper | 91 x 105cm | c.1954 | Estate of Martin Ramírez

I t's only during the last 150 years or so that we've begun to appreciate the qualities of art produced by people with mental illnesses. Even now it's often put into a special category, and labelled "Outsider Art". But why have a distinct category at all? Visual expression is valid whatever people's mental state, and if this work vividly communicates deep feelings it should be recognized as art, without any special pleading.

Martín Ramírez González (1895–1963) was born in Jalisco, Mexico, one of eight children, the son of a poor tenant farmer. The family were proud of their Spanish ancestry, and devout Catholics. Ramírez married in 1918, and became a sharecropper, rearing a family of four on a small plot of land, much of the produce from which went to pay the rent. A photograph of him in his mid-twenties shows a dashing, bright young man, confidently smiling, with his hair swept back over his forehead. He was already famous locally as a horseman and hunter. But relentless poverty ground him down. In 1925, like thousands of others, he went to America, labouring on the railroads to save enough money to buy land. But while he was away civil war broke out across Mexico, and his wife and family had to flee. The evidence is scanty, but it appears that he received a letter from a cousin who could barely write, which he misinterpreted as saying that his wife had left him and abandoned their Catholic faith. He never returned to Mexico, and when once asked, much later in life, whether he wanted to see his wife, he replied that they would meet "in the Valley of Jehoshaphat", where God judges people's lives.

What happened to Ramírez in America is unclear. He was picked up by police in California, wandering distractedly, was diagnosed as a manic depressive and incarcerated in the grim Stockton State Hospital. A railway ran outside. He withdrew into himself and began to draw obsessively on scraps of paper. In 1948, he was moved to the DeWitt State Hospital, Auburn, where conditions were little better, though he did manage to get more bits of paper which he stuck together with glue he made from oatmeal and spit. Ramírez would crouch on the floor on these mats of paper and draw painstakingly with a pencil, using matchsticks to apply the colours, derived from ground-up crayons, charcoal, fruits and boot polish, which he mixed with spit and kept in little cups made from oatmeal paste. Tarmo Pasto, the professor of art at nearby Sacramento State College, visited the hospital where he saw the artist at work. Fascinated, he began saving his pictures and promoting them.

Ramírez never explained what his pctures were about. A frightened rider on a friendly horse often appears, as the world closes in around them. The tunnels that he drew obsessively seem obviously sexual: a penis emerging from a foreskin and entering a vagina. But they may have another meaning. The train here has windows in its roof. It could be that Ramírez has depicted a brief interlude of mental clarity before his mind was hurtled back into darkness.

7 Hidden by Conceptual Art

All art is a concept, because it's the product of thought. But all visual art must also be a creation, because it's made out of visible material, be it paint, stone or objects, elaborated to create something new, such as the bull's head Picasso made out of a bicycle saddle and handlebars. The notion that art can be just an idea is a recent invention, born out of the confluence of modernist philosophies, consumerism and the intellectualization of art education. Now anything can be art if anyone who thinks they're an artist says it is, whether it's a stack of bricks, an unmade bed or a bin-bag. The trouble is that you can't tell by looking at a found object what the person who put it there is trying to tell you, if he or she hasn't altered it in any meaningful way. Nor does the act of placing something in an art gallery automatically make it art, any more than canvas with paint on it automatically becomes a painting. A pickled shark put on display in a museum rather than a gallery remains just what it is. You have to be able to see art; it can't be merely a projected thought. You can dress up anything in fancy ideas, as the emperor found out to his eternal embarrassment. The contemporary art world has become a self-referential court sustained by public funds (largely through galleries and educational institutions) and a few rich dealers and collectors, in which con artists weave their spurious reputations. Despite the millions spent on them, found objects are worthless, and their promotion has sidelined the genuine art of our times.

Sharmanka Theatre

Eduard Bersudsky

Mixed media | 1967– | Sharmanka Kinetic Theatre, Glasgow, Scotland

Entering the Sharmanka Theatre is like walking into someone's skull and seeing all the brain cells working at the same time, not just the wheels of thoughts going round but the countless images that spark from each one: the dreams and nightmares of a dark subconscious exposed to your gaze. A wealth of bizarre scenes vies for your attention: cavorting monkeys; skeletons and angels; chains, wheels and axes; alchemists and magicians. You need to get up close to see the little eyes that glow at you down from pinnacles and up out of crevices, to watch an old man fishing sadly into empty space, or an overweight rabbi repeatedly, but impotently, lowering himself down on to his plump wife. Each piece has its own climax, provoking amazement as much as laughter. In his *Time of Rats*, 1989 (see opposite), rats dance to records, turn handles, pull strings – typical human activities – while a big-busted beauty types messages and compiles reports on an old machine, and a show-off, military rat displays his prowess by jigging madly up and down a pole. These scenes are all being performed on the back of a giant, blind mole with whirling whiskers and lolling tongue, which is fishing for worms. Its paws spin madly but it's going nowhere, just slowly turning round. This ludicrous brute is Russia. Communism haunts this imprisoned vision, and the terrible dictatorship of ideologies.

Eduard Bersudsky was born in 1939 in Leningrad (now, as it was originally, St Petersburg). He narrowly escaped starving to death in the terrible siege of the city during World War II. His experience in the Arctic during military service, where he met gulag survivors, and the elimination of several of his friends, robbed him of the desire to speak. Instead, earning his living as a naval mechanic, he began to carve figures out of bits of broken furniture. He made his first automaton in 1967 – a carving of an old barrel-organ (*sharmanka*) player, with hunched shoulders, a grim weariness on his face and a long, straggling, unwieldy beard. After he'd hitched up a motor inside and made the man's arm grind round, Bersudsky jumped back in surprise: he had found his artistic voice. He couldn't speak but his sculptures could. Officials dismissed him as a toy maker, little realizing that his "toys" showed Lenin shouting from a pulpit and Stalin chopping heads off in a basement. Bersudsky was exceptional among Russian underground artists in being a macabre joker.

When Tatyana Jakovskaya, a well-known theatre director, saw Bersudsky's secret room in 1988 she realized it could be presented as theatre, and so Sharmanka was born. After the perestroika reforms of the late 1980s, Bersudsky and Jakovskaya both moved to Glasgow, helped by their friend, the sculptor and furniture-maker Tim Stead. Once again Bersudsky found his work largely dismissed as toy-making by the contemporary art establishment, though it was enthusiastically embraced by the theatre world. The orthodoxy of modernism cannot accept art that is funny and sad, popular and profound, and crafted by hand. So Bersudsky's art is still being obscured by ideology in the free West, as it was in the Soviet East.

Il Giardino dei Tarocchi

Niki de Saint Phalle

Mixed media | 1979–98 | Garavicchio, Italy

Sun-drenched olive leaves drip silver, and shadows shimmer beneath them. In the *Giardino dei Tarocchi* (Tarot Garden) the light is magical. Between the dark trunks and shaded branches of the olive trees are walls of multicoloured mirrored glass, reflecting their dappled light back at you, so that you feel you're bathing in some celestial stream. The effect is sensual, spiritual, sexy and innocent all at once. Then, as you wander along the twisting paths, the branches above your head part to reveal the mirrored walls rising into the deep azure sky, forming the breasts and head of a great sphinx, a toppling tower, a red rocket, a looming judge and the masked face of a magician (illustrated here).

The grove you are walking in is inhabited by gods and goddesses. What's odd is that, because everything is so light, you don't feel their massive presence between the trunks and branches, but only sense them as if they were daylight ghosts or spirits – apparitions from another age, allowing themselves to be glimpsed as a special privilege. There's something very ancient about this garden, even though it was only made recently. The sensation it gives the visitor is surely what it must have felt like to walk through the sacred grove at Delphi or down the Avenue of the Dead in Teotihuacan, when these spiritual places were packed with painted, gilded statues of the gods.

That wasn't the conscious intention of Niki de Saint Phalle (1930–2002). She achieved a confluence with the distant past by following her artistic instincts, ignoring all the dos and don'ts of modernism, in creating the garden she had dreamed of as a child. It was the magical place where she wanted to be, bathed in love and beauty, safe from the sexual advances of her father (who wanted her as well as her mother); a garden that she painted in little gawky pictures as therapy after a breakdown following her first marriage. Abandoning her high society existence as a glamorous model (she once graced the cover of *Life* magazine), she joined a gang of dropout beatniks and began to make her "shooting pictures": sacs of paint buried in plaster which bled when she fired at them. Her marriage to the artist Jean Tinguely settled her down a little, and she started to produce sculptures – brides in white dresses and devils in black coffins, and realizations of the mythic figures in Tarot cards. Tinguely helped her to build her dream garden, in an olive grove in Tuscany lent to her by an Italian friend. The income from a scent marketed under her name, in a snake-headed bottle made to her design, helped fund the project. The garden took her twenty years to complete, with the artist sleeping inside the right breast of the sphinx, a journey back through the dreams and nightmares of her life.

There is pain here – a bloodied beast on an altar and Death riding through a sea of chopped-up, waving limbs – but mostly the mood is of glorious, exquisite tranquillity. The garden is best seen at dusk, as night begins to settle over the nuclear power station down the coast, and her towering figures begin to glow in the starlight.

Rock Garden of Chandigarh

Nek Chand Saini

Mixed media | 1958– | Sector No.1, Chandigarh, India

The Rock Garden of Chandigarh began as a secret. Its creator Nek Chand Saini (b.1924) was the son of a poor Hindu farmer in what is now Pakistan. After the Partition of India and Pakistan in 1947, his family moved east, and Nek Chand took advantage of a government employment scheme to get work in Chandigarh, a new city being built to help house the millions of refugees from the west. It was the first modern planned community in India, designed by the Swiss-French architect Le Corbusier, and described by Prime Minister Nehru as "a new town symbolic of the freedom of India, unfettered by the traditions of the past". Nek Chand worked as a roads inspector, but soon began to loathe what he was helping to create. The roads, the houses, even the sewers were locked in a grid system. There was little room for anything as natural as a curve.

In 1958, Nek Chand built a hut for himself, hidden among the trees on a stretch of wasteland near the Public Works Department depot where he was based. He collected lumpy rocks that looked a bit like animals and people, to make him feel at home. Then he began to make animals and people himself, out of discarded metal and concrete from the depot, decorating them with broken pieces of lavatories, sinks and baths, and other fragments from the villages bulldozed to make way for Chandigarh. He worked at night, always in secret, perpetually in fear of being discovered, for he knew it was illegal to build on a site designated as "open space". But he was driven by the desire to create a place where he and others would enjoy *being* – so different from the desolate city he was building by day. By 1975, when his "garden" was eventually discovered, it already covered twelve acres! Officials were amazed by this "hidden art treasure" and, quite exceptionally, they changed the law to accommodate his creation. Nek Chand was given a salary and a team of workmen, and told to get on with the job of building his dream.

In Nek Chand's Rock Garden his spirit of selfless generosity takes wing. You feel elevated the moment you go in. The garden is built along the sides of a twisting ravine, and much of the early section is seen at eye level. It's as if you have just risen up through celestial clouds and are looking around, wonder-struck, at the fields of heaven, seeing all the monkeys, elephants, peacocks and people, happily perched in everlasting bliss. The garden now stretches way beyond this area: deep gullies are woven with the twisted roots of trees, some real, some made of concrete. Hindu gods stand smiling above a cascading waterfall; there are arched grottoes where visitors can sit on swings and gaze up at a herd of white horses riding overhead. It's not surprising that this is now the second most popular visitor attraction in India, after the Taj Mahal – a remarkable achievement for a humble roads inspector.

Mother and Child
Elizabeth Nutaraluk Aulatjut

Grey stone | 1972 | 16.8 x 17.2 x 15.6cm |
Art Gallery of Ontario, Toronto, Canada

People reached the Canadian Arctic more than five thousand years ago, searching for new hunting grounds. They made everything they needed with their hands from the skin, sinews and bone of animals, and out of ice and rocks. But because they were nomadic, very little evidence of their work remains. Their culture was mostly carried in their heads, tales told during the weeks of winter night when the sun never rose, such as the story of the beautiful Sedna who refused all suitors and married a seagull, who promised her a life of luxury and ease. Carried off to a barren island, Sedna was left there alone and weeping. When her father rescued her, the birds attacked his boat. In a desperate effort to escape, he threw her overboard, but she clung on. He had to hack her fingers off before he could finally get away. Sedna, with her stumpy palms, sank to the bottom of the sea and became the spirit of the waves. Her fingers turned into whales and seals. In Inuit culture everything in nature is transforming – water into ice, clouds into snow, people into animals – and everyone has a protective spirit. Tiny carvings, over a thousand years old, have been discovered of flying polar bears, their bodies marked with crosses as if they were constellations. You could easily carry one in your pocket, a good-luck amulet to watch over your destiny.

By the eighteenth century almost all the Inuit had been converted to Christianity but continued to lead a peripatetic hunting life. In the twentieth century pressure grew for them to settle. Modern amenities and goods became available – the gull's promise of luxury and ease – but for many it proved a hell of aimless, workless, welfare existence, alleviated by violence, sex and drugs. The Canadian Guild of Crafts proposed that the Inuit start making ash trays, napkin-rings and little boxes carved with scenes of Arctic life. Then in 1948, while staying in Port Harrison, Inukjuak, the artist James Houston drew portraits of the people there and was given small carvings in exchange. He showed these to the Guild, who realized that this was authentic Inuit art. The Inuit had been making art for years without knowing it, since they had no word for "art". Carvings were the things they made with their hands to illustrate the tales they told.

Elizabeth Nutaraluk Aulatjut (1914–2002) lost more than half of her thirteen children during the famines of the 1950s. She has said: "Before I make a carving I think about women, how they used to live a hard life before, how they were always cold. I always talk to the stone: 'What are you going to be? I know you won't answer, so I will do what I want.' I always have strong feelings before I make a carving." This stone is like a womb. The figures are wrapped up in it as bodies are wrapped up for warmth, especially babies just after birth. But their extremities are exposed – to cold, death and grief. The scratches on the edges here could be Sedna's fingers grasping to hold on to life. This is heartfelt sculpture, genuine expression without any trace of pretension, worthy, in its modest way, to sit alongside the works of Barlach, Moore and Michelangelo.

Buka War

Mathias Kauage

Acrylic on canvas | 122 x 173cm | 1990 |
Gallery of Modern Art, Glasgow, Scotland

Art flowers in unexpected places, along
fault lines between cultures – symbolized
by the black snake-line that divides the two
worlds in this painting. The traditional warriors
dressed in modern army uniforms hide in the green,
flowering jungle haunted still by birds of paradise. They
are attacking the Australian miner in the bulldozer
who is clawing up their mountain. Hand grenades fly.
This is a painting of the war fought between the native
people of Bougainville, a dependent island of Papua
New Guinea, and Bougainville Copper, a dependent
company of Rio Tinto Zinc. The locals claimed that the
huge mine was destroying and polluting their country,
and that they didn't benefit from the fortune made
there. Bougainville Copper argued that the mine was
vital to the wealth of Papua New Guinea as a whole. The
Bougainville War of Independence erupted in 1988 and
closed the mine in 1989. The troubles have since been
smothered, but the mine remains closed.

Papua New Guinea is one of the last places on
Earth that remains largely unpenetrated by Western
materialist values. Its vast mountainous interior, still
uneaten into by roads, is inhabited by tribes who've
been settled there for so long they speak over eight
hundred different languages. Inter-tribal disputes are
resolved through ritualized wars, involving elaborate
displays of carved shields, war paint and headdresses
made of bird of paradise plumes. Mathias Kauage
(1944–2003) was born in the central highlands. He saw
his first helicopter when he was a child: "I went to get a
bow and arrow. I wanted to shoot the bird." He worked
first on an Australian-owned coffee plantation, before

drifting into the capital Port Moresby where, as an
illiterate worker with no skills, he got a job as a cleaner.
In 1969 he saw the drawings of Akis, a highlander who'd
been inspired by Georgina Beier, the British artist-
in-residence at the university. Kauage began making
copies of illustrations in Western books and sent them
to Georgina. Though she disliked them she encouraged
him, feeling he was like "a volcano about to erupt". One
day, her eye was caught by a strange insect in the corner
of a landscape. Kauage then began drawing imaginative
animals and people. He had found his style, a shotgun
marriage between traditional tribal designs and
representational Western art.

Paintings poured out of him on all aspects of
contemporary Papua New Guinea life. One, entitled
Carry Leg, shows a couple with their legs entwined and
radiant smiles on their sun-like faces. These were the
liberated young who had defied their parents' wishes
and married for love. Flowers bloom around them
in the green jungle. Another, called *Suicide*, reflects
what was a growing problem among young women
in Papua New Guinea. It tells the story of a woman
who, against her wishes, has given up her life of sexual
freedom and agreed to the traditional marriage her
parents have arranged for her. But her husband is
consumed with jealousy, constantly accusing her of
continuing to have other lovers. She cannot make
him content, and hangs herself from a tree at night.
Her husband weeps white tears at her feet, in the dark
moonlight. Kauage's paintings were produced totally
outside the contemporary art world, yet they deal with
contemporary issues in the most vivid way.

The Botallack Hoard

David Kemp

Scrap materials | 1979– | Artist's collection

Our knowledge of the Last Machine Age is very sketchy. The sagas of the *Tekniko* and *Mekanik* cults provide conflicting information, but their repeated references to an even earlier mythology of omnipotent "machines" leads us to believe that these must have some basis in fact. Recently a major breakthrough occurred to confirm this. Settlers sinking a well on a cliff edge in western Britain broke through to a long gallery filled with ancient artefacts (obviously an early *Tekniko* shrine). But then they dug deeper and discovered chamber after chamber littered with the dismantled components of a far earlier era. Guided by the clues mythology has passed on to us, it has been possible to attempt some partial reconstruction of what must have been the sentient "machines" of that lost age. The main element which is missing, and of which there seems to be no trace, is the source of their motive power, the fabulous "magic" of the White Men. But we can now confidently claim that there once was an ancient tribe whose knowledge tied the four corners of the world together and whose sorcerers had many powers. They made great poles that held the sky up, and had great cunning with fire, making night like day. They could send pictures in the wind and their long tongues could speak over many miles. Their warriors rose in the air over land and sea and overcame all the other tribes of the Earth. But one day the smoke from their machines grew thick. Fires spread everywhere. Flames licked up the poles and burnt a hole in the sky. Slowly the sky started to fall, and the tribe, fearing the dreadful weight of the clouds, dug deep holes in the earth and hid, waiting for the sky to be pushed up again.

David Kemp (b.1945) created the world's first and last Museum of the Future in a building on a tin-mine site near Land's End in Cornwall, where he has lived for over thirty years. He is one of the most inventive artists to follow Picasso's lead in making playful puns with junk. But his work isn't only a sequence of imaginative flips between familiarity and fantasy, though it achieves that a thousand times, when tail-lights turn into angry eyes, road cones into flower trumpets and rubber boots into frolicsome dogs. What makes his art unique is the world picture it constructs. Those who visited his spoof museum laughed and cried at the myriad witty and poignant correspondences it constructs between contemporary life and the great world cultures of the past. The Trundler Sun of 1987 (see opposite), his variation on the theme of the Trundholm Sun Chariot (see p.55), is made from scrap metal, old agricultural equipment, a child's rocking horse, a dustbin lid and toffee wrappers. Our hopes and fears, still mostly irrational, are the myths of the past. This extensive museum is only part of Kemp's output. He's also one of Britain's best public sculptors. On the former site of Europe's largest steel works, at Consett in County Durham, colossal faces made of industrial transformers peer over the grass fields, like modern Easter Island heads – moving tributes to the passing of a real Industrial Age. Sadly, Kemp's museum is now closed, though part of it was on show in 2010 at the the Royal Cornwall Museum in Truro.

Bimbo Town

Jim Whiting

Mixed media | 1995– | Leipzig, Germany

Bimbo Town only opens once a month, in an old spinning factory in Leipzig. Around midnight, thousands of people huddle through its unprepossessing door. If they're not careful, a pair of electronic legs kicks them on the shins. The punishment begins. You need to be quick on your feet in Bimbo Town. The best way to get about is to leap on to a passing bed. Then you can glide gracefully past bars, cabarets and living rooms, while far above you, shirts, dresses and suits skip and jerk about on pulleys – echoes, in the night, of the madness of your daily work. At one junction, high up, a big grey bottom is given a mighty thwack. Then you turn into a tunnel. Ghosts open their wings. You might be safer on your feet. But not for long. A wobbling mini-mountain of lorry inner tubes heat-senses your presence and pursues you, the embodiment of dark desire. You escape to a seated area, carpeted and lined with books. But then the library begins to move. Someone has found a joystick and is driving it and you, at speed. You jump off. You need a drink, but the seats at the bar have a nasty habit of spiralling upwards. Nearby a table has started to walk. A couple have taken their clothes off and are splashing about in a cascade of baths. You're not quite ready for that. A large, comfy sofa calls. You sink into it but the sofa suddenly gobbles up you and your laughter and ejects you on to a bouncing bed.

Jim Whiting was born in Paris in 1951; half English and half Swiss, he was brought up in Rhodesia (now Zimbabwe). His parents were devout Christians, and he was allowed no books except Biblical texts. As a boy he suffered from rickets and had to wear leg-clamps. One night, he saw a woman being raped: he glimpsed an exposed leg and the flash of a knife, and thought her leg was being cut off. Terrifying nightmares haunted his childhood. His father made immaculate model boats for him but he wasn't allowed to touch them. The local boys were more generous, and showed him how to make toys and musical instruments out of junk. He began to create an imaginary world. He dreamed of constructing a funfair for everyone, became a wizard with Meccano and later, at school, invented robots.

In England, Jim Whiting studied electronic engineering and systems control but got bored, then briefly attended art college, leaving when he realized it had nothing to teach him. He earned a living renting out robotic legs for discos and videos, most famously for Herbie Hancock's 1983 album *Future Shock*. He's never applied for a grant, believing that to be the kiss of death for an artist. How can artists say what they're going to make before they make it? Making is everything and the "it" has to remain out of reach. For a time he lived in a pantechnicon, driving round to different venues – a quarry, a public square, even, occasionally, an art gallery – showing his heavenly hosts of angels, purgatorial drunks, and demons made of articulated buckets and suitcases, whipping out of hell. Eventually he settled in Leipzig, where he has built a world animated by compressed air – precision engineering turned into the most fantastic art.

Night Sky Dreaming
Paddy Japaljarri Sims

Acrylic on canvas | 281 x 406cm | 1993 |
Glasgow Museums and Art Galleries, Scotland

In 1993 Tamara Lucas, a young curator from Glasgow Museums, went to Australia to purchase examples of contemporary Aboriginal Art for the city's new Gallery of Modern Art. Her brief was to acquire art that had been made not for tourists but for religious reasons, and to find out what she could about the work's spiritual meaning and purpose. This meant staying with Aborigines in Yendumu in the Northern Territory. A vegetarian, she had to get used to eating kangaroo, lizard and grubs. She slept in the open on the ground (there were no hotels), plagued by mosquitoes. But gradually she began to understand these people's culture and became absorbed by the infectious warmth, animated storytelling and laughter. One day, one of the women recognized her and gave her an Aboriginal name. Suddenly she had a father, Paddy Japaljarri Sims, and was expected to cook for him. He complained immediately about her food. She returned to Glasgow with a few paintings, some stories, but nothing much. Then, a few months later, a fax arrived from the Walukurlangu Aboriginal Artists Association saying that Paddy Japaljarri Sims was about to perform a Night Sky Dreaming and if his "daughter" would return, she could see the ceremony, and Glasgow could have the painting. The Aborigines had no use for it after it was done; they had no tradition of hanging art on walls. The doing was all that mattered to them. But they liked the idea of their "art" hanging in foreign galleries because this helped to promote awareness of their culture. So Tamara went again.

Traditional Aborigines have their own concept of time. For them everything has its own time – the seasons, rocks and waterholes, plants, animals and humans. These times are distinct rhythms repeated from the beginning of creation when everything was dreamed into existence. The chief purpose of a traditional Aborigine's life is to re-dream the beginnings of things so that all stays well with the world. Paddy Japaljarri Sims (born c.1916), a senior figure in the community, was responsible for dreaming the Night Sky. The ceremony began with a group of men travelling to different sacred sites to gaze up at the stars. Tamara, who was allowed to go with them, was amazed by the brightness and jewelled colours of the night sky. The painting began when they got back to base. In the past it would have been executed in earth pigments on the ground, left to dry and then blow away. Now the Aborigines are attracted by the greater range and brightness of modern acrylics, but it's difficult to work on the ground with acrylic paint, so they use canvas, delighting in its smooth expanse.

Paddy covered it first with a bright pink which glows through, giving the picture the glorious restrained radiance of a night sky unpolluted by urban lights. Though he conducted the ceremony, everyone, including women, joined in to paint the picture, sitting on the canvas, adding the tiny dots, a process that took over three weeks. Paddy told the convoluted stories of the constellations while the painters burst into laughter and song, or broke away to dance. Even though Aboriginal painting is the greatest abstract art of our times, and an expression of the oldest continuous culture in the world, many modern art galleries refuse to recognize it as such because of its religious and social purpose.

Monkey King

Hock-Aun Teh

Acrylic on canvas | 153 x 153cm | 2009 | Private collection

T he Monkey King hatched from a stone egg at the beginning of the world. Leaping great distances, he soon conquered the Earth, and then jumped up to heaven and pinched the peaches of immortality. Buddha told the Monkey King he could have his throne if he could jump across his hand. Hurling himself with all his might, the Monkey King reached a pillar, and assuming it was the Buddha's little finger, peed on it. Then his eyes were opened. He'd only reached the first finger. Buddha clamped the Monkey King under a mountain, but eventually let him out to help the monk Tripitaka bring the Buddhist scriptures to China. The Monkey King's antics have long been favourite children's stories; countless acrobatic operas and now TV cartoons are based on them. This painting captures the cheeky spirit and vitality of the Monkey King, his explosive birth and flaming energy.

Harnessing energy is the key to Hock-Aun Teh's art. His paintings look quite spontaneous, but they are in fact built up in layers over many days, the products of gradual thought, in this case remembering stories his grandmother told him. Every brushstroke is deftly executed; its action has to be exactly right if the life in it is to leave a trace. Though it might not look like it, this is traditional Chinese painting. Enabling the brush to capture the "spirit flow" is the essence of their ancient calligraphic art. Chinese characters are summaries of pictures of things – a tree, a house, a man – so their writing is in fact an abstracted form of painting. Hock-Aun Teh has extended calligraphy to embrace the whole experience of living. A dive into an ice-cold lake, running with a kite, or the slow burgeoning of

spring will all inspire paintings with totally different conflagrations of colours and brushwork.

Hock-Aun Teh was brought up in Malaysia, where his parents had moved to from China. He learnt traditional Chinese watercolour painting, but felt restricted painting sparrows flitting through bamboo. Then he discovered "Mad Grass" calligraphy, an ancient Tang Dynasty style, in which scribes attacked large sheets of paper with vigorous strokes. This chimed in with Teh's growing mastery of martial arts. Martial arts release the energy in the body: executing a leap is like wielding a brush. But Hock-Aun still felt constrained, and he made another leap – to the West. He was liberated further by Abstract Expressionist painting, which had itself sprung from the Eastern, particularly Zen, idea that the spirit resides in the action, not in the end product. Many Chinese artists have tried to regraft Abstract Expressionism on to their own traditions, but memories of landscapes usually restrain their shapes and colours. Hock-Aun Teh's painting is startling because of its explosive spectrum and pure abstraction. There are currently about a million officially registered artists in China, and no one will ever know all their work. But major exhibitions in Beijing and elsewhere indicate a culture confused after a long period of officially imposed Soviet-style socialist realism. Instead of depicting happy peasants at work, artists have now turned back to painting misty mountains in watercolour or are emulating Impressionism in oils. A few have leapt on to the bandwagon of Western conceptualism. Hock-Aun Teh's paintings demonstrate that genuinely modern Chinese art can flower on its ancient tree.

Hinten, fern…

Peter Angermann

Acrylic on canvas | 200 x 250cm | 2009 | Private collection

Peter Angermann (b.1945) now seldom leaves the region of Germany where he was born, the beautiful rolling countryside just north of Nuremberg. Here he paints life around him: summer fields with bales of hay wrapped in bright blue plastic, rolling woods cut through by a motorway clogged with dismal traffic, or just a cherry tree in full bloom, every picture a blaze of colour. Sometimes his subjects are disturbing: a scene based on a local newspaper report about the rape and murder of a girl on a canal towpath, in broad daylight, within sight of cyclists riding past.

On the eve of the Iraq War, explosions and flashes from the NATO base near Angermann's home punctured his usually peaceful horizon. In *Hinten, fern…* he painted his family watching the real war on television. The whole painting is the TV screen (the rainbow ball is the channel logo). Within its frame, the family watches goggle-eyed as limbs are sliced off, people are shot and a head explodes. The television has transported them into the middle of the battlefield while they still lounge comfortably at home. Reality morphs into entertainment before their eyes. This transition is picked up by the brushwork, which becomes cartoon-like as the suffering intensifies. Each watcher gazes at what's happening, trapped in feelings of impotence. Only the baby crawls close, unaware of the reality behind the illusion. The painting is very large. You feel, as you stand in front of it, that you are looking at the same television screen as the family. Angermann has created an image about watching and being watched, a contemporary variation on Velázquez' *Las Meninas*.

Hinten, fern… (Near and Far) is the quintessential image of a very modern feeling of informed helplessness. But how is it that the old-fashioned medium of painting, which some critics argue is or should be dead, can express such a challenging and elusive contemporary dilemma? Surely this is a subject for video, not pigment on canvas. Painting has had a hard run of it recently, but fortunately it hasn't totally died out. In Germany, it's been sustained by artists like Baselitz, Immendorf and Kiefer. Angermann has achieved something different because he can paint light, both everyday and imaginary. Somehow, he has managed to capture the shimmering quality of the television screen itself.

Angermann's mastery was hard won. He studied art at Düsseldorf from 1968 under the conceptualist Joseph Beuys, and did his best – without success – to get expelled. After leaving college, he gradually began drawing again: frogs, worms and dancing bugs. He painted big pictures collaboratively with Milan Kunc and Jan Knap, exhibiting under the banner "Group Normal", demonstrating that painting could be a regular, shared activity, like playing in a band. In 1986 he took the step – by then, bizarrely, radical – of painting in the open air. He became fascinated by the colours he actually saw. The hues of the sky and tree trunks didn't come out of tubes. He had to teach himself how to paint them again. Slowly and methodically, Angermann has remastered the whole language of painting as an expression of feeling, from the sheer joy of looking at the world around him to fantastic flights of the imagination. In his skilful hands, the art of painting has regained its full power.

8 Hidden by Collecting

Collecting can enhance the meaning of art, but it can also hide it. It's wonderful to walk around London's National Gallery and see the peaks of European painting ranged along its walls. But while you gain a concentrated awareness of the glories of this art, you lose the meaning of individual paintings in their original contexts. Nothing equals the experience of exploring a church like the Basilica of the Frari in Venice, and seeing Titian and Bellini altarpieces in the locations they were painted for. The Communist regime in Russia closed all the churches and put their icons in museums. Many of these have now been returned, to be touched and kissed by worshippers, much to the horror of museum conservators. Which is to be valued more highly: a work's artistic or its religious meaning? There are increasing calls, from countries stripped of their treasures by Western imperial powers, for the return of cultural property. The case for building local cultural identity is strong, but there is also a need for people, wherever they live, to appreciate the artistic heritage of others. Both local and global cultures need strengthening, and that will inevitably involve generous action by the culture-rich nations of the West. What's unforgivable is when collections bury what they've got. The world's cultural history lies in the stores of European and American museums. Many are so rich that what they have gets lost even when it's on display. The museum community needs to work internationally towards a more equitable and creative distribution of world culture.

Deer in Autumn Forest

Artist unknown

Ink and body colour on silk |
69 x 53cm | 10th century CE | National Palace Museum, Taipei, Taiwan

B y far the oldest and richest continuous tradition of painting in the world is that of the Chinese, but it's difficult to find original works of real merit on display. Going round the Forbidden City in Beijing today, you hardly come across a single painting, although for centuries beautiful pictures were created and kept there for the delight of the emperor and his court. Under the centralized system of government which ruled China for two thousand years, most great works of art, wherever they were produced, eventually found their way into the Royal Palace, enthusiastically collected by emperors and their chief officials, who were often artists themselves. The whole palace was stuffed with painted treasures.

Many of these treasures were made publicly accessible in 1925, when the Forbidden City was turned into the Palace Museum after the expulsion of the last emperor from his official residence, in the same way that the Palace of the Louvre became a museum after the French Revolution. But the Forbidden City now seems empty of art, for the simple reason that it largely is. In 1931, on the orders of Chiang Kai-shek, all the great paintings were packed away in crates and taken out of the palace, to protect them from the invading Japanese army. As civil war raged across China, and when it looked as though the Communists would win, the Nationalists shipped as many of these cases as they could to Taiwan. A small fraction of their contents can be seen in rotating displays in the confusingly named National Palace Museum, opened in 1965 in the capital Taipei. It's better than nothing – and there could have been nothing. The Nationalists argued,

with good reason, that they were the preservers of Chinese culture, for if these treasures had remained in China they might well have been destroyed during the Cultural Revolution of the 1960s. Thankfully they're safe, but despite building several recent extensions, this museum can never do justice to the most prolific and long-lasting tradition of painting in the world. At some stage there has to be a homecoming for China's art.

The Taiwan collection gives us a glimpse of what we're missing, and blows aside all the stereotypes about Chinese painting we've gleaned from the few works shown in foreign museums. Within the intimate language of watercolour, the Chinese tried everything, from minutely detailed work to the broadest brushstrokes and most diaphanous washes, from brilliant colour to the most austere tonal shades. Deer in an Autumn Forest is just one instance of the richness of Chinese invention. If you didn't know where it came from you might think it was a product of the Italian Renaissance, perhaps a study by Pisanello, famed for his rendering of elegant deer and slender, growing branches. But there is something purely decorative about this painting that makes it Chinese. There is no hint of religion, as there would have been in Western art; no dark undertow of original sin. In China there was, in the words of the great Confucian scholar Mencius, "no god sitting in the sky judging what we do". The beautiful sights of nature were there not to teach mankind lessons, but simply to be enjoyed, all the more so in times of violent political upheaval, like the period of the Five Dynasties during which this picture was painted.

The Hours of Engelbert of Nassau

The Master of Mary of Burgundy

Body colour on vellum | 13.6 x 12cm |
c.1470 | Bodleian Library, Oxford, England

Medieval Christian Europe saw the development of a unique, intimate new art form – illuminated Books of Hours. Bibles, gospels and prayer books, which governed the daily conduct of monasteries and churches, had for centuries been elaborately decorated, but they were vast tomes set on lecterns whose heavy pages were turned by priests, as the bell tolled. Books of Hours were tiny volumes, hand-held and kept at home. They listed prayers and psalms and stories from the Bible to be said, sung and read at different times of the day, according to the season and the occasion. They were personal guides to salvation while living in the wicked world. At first they were plain. Everyone who could read even a little had one – poor peasants in villages, servants in their quarters – and it was often the only book people had. This was in the days before printing in Europe, so all of them were handwritten.

The nobility, naturally enough, wanted theirs to be special and commissioned the best scribes and binders to make them. Then it was realized that these books could be illustrated too, like the great volumes in churches, but with miniatures. They became especially popular with ladies (who had few possessions of their own), as a status symbol no one could deny them – a kind of personal passport to heaven, complete with their picture. It became fashionable for a groom to give a Book of Hours to his bride on their wedding day, containing a portrait of her, thus sealing its ownership and purpose. The pages illustrated here are from the The Hours of Englebert of Nassau and are by an artist identified with the author of a portrait of Mary of Burgundy, sitting by a balcony looking into a church where the Madonna and Child are enthroned. Black irises stand in a glass jar on the ledge beside her while she reads her illuminated Book of Hours, cushioned in a green cloth in her hands.

These books were precious, both in a spiritual and an earthly sense, for they were about God's goodness in this world. That is what makes them so rare as works of art. The artists could combine in them their feelings of devotion to God with their love of the world around them. And their intimate nature encouraged close inspection. It might at first seem odd to see scenes of great moment – here the death of the Virgin, envisaged in a contemporary bed-chamber, and Christ crowning her in heaven, flanked by hosts of angels – set in close proximity to minutely rendered flies, flowers and butterflies. And what is a hairy caterpillar doing there? But God made all things great and small, and Christians, exceptionally among world faiths, believed that he had appeared in his creation, and that they could see him if they looked closely enough. And they could also see Satan. There is a darkness in this tiny painting. The cabbage white butterfly's wings are half-closed in the way they would be if it were dead. There is great emotional intensity around the bed of the Virgin. Books of Hours were aids to contemplation: death is present in all worldly things. Hundreds of these tiny volumes survive, each individually crafted and originally inspired. They are one of the great treasures of world art, but they are almost all hidden in libraries and hardly ever shown.

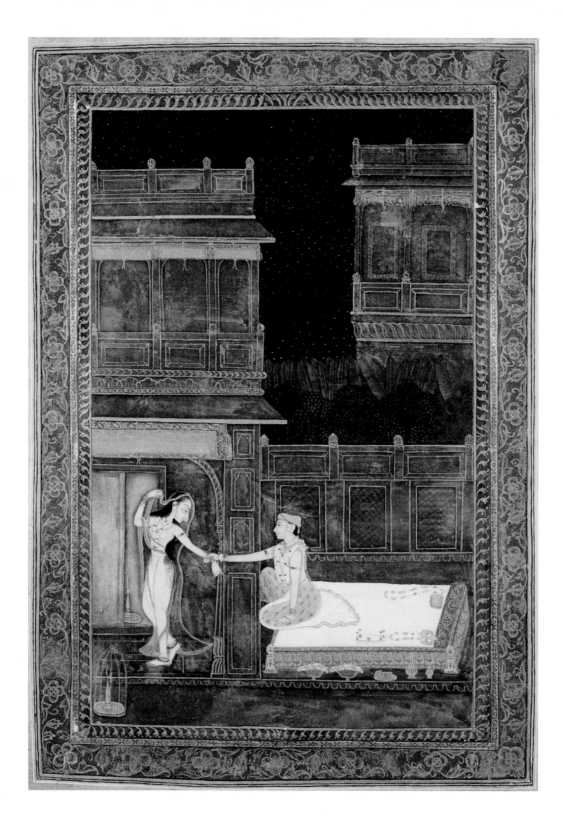

Love Scene
Nihal Chand workshop

Body colour on vellum | 28 x 19.5cm | c. 1760 | private collection

There was something magical in the air at the eighteenth-century court of Kishangarh. The local Raja, Savant Singh (1694–1764), who wrote poetry under the name of Nagari Das, fell deeply in love with a singing girl called Bani Thani, who was also a poet of distinction. The two lovers wrote verses to each other. And then they were joined by a painter. We know very little about Nihal Chand (1710–82), except that he headed a workshop that included his sons, Sitaram and Soorajamal, and later his grandson, Soordhaj Nanagram. Nihal does not seem to have been an ordinary craftsman, however, nor was he treated as such – he was eventually given 200 acres of land in the kingdom, an exceptional display of royal favour. It appears that he became part of Savant Singh's intimate inner circle. The court was dedicated to love, art and religion – a heady mix.

Hinduism is, above all, a celebration of love in all its manifestations: physical, intellectual and ecstatic. Savant Singh and Bani Thani saw themselves as the incarnations, not in person but in spirit, of the god Krishna and his consort Radha. Krishna, whose dark blue flesh was the colour of a storm cloud, spied the gopi, the girls who tended the sacred cows, bathing naked in a river, and hid their clothes. He dived in among them and had sex with all of them simultaneously, each of them thinking he was making love to her alone. Radha glowed more gloriously than the others, and became his chosen one. Her divinity was revealed: she was Lakshmi, wife of Vishnu, daughter of the king of the Milky Ocean which was churned at the beginning of time; the goddess of wealth, wisdom and fertility, from whom all light flowed.

The religious texts of Hinduism are full of poems praising Radha's beauty: "The moon is beautiful, but fades at dawn. The lotus is beautiful but closes at dusk. To what can I compare you, oh Radha? – because your beauty shines through the day and night." So Savant Singh and Bani Thani played out their lives and their love, and Nihal Chand captured it in art. He painted them drifting in a boat together among the lilies and cranes on a lake beside their white marble palace. He painted them throwing rainbow-coloured water over one another during the Holi festival, draping each other's shoulders with garlands, or just sitting together on a lotus flower, forever gazing into each other's eyes. He painted as if the whole world were in love. What he caught above all was a sensation of light, especially of the evening and early night when blues glow in the gathering dark. Here Savant Singh, kneeling on the edge of their bed, gently but firmly draws Bani Thani to him. She pretends to resist, but you know she will come. Nihal Chand was a master of curves. In the sacred text the *Vidagdha Madhava*, when Radha smiles her hair ripples against her cheek like waves at the edge of a lake, her brows arch like a huntsman's bows, and she sways like a bumblebee drunk with nectar. Nihal Chand and his family produced some of the most beautiful paintings in the world, but hardly any are on public display. There needs to be a museum devoted to their great art, preferably in Kishangarh.

Portrait of Tommaso Inghirami

Raphael

Oil on panel | 61 x 91cm | c.1518 | Palazzo Pitti, Florence, Italy

T here are a lot of vacant stares in the galleries of the Pitti Palace, not just on the faces of the visitors, but gazing at you from ceilings, plinths and walls. They all look the same, these blank painted and carved eyes, glazed-over, thinking and feeling nothing, suspended in unresponsiveness. The hundreds of gods, goddesses and saints – pagan and Christian here mingle freely – all marble-limbed and veined in pink, claim to be alive, dancing and prancing, praying and sighing, but anyone looking up at them from the foot-slogging marble floors gets their measure pretty soon and spots the same repeated lifted chin, raised brow, clasped breast and cocked leg. They're all posing; there's not a drop of genuine human feeling in the whole gallimaufry. They're a backcloth and set, put up to boost the reputation of the Medici dukes, who became kings of Florence in all but name. The Pitti Palace, enlarged by the Medici in 1549, is as gross inside as out, the perfect image of crass dictatorship crushing humane republicanism. No wonder the thousands who wander through its rooms soon look brain-dead, wondering how long they have to stay to justify the ticket price. This is a pity because, among all the gilt-edged dreariness, the Pitti contains a handful of superb paintings that are easy to miss.

The portrait of Tommaso Inghirami by Raphael (1483–1520) might at first glance seem like any other Renaissance portrait of a cardinal, but look more closely and you sense at once the alert intelligence behind his look. Inghirami was an eminent humanist, rhetorician and poet, who became the Vatican librarian

in 1510, and probably worked closely with Raphael on the programme for the frescoes in the Stanza della Segnatura. Despite, or because of all this learning, he had a sense of humour. When acting the part of Phaedra at the age of sixteen he had famously improvised in Latin when the scenery fell down; thereafter he was known to friends as "Fedra", a name proudly passed down through generations of descendants.

Looking at this portrait you think you're looking at a real man, not a painting: it's a work in which the art is totally hidden. If you narrow your eyes you can appreciate the rhythmic structure that creates the entirely natural effect. There are five pure whites in the picture: in the eyes, the moon-sliver collar, the blank sheet of paper and, most beautifully and upliftingly, the cusp of light in the corner which catches the open page of the book. These lights create a quiet dance within the space. They are complemented by five notes of pure black: in the angled pen, the inkwell, the curved cuff and the irises of Inghirami's eyes. You keep coming back to those eyes. There's something not quite right about them – did Raphael get the drawing wrong? Of course not – it's precisely correct. Inghirami had a wall eye. He has glanced up as if distracted, or perhaps he's had a genuine thought of heaven, though nothing like the pompous overreaching uplifted gazes which now surround him. In doing so he has for a moment disguised his deformity. Was this vanity? That smile of his, which hovers perpetually around his lips, seems to say, "Perhaps a little – but wouldn't you be vain if you were being painted by Raphael?"

The Vain Man

Honoré Daumier

Painted unbaked clay | 15.9cm high | c.1832 | Musée d'Orsay, Paris, France

If no other use can be found for a historic building, the tendency is to convert it into a museum, no matter how unsuitable it may be for the intended contents. Many of France's greatest art treasures ended up in an ex-railway station when the Gare d'Orsay in Paris was reopened as a museum in 1986. An airy modern framework with spaces suitable for showing art could have been created under the station's great barrel vault. But, in a sadly familiar architectural ego trip at the expense of art, the chosen architect, Gae Aulenti, decided instead to install a massive, faux-Egyptian, granite stage-set. The paintings had to be jammed into the corners that were left. The world's greatest Impressionist collection, which had looked so wonderful in the Jeu de Paume building, was now banished into a cramped loft, to be peered at behind pillars. The new museum did however allow the display of art which had languished in storage. One of its greatest treasures is easy to miss: a long red case containing thirty sculptures by Honoré Daumier (1808–79). These are a remarkable survival, made of fragile unfired, painted clay, the spontaneous throw-offs of a master who became famous as a lithographer rather than a sculptor.

Daumier was born in Marseille, the son of a glazier who went to Paris to seek his fortune as a poet and playwright – an ambition which would have been inconceivable before the Revolution. Coming from this background, Daumier remained a staunch Republican. He trained as an illustrator and lithographer, and got a job on a new satirical magazine, La Caricature, where he quickly earned a reputation with his scurrilous cartoons. A drawing he made in 1831 portrayed the new "people's king", Louise-Philippe, as Gargantua, the gross, all-consuming giant of Rabelais' great novels. Its publication got Daumier arrested and he ended up with a six-month gaol sentence and a fine. This experience left him with a healthy contempt for lawyers (who make money whatever the outcome) but also established his fame. He produced a remarkable 3958 lithographs, drawing back the curtain on all aspects of French life, from the bedroom to the coffin, each one gloriously and summarily drawn. His few paintings were exhibited at the Salon – for he had aspirations to High Art – but his clay sculptures he made for himself.

Charles-Guillaume Etienne was a minor playwright and an even more minor politician, whom Daumier modelled as Vanity. His eyes are almost closed, as if the best view in the world was within. He keeps one wary eye open, though you know he only sees you in relation to himself. His cranium, containing his diminished brain, is reduced to a little crest of a wave in a sea of smoothed-down grey. Underneath, his eyebrows rise as if perpetually surprised that anyone might not share his high opinion of himself. His squashed cheeks and skewed, sniffy nose reveal the lack of foundation for all this self-approbation, but these are features he cannot see. Most telling of all is the pert little mouth. The whole of this fleshy excrescence is cosily tucked into a high collar and tied, as a present to himself, with a big bow. All this in a few fingerfuls of clay.

Delilah

Gustave Moreau
Gouache on paper | 17.5 x 25cm | c.1875 | Gustave Moreau Museum, Paris, France

I n 1852, the wealthy architect father of Gustave Moreau (1826–98) acquired a fine town house in the Rue de la Rochefoucauld in the centre of Paris. His artistic son moved in and stayed there for the rest of his life. He built two great studios on top of the house, connected by a magnificent cast iron spiral staircase which afforded great views of the pictures on the easels and the walls. Here he dedicated himself to art. He never married, but lived with Henri Rupp, an ex-pupil who became his secretary and probably his lover, and who remained his confidant and companion until he died. Moreau left the house with all its contents to the state, to be turned into a museum in which everything was to be accessible. Against much official opposition, Rupp worked hard to realize Moreau's dream, and – unlike Turner's supporters in England (see p.219) – he succeeded in the end.

It was a problematic bequest: there were 800 paintings, many of them huge, and 13,000 drawings and watercolours, all to be shown. Paintings were clustered cheek by jowl on the walls and freestanding cases were designed to contain the sketches, which could be slid out on racks. The drawings were hung on folding screens behind curtains in bays under the windows. Every inch of space was used, and proper consideration given to the damaging effects of exposure to light. The museum today remains a rare encapsulation in one place of an artist's life work – though it doesn't contain the whole of Moreau's output by any means. His major paintings, the ones that made him famous (another 500 of them) are mostly in museums in France and abroad. The Moreau Museum contains the works he never completed; there were a lot of these because of his practice of working on paintings for years, sometimes decades. He seemed reluctant to finish. "Painting", he said, "is impassioned silence." You can feel that, walking into this unforgettable artistic time capsule.

The more finished of the paintings, with their portentous symbolism, have long since begun to pall. Few today can relate to his stiff, androgynous, idyllic youths with their jewel-encrusted loins, and awkwardly droopy semi-clad women, posing as mythical deities or classical personifications. They were ridiculed by some at the time. Degas, a friend of Moreau's who drew with him in Italy, commented drily, "He'd have us believe the gods wore watch chains." It's the unfinished paintings that are exciting, the first groping thoughts, the snatched glimpse of a visual idea. These can be seen on vast canvases, roughly sketched over with brushmarks, but even more vividly in the works on paper, where stark concoctions of blues, pinks and creamy yellows have been rapidly applied straight from the palette. This elegant, elusive nymph seems to be stepping out of the drags of paint as if they were her clothes.

Artists were magnetized by Moreau. In his later years he took students, among them Matisse. The first curator of the museum was Georges Rouault, another pupil. Matisse said later, "It was an almost revolutionary attitude on his part to show us the way to the Museum, in an age in which official art, dedicated as it was to the worst sort of pastiche, and living art, giving over to painting in the open air, seemed to be united in trying to turn us away."

Staffa

J.M.W. Turner

Pencil and watercolour on paper | 24 x 34cm | 1844 | Tate Gallery, London

During his lifetime Turner (1755–1851) kept back three hundred of his best oil paintings, as well as accumulating a staggering thirty thousand watercolours and sketches. On his death he left these to the nation on condition that the government build a gallery to show them to the public. After much dithering, parliament accepted the gift in 1856, but it has still failed to deliver its side of the bargain. Eventually, in 1987, the Tate opened an extension, called the Clore Gallery after its sponsor, which displays a fraction of the Turner Bequest under insipid lighting. This will provide useful extra space for Tate Britain when the Turners are finally given a proper home.

What's extraordinary about Turner's gift is that no other artist of his stature – apart, perhaps, from Picasso – has left us such complete documentation of his development from his student days to his final, mind-blowing creations. Turner's work charts a progression from the most exquisite shades of rainy greys to rainbows, sunsets, and blazing, obliterating pure white light. The sequential richness of Turner's gift enables you to watch him looking at the world more and more clearly, as if veils were being peeled off his eyes, until all he could see were luminous rays – the insubstantial substance of vision itself. This wasn't a premeditated agenda but a practical discovery, realized only through the medium of paint, worked by the fingers of an artist inspired. Sometimes he drew and painted on the spot but mostly he worked from memory, first of all sketching out an impression in the broadest washes of colour. He hung these on washing lines round his studio to dry. These "beginnings", several of which survive, are like miniature Rothkos. The Turner Bequest represents a lifetime of seeing, collected together in one place.

In 1831 Turner sailed to the tiny island of Staffa, off the west coast of Scotland, in what he later described as "a strong wind and head sea". Staffa is one of the most extraordinary geological sights in the world, its basalt columns towering in the middle of the ocean and splaying out in fabulous patterns in the waves. It is famous, above all, for its cavern, as high and gloomy as a cathedral, with a floor of dark booming water which inspired Mendelssohn (who visited it two years before Turner) to write his overture *Fingal's Cave*. None of this is visible in Turner's watercolour, nor in the oil he painted a year later. What interested him was the way the striated cliffs become a wall of light that is swallowed up, so to speak, by an opening in the clouds. Weather and waves are more powerful than rocks.

It was a view of the world that made many uncomfortable. The oil painting of Staffa was the first Turner to go to America. A private collector, James Lenox, had bought it without seeing it, for the then considerable sum of £500. When it arrived, he was distressed by its "indistinctness". Turner, when he heard this, commented, "You should tell Mr. Lenox that indistinctness is my forte." Turner's subject matter was the atmosphere. That's why building a gallery for his work is so important now. We have to learn to appreciate the Earth's atmosphere again, in all its transient beauty, if we are going to save our world from catastrophe.

Parthenon Frieze

School of Phidias

Marble | this section 102 x 132cm | 440–435 BCE | Acropolis Museum, Athens, Greece

The Parthenon is now a skeleton of what it once was: a vision in white marble of strength, equality and harmony, the perfect symbol of Ancient Greek democracy. Within its dark interior, facing east, stood a colossal statue of Athena, her flesh ivory, her robes gold. A pool of water spread before her, reflecting her image in the world below, while the rising moisture kept her ivory flesh smooth. She was the mother, mistress and protector of Athenian men, above them, under them and all around them. The temple was crowned with sculptures showing Athena being born from the head of Zeus and sitting with Poseidon on the Acropolis hill, the site of her sacred olive grove and his salt water spring. A painted frieze ran high up round the inner wall depicting the great procession that threaded its way every four years through the city streets below, bringing a new robe for Athena and celebrating the heroes who'd died at the battle of Marathon, defending Athens against the Persians. All was of a piece, architecture and sculpture, a single magnificent work of art.

The Parthenon has had a sorry history since: emptied of its treasures, converted into a Christian church, used as a munitions store by conquering Muslims, partly blown up in 1687, then abandoned to the elements and treasure seekers. Most drastically Lord Elgin, with questionable permission from the occupying Ottomans, hacked off most of the weather-beaten frieze from the east end and sides (thinking, wrongly, that the west end was the front), and eventually sold them to the British Museum in 1810. These carvings can't be put back on the Parthenon; it's now too fragile and exposed to pollution. Exhibiting them in a nearby museum sounds like a poor alternative, but the new Acropolis Museum (opened in 2009) is a triumph of presentation. The originals, together with plaster casts of the absent sculptures, have been assembled in a vast glass box exactly as they would have appeared on the Parthenon. What makes the experience of walking round them so vivid is that you can see the real Parthenon through the glazed wall standing above you in the sunlight. So this great work of art can easily be recreated in your mind's eye. The frieze is aligned exactly as the original: east to west. Suddenly a new meaning emerges.

On the west face, riders get ready for a race, as the sun is about to set. The south and north friezes (now mainly in the British Museum) show riders galloping east, as the sun passes under the Earth. The rippling motion through their cloaks suggests time passing. As they near the east, the pace slows with the approaching dawn. Bulls are being led to sacrifice and, in the panel shown here (still in Athens), one kicks to be released. A young girl carries Athena's shawl, but that isn't the climax of this frieze. In the very centre of the south side, Hera lifts her veil and reveals her face to her husband Zeus, as the sun rises and lights up the statue of Athena within. That's the moment all lovers wait for – the unveiling of their beloved. The whole temple was a hymn to love and time. The British Museum must now give back its originals, and help to recreate one of Europe's oldest and greatest works of art.

9 Hidden by Conservation

Conservators used to be called "restorers", and their job was to make works of art look brand new, like repairers still do with vintage motor cars. Now their job has changed. No conservator today would obscure original paint or do anything irreversible to an artefact, as Sir Arthur Evans' restorers certainly did at the palace of Knossos, which finished up looking like an Art Nouveau garage. But the pendulum has since swung too far in the direction of touch-me-not protection. The *Mona Lisa* should certainly be cleaned of its old varnish, which obscures the wonderful painting underneath. And the edicts of preventive conservation have turned galleries into hallowed halls of gloom. Light, once the essential friend of art, is now seen as its enemy, and artworks on paper in particular are so dimly lit that they can't be properly appreciated. But it is a simple equation to minimize potential damage by limiting the length of time such items are illuminated, rather than by reducing all lighting to such a dismal level. Most museums have thousands of "sensitive" items in their stores, more than enough to ring the changes. A selection of the great Holbein drawings (see p.159) could always be on show in rotation. Another insidious policy that must be rethought is limited-time visiting, which forces you to rush round Giotto's greatest work in fifteen minutes flat! Conservators should be enabling people to enjoy art, not keeping treasures hidden from them.

Annunciation

Ambrogio Lorenzetti

Fresco | c.1344 | Oratorio of San Galgano, Montesiepi, Italy

Modern conservation methods have exposed a layer of art that was never meant to be seen. In former times, if restorers wanted to save a fresco painting endangered by damp or crumbling masonry, all they could do was hack off a section of the wall, in chunks as big as they could handle. In the last century, however, hastened by the imperative of preserving murals damaged by wartime bombardment and catastrophic floods, techniques were perfected in Italy of separating the thin topmost layer of plaster, in which the painting is embedded, and removing it to safety.

Almost all the great mural paintings of the Italian Renaissance, from Giotto's Arena Chapel to Michelangelo's Sistine Ceiling, were executed in the technique known as *buon fresco*. It required great skill to master, and has seldom been successfully used since. An underlayer of plaster known as the *arriccio* was first spread on the prepared wall surface. When it was quite dry a finer layer, the *intonaco*, was carefully applied over it; this was done in a sequence of sections, or *giornate*, starting at the top of the wall and working downwards. These sections varied in size and shape according to what the master intended to paint in any one day. He had to finish his work before the plaster dried out, for all he had on his brushes was pure pigment mixed with water; as the colours soaked into the damp plaster they formed a chemical bond with it and set to a luminous and highly durable finish.

From sources such as the artists' manual written around 1400 by Cennino Cennini, it was known that a full-size preparatory drawing, or *sinopia*, of the composition was usually painted in outline on the *arriccio* beforehand. (Most of these were executed in a reddish-brown pigment which was imported from the city of Sinope in Syria: hence the name.) This would gradually be covered up as the painting progressed. But until it became possible for conservators to detach the final plaster layer and reveal what lay beneath, no one had any idea of the quality and range of styles of these hidden sketches, nor of the fascinating evidence they could contain of how artists of the early Renaissance worked. Many include plumb-line marks, grids or perspectival guides for plotting the composition; some are in simple outline, while others show reworking and the development of the artist's ideas; some include highly finished, shaded drawings, probably for assistants to follow. Some must surely have been done for the approval of the client, to give an idea of the effect of the overall composition before painting began.

The *sinopia* discovered under the *Annunciation* fresco at Montesiepi (detail opposite) is one of the most remarkable surviving drawings of the fourteenth century: raw, fresh, inspired and strikingly different from the finished painting. With rapid strokes and confident facility, Ambrogio Lorenzetti (active 1319–47) has worked out the drama of the scene – the positioning of the figures, the emotionally telling angle of the Virgin Mary's chin. She is terror-struck, almost fainting with fear and apprehension, grabbing the pillar for support as the angel Gabriel tells her she is pregnant with the son of God. He holds a palm, a symbol of martyrdom, indicating that this son's mission would end with his sacrifice. This must be the reason for Mary's extreme anguish. But such a radical interpretation of the Gospel story clearly offended someone, for the final painting was altered not long after its completion to show a very different Mary, her hands folded across her breast, conventionally obedient and submissive.

The largest collection of *sinopie* on display is to be found in a little-visited museum in the Campo dei Miracoli in Pisa, just a few metres away from the groups of tourists taking photos of each other pretending to hold up the Leaning Tower. Housed in a thirteenth-century hospital, the Museo delle Sinopie contains the vast underdrawings for the series of frescoes which once decorated the serene cloisters of the monumental cemetery or Camposanto, on the opposite side of the square. Painted by a succession of Florentine masters of the fourteenth and fifteenth centuries, and long considered one of the great fresco cycles of the early Renaissance, it was seriously damaged in a fire following a bombing raid in 1944. After the war, the remains of the paintings were removed for conservation – which is still ongoing – and in the process the *sinopie* were discovered. These now fill this unique museum. Here you can watch the ghosts of Italian artists working freely and deftly, sketching out ideas, changing compositions, altering expressions, correcting the angle of a hat or the profile of a horse's leg, or switching the direction of a devil's tail. It is a most intimate and moving experience, seeing the Renaissance being made.

The right-hand section of Lorenzetti's much deteriorated *Annunciation* shows the altered head and hands of the Madonna. The outline of the original figure, crouching and clutching the pillar, can still be made out.

Les Très Riches Heures du Duc de Berry

Limbourg Brothers

Ink, body colour and gold leaf on vellum | 29 x 21cm | c.1410 |
Musée Condé, Château de Chantilly, France

This great cycle of paintings is never on show. It's the jewel in the crown of the Chateau of Chantilly just outside Paris, but if you go there all you will see, in a low vitrine, is a modern facsimile of the book, open at one page. You could leaf through a copy more enjoyably in a public library. There is a computer screen nearby where you can see images of more pages, but you could do that anywhere. A notice tells you that "maintaining the original book open over long periods of time would pose a significant threat to its conservation". But a few rooms away in this same building, forty original manuscript illuminations of superb quality by Jean Fouquet, a near contemporary of the Limbourg brothers, are on permanent display. So could the paintings of the Très Riches Heures be, if they weren't bound together – as they never were in the first place.

A Book of Hours was a Christian prayer book used by people to sustain their faith outside church (see p.208). The rich had their copies elaborately decorated. The Book of Hours known as the Très Riches Heures was commissioned in 1410 by the Duc de Berry, son of the king of France, from three artist brothers, Paul, Herman and Jean Limbourg. We know little of their lives, beyond the fact that they came from Nimwegen in the Netherlands and worked indistinguishably together, though Paul seems to have been head of the workshop. The brothers were in their thirties when all three died, probably of the plague, in 1416. Only six illustrations had been completed by the time of their deaths, and these paintings remained unbound; some time later an unknown artist illustrated the other six months. Later still, in 1485, Duc Charles I commissioned Jean Colombe to add 194 leaves to the first twelve. These contained Gospel extracts, prayers to the Virgin, penitential psalms and many beautiful full-page illuminations. Only after this were the pages bound into a book, which disappeared from history shortly afterwards.

The Très Riches Heures re-emerged in Italy in the eighteenth century, as a newly bound volume in the library of the Spinola family. In 1855 it was bought from a girls' boarding school in Genoa by the Duc d'Aumale, the son of King Louis-Philippe, who was assembling a "royal" collection of medieval treasures. These were to be housed at his chateau at Chantilly, which he was turning into a Gothic palace, in the hope that France would revive its monarchy with him as king. The Très Riches Heures are currently treated as an element of this ducal fantasy. They are much more significant than that, and should be released from their eighteenth-century binding and displayed separately page by page for all to see. Neither colour printing on a flat page nor pixels on a computer screen can equate with the eye-tingling sensation of seeing the build-up of hair's-breadth brushstrokes on the gently undulating surface of fine animal hide. There are minute details in these paintings. For instance, in *February* (opposite) we see the misty breath of the woman in the snow, the couple warming their privates in front of the fire, the smoke from the flames – all exist at the very limit of human vision, wonders of art that can only be fully enjoyed by looking at the originals with the naked eye.

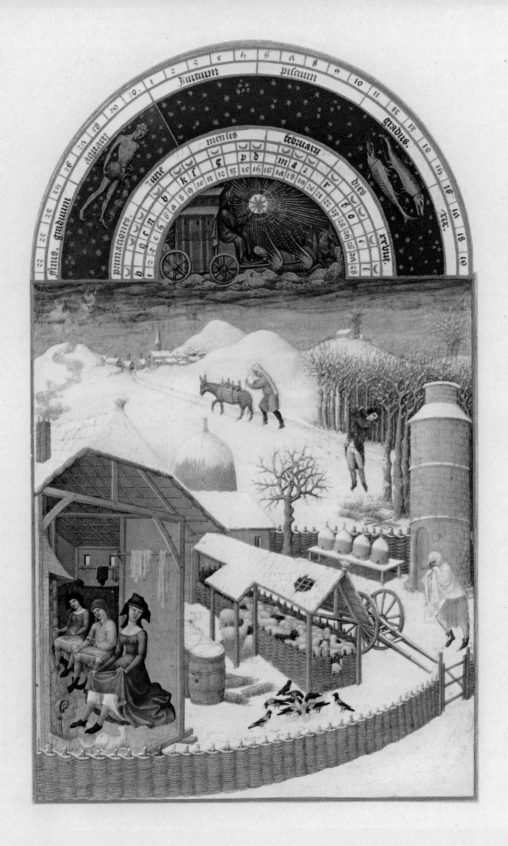

Miniatures from the Falnama

Kalender Pasha

Ink, body colour and gold leaf on paper |
59 x 44cm | c.1610 | Topkapi Palace Museum, Istanbul, Turkey

I slamic representational painting is one of the great hidden treasures of the world. This is because it is almost only ever found in books. The art was squeezed into this private format by the general culture of Islam, which was adverse to representational imagery in any more public form. Representation is not specifically forbidden in the Qur'an, but idolatry is. This distinguishes Islam from other faiths, such as Hinduism, Buddhism and Christianity. Islam, like its parent faith, Judaism, maintains that God cannot be seen and therefore cannot be given representational form. Human eyes are screened from divine glory. Islamic art found its most perfect expression in the screen: delicate, interweaving patterns of bewildering intricacy and beauty which indicate an ineffable, light-filled wonder beyond. Their shrine walls, domes and carpets are all heaven's screens. The patterns on them were drawn from nature, from flowers, feathers and the drift of stars, but rendered as abstractions, not likenesses. The sultans and shahs of the Ottoman and Moghul dynasties, alone among the great rulers of the world, frequently had themselves depicted gazing in ecstasy at flowers. The surprising thing is that they had themselves depicted at all. But then they were not holy. Representational painting (but not sculpture) flourished in Islam during periods of prosperity and widespread tolerance – though it only did so within the covers of books. Hidden in their pages the rich panoply of Muslim life unfolds, including, rather surprisingly, their religious beliefs.

Charm is a crucial element in Islam's sense of beauty. The primary aim of Muslim artists was to delight the eye. In this miniature, from the Falnama (or Book of Omens), Adam and Eve leave the Garden of Eden holding hands, followed by the snake. In the Qur'anic version of the story, unlike that of the Hebrew Bible, Adam and Eve eat the forbidden fruit together and share the guilt. They look mildly surprised rather than upset, but they needn't worry – they are about to be forgiven. There is no concept of original sin in Islam, no need for wailing and gnashing of teeth. Adam and Eve soon repented, and Earth wasn't such a bad place – it was full of lovely flowers, arched here at the back in sprays that echo the curved droplet form so beloved by Islamic artists, and made famous in the West through imitative Paisley patterns. The origins of this extremely satisfying shape are obscure. It is half a Yin-Yang and a leaf, feather and flame (the sacred fire of the Persian Zoroaster) at the same time. It's seen here again in the golden haloes – for despite their error, Adam and Eve are still holy. Adam is regarded as a prophet in Islam, because God spoke directly to him. And many believe that the Kabaah, Islam's most holy site, was built by Abraham on the foundations of the house which Adam first built when he left heaven, and under whose floor he still lies buried. This painting is a picture of heaven on Earth, with heaven as usual screened behind, the abode of angels and peacocks. Peacocks graced the gardens of the Topkapi Palace in Istanbul, the residence and court of the Ottoman sultans from 1465 to 1853, where this miniature is kept. It is one of about ten thousand in the palace library. Only a handful is ever on show, though with modern preventive conservation techniques most could be exhibited on a rotating basis. They need to come out of heaven, like Adam and Eve, so the world can see Islam's hidden beauty.

Arena Chapel Frescoes

Giotto di Bondone

Fresco | completed c.1305 | Arena Chapel, Padua, Italy

One of the world's greatest works of art has been reduced to a sight-bite. You cannot see the frescoes of the Arena Chapel in a quarter of an hour, but that's all the time visitors are currently allotted. You buy your half-hour time slot and are first forced to watch a video for fifteen minutes; you then get your glimpse of the real thing before being curtly ushered out. It would presumably be possible to buy a sequence of tickets, but then your visit would be repeatedly interrupted by trotting back to sit through the same video. You're not allowed to stay in the chapel itself for any meaningful length of time, even though there's no earthly reason why you should have to keep on being "acclimatized".

The Arena Chapel is unique, by far the largest and most complete early Renaissance frescoed church to survive almost complete and still, for the most part, in scintillating condition. Above all, it's the blue – azurite, a pigment derived from copper ore – that is utterly overwhelming (see p.234). It's as if the sky has come inside and flooded down the walls. In mosaics and panel paintings of the time, scenes were bathed in gold, which symbolized the spiritual light of heaven while at the same time demonstrating that no expense had been spared. It seems, however, that Enrico Scrovegni, who paid Giotto (c.1267–1337) to paint his family chapel, didn't want to display his wealth, but to atone for it. His father had amassed the family fortune by usury, lending money with interest, when such ungenerous and exploitative gains were considered sinful. Enrico wanted to be seen as a humble man. Giotto shows him here, presenting his chapel to the Virgin.

There was also a religious reason for the blue. Giotto was painting just after the turn of a new century, when Christ had again failed to reappear. The Church needed to reinforce its message that the son of God had once walked on Earth. Catching this spirit, Giotto showed Jesus in broad daylight, simply robed, as he imagined he would have been in Roman times. The Arena Chapel was built beside the ruin of a Roman arena, where a sacred performance of the Annunciation was given annually. Giotto painted each Gospel scene as if it was being re-enacted in the same space as the viewer, in broad daylight. The episode of Judas's kiss captures a silent, intimate pause when the eyes of goodness stare into those of evil, surrounded by the clamour of the crowd. You need hours, not seconds, to respond to each of these paintings, and tune into Giotto's unique vision. He was by all accounts strikingly small and ugly, but as quick-witted as he was charming. When someone asked him how a man who painted such beautiful pictures could have produced such unattractive children, he is reputed to have replied, "I made them in the dark."

When viewing the *Last Judgement* on the west wall you can make out, just above your head, a little naked figure hiding behind the Cross (see opposite). It's a detail you need to visit the chapel to see. No one knows why Giotto put him in, but he perfectly demonstrates a natural human response to the prospect of being tossed into hell. The whole chapel acquires a human

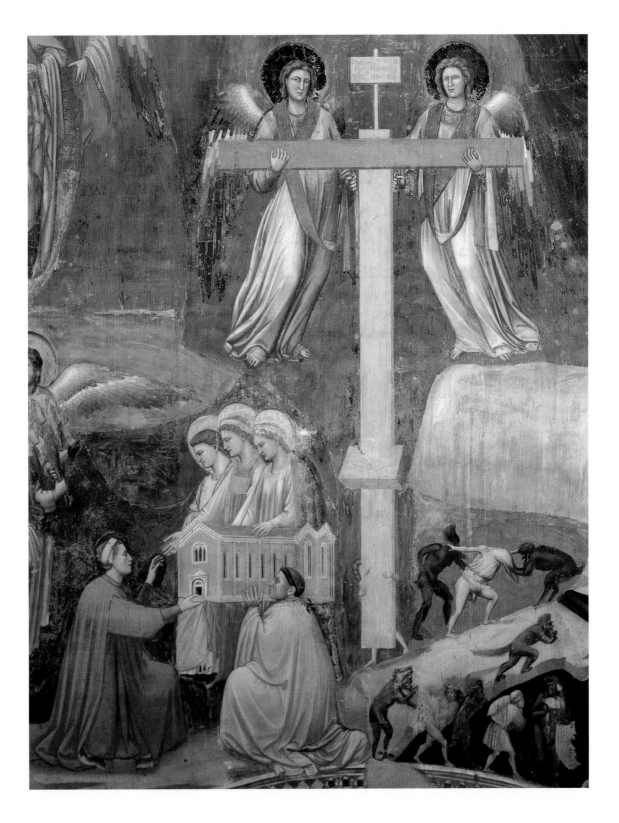

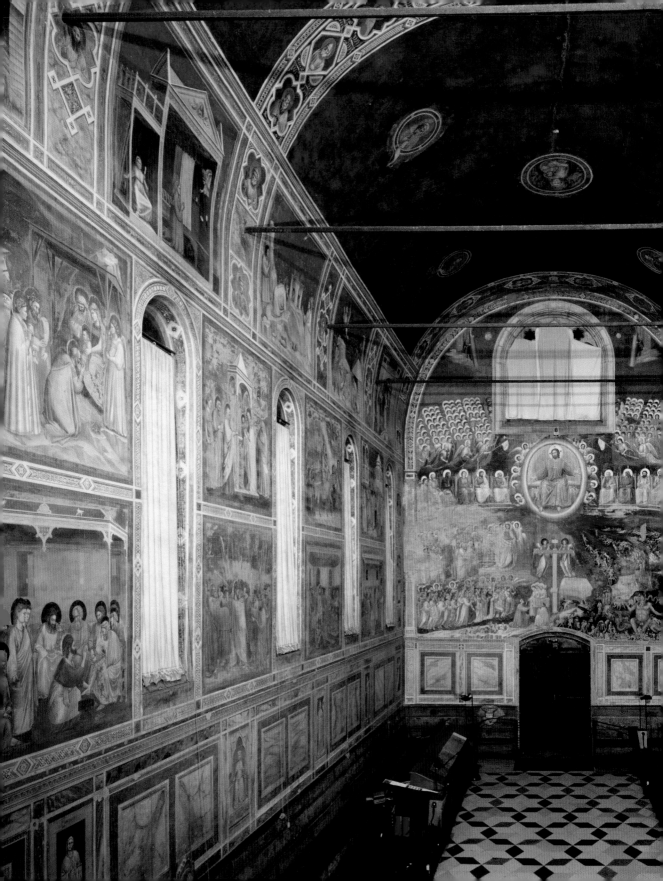

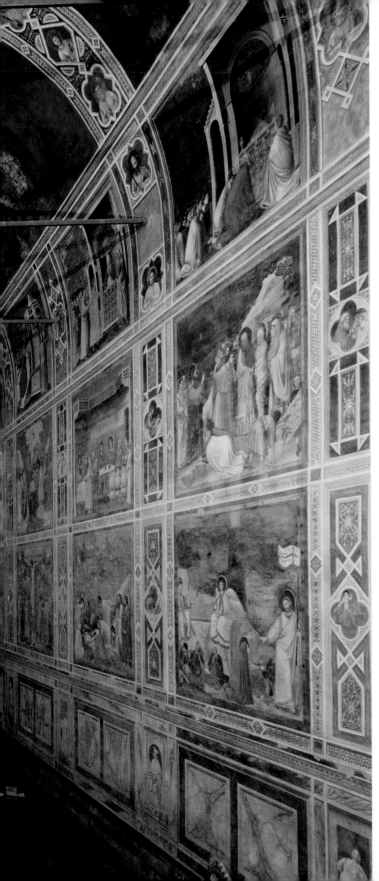

dimension because of the presence of this little hiding person. The scenes in this chapel are contained within a highly elaborate and very beautiful framework of illusionistic architecture and marble panelling, all of it conceived by Giotto himself. The longer you spend in the chapel the more this comes into play and you realize that the artist is playing games with the buildings within the scenes, with the fictive architecture on the walls and the real architectural space within the chapel itself. You find yourself getting more and more absorbed in the whole ensemble. The personalities of Christ and the people around him become intensely alive, and for a while seem to share your existence. It's an extraordinarily moving, accumulative feeling, but one that you cannot even begin to sense in a quarter of an hour! The Italian authorities should at least allocate a number of daily tickets for those who want to spend time in this wonderful place.

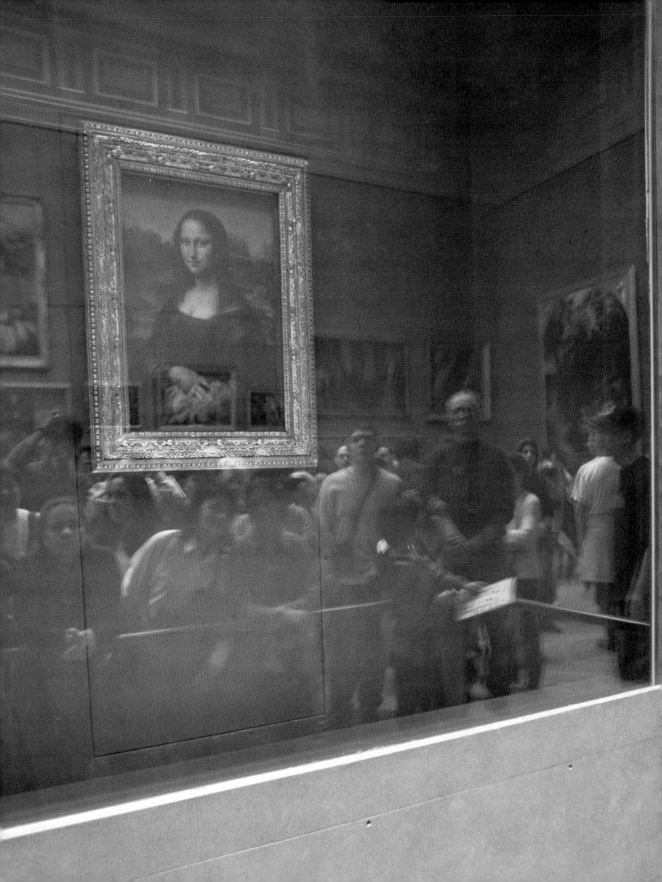

Mona Lisa

Leonardo da Vinci

Oil on wood | 53 x 77cm | c.1505 | Musée du Louvre, Paris, France

How can the Mona Lisa be a hidden treasure? Millions visit the painting every day, but they don't really see it, because it's impossible to view properly. Set behind a barrier and a glass screen, it's faced by a crowd of people (many clicking cameras) who, even if they could get close, wouldn't see what Leonardo (1452–1519) had originally conceived. When newly painted, the figure sat between pillars, but at some point the panel was cut down. It's not known why. Nothing can be done to restore its proportions, but there is no reason why the painting should be dirty brown. Paintings were traditionally covered with transparent varnishes, made from natural resin, to make the colours glow and protect the surface. These varnishes discolour badly over time, yellowing and growing more opaque, so that the original colours and tonality are distorted. Modern conservation techniques enable conservators to remove old varnishes safely, without damaging the paint beneath, and such cleaning of the masterpieces of world art is now standard practice. The Mona Lisa was last cleaned in 1809, and the murky, uneven layers that currently obscure it have nothing to do with Leonardo. All they do is hide its beauty. Vasari, who viewed the work sixty years after it was painted, wrote: "The eyes had that lustre and watery sheen always seen in life ... the nostrils, rosy and tender, seemed to be alive ... The opening of the mouth seemed to be not coloured but living flesh." The Mona Lisa must still be like this underneath, as fresh as apple blossom, the miraculous rendition of a living, breathing, strangely smiling woman.

Who is she? No one knows. The painting wasn't commissioned, and therefore probably wasn't a portrait.

Leonardo kept it with him till he died. The woman is a mystery, and Leonardo was fascinated by mystery. And by mist – the mist that veiled the mountains in the distance and the mist that was formed by breath on glass. Was mist the essence of life, as the Ancient Greeks had thought? In order to capture the effects of mist, Leonardo developed a technique called sfumato, in which objects were formed by shading rather than contours. And what about her expression? Two hundred years earlier, Dante had described a smile as "the flashing out of the soul's delight", but the Mona Lisa's smile is sorrowful as well as joyful; it hovers between love and loss. Even if he did base his painting on a real individual, Leonardo transformed her into a universal image. The Mona Lisa is his attempt to make visible the soul of humanity and the soul of the world, to paint the essence of creation – an extraordinary ambition.

The painting demands contemplation. People wanting to view it properly should be able to book chairs in front of it, allowing others, content with briefer contact, to look over them. But most urgently, the Mona Lisa must be cleaned. The Louvre's most recent conservation report on the painting (published in 2006) states that it is in "exceptionally good condition" underneath the "thick deteriorated varnish", which they admit "veils the work and greatly impairs its interpretation." Bizarrely, the museum doesn't explain why it hasn't been cleaned, in line with other works by Leonardo in their collection and elsewhere. This is doing the public and art a great disservice. The Mona Lisa, cleaned, will once again become a shining beacon for the art of painting.

Prince of the Lilies

Artist unknown & Emile Gilliéron

Fresco (reconstructed) | 1600–1500 BCE | 178 x115cm | Heraklion Archaeological Museum, Crete, Greece

K nossos is by far the most popular archaeological site on the island of Crete, attracting over a million visitors a year to marvel at its great horned entrance gate, squat red pillars, high loggias, ceremonial staircase and painted throne rooms. But the ancient remains that visitors might have seen are totally hidden. Everything that looks intact is in fact a twentieth-century sham, made of reinforced concrete. The alluring images of ancient Cretan life are in fact the products of the deliberate manipulation of tiny fragments of original painted plaster. This wall painting, known as the *Prince of the Lilies*, is one of the treasures supposedly unearthed at the site. Only a few pieces of it are genuine: a section of the "crown", a stretch of torso, bits of arms and two slabs of a leg. The pert face, the droplet tail feathers, the wavy black locks, the skimpy fringed skirt and bright blue jockstrap are made up. What's even more unsettling is that scholars are now confident that the original shadowy sections actually came from different walls in the palace, and so weren't even parts of the same figure. Hard though it might be to believe, this picture is actually a slimmed-down version of the first reconstruction. The "prince" was originally stepping daintily through a field of lilies accompanied by dancing butterflies, hence his acquired title. These were all total fabrications which have now been cleared away in deference to modern archaeological truth. But it's evident that what remains is still an early twentieth-century creation by Emile Gilliéron, the Swiss artist employed by Sir Arthur Evans to "restore" images of the civilization he believed he was digging up.

Arthur Evans was a wealthy British archaeologist who bought the site of the ancient "palace" at Knossos in 1900 so that he could excavate it undisturbed. For five years he dug there assiduously, uncovering a vast complex of chambers and passages. He was convinced he'd stumbled on the original labyrinth, which, in legend, King Minos ordered Daedalus and his son Icarus to build in order to house the Minotaur, the bull-headed man-monster that his queen, Pasiphae, had given birth to after her passionate coupling with a sacred white bull. (She'd hidden inside a wooden cow – also built by Daedalus – to make herself more appealing.) Imagining he'd discovered the fabled palace of Minos, Evans invented the name "Minoan" for this lost civilization, to distinguish it from the Mycenaean culture that the German archaeologist Schliemann had unearthed on the Greek mainland. Evans set out to prove that his civilization was not only earlier but better. He discovered an emblem ring, snake-goddess statues and frescoes in halls to support his theory that the Minoans were a peace-loving people who worshipped a mother goddess, played leapfrog games with bulls and swam with dolphins. Many of these finds are now considered to be wildly fanciful reconstructions or downright fakes.

Whatever his personal motivation, the sad truth remains that Evans's attempts to rebuild Knossos in the light of what he wanted to see have prevented subsequent archaeologists from discovering what and how it actually was. Recent excavations nearby indicate elaborate defences, and the bones of children who could have been ritually sacrificed, a far cry from Sir Arthur's dream of a golden age of early humanity, when princes were devoted to flowers and danced with butterflies.

West Portal of Amiens Cathedral

Artists unknown (lit by Skertzo)

Limestone | c.1220–66 | Amiens, France

T he great Gothic cathedrals were meant to be coloured, inside and out. There is evidence that oil paint was used on pillars and statues long before the technique was refined for panel paintings, but often paint for buildings was made with less durable binders such as lime or animal glue. Though weathered and damaged areas would have been regularly repainted, this did not continue indefinitely over the centuries. Plain stone was, in any case, more in keeping with the self-effacement of later Christianity. These cathedrals were once as brazen as Hindu temples; what we see now are pale shadows by comparison.

Traces of original paint have been found in crevices on the few pieces of stone that still survive from the time when these cathedrals were built. At Amiens, for example, fragments of red and blue were found on Christ's halo, tucked under the top of the central west portal. Then, during laser cleaning in the 1990s, more minute traces of pigment were discovered, enough to indicate a possible reconstruction. The stone itself could not be repainted, but the original appearance of the facade has now been recreated by the projection of coloured lights. At night in high summer and over Christmas, a son et lumière collaboration between Skertzo (Hélène Richard and Jean-Michel Quesne) and EDF switches on the past. The effect is artificial, of course – in medieval times the cathedral would have been dark at night – but it conveys an imaginative truth. It's like looking at a stained-glass window; the colours have that radiant inner glow. This was undoubtedly what the original church painters

wanted, and most probably achieved. They painted on brilliant white grounds, using bright reds, blues and greens from mineral sources, such as vermilion, azurite and malachite, and of course gold. Their aim was to create an impression of light and glory, for on stepping through the cathedral portal, worshippers left the material, sinful world behind them and entered the house of God, which was itself a vision of heaven.

Amiens is one of the most complete and harmonious of Gothic cathedrals, conceived by Robert de Luzarches in 1220 after the old church burnt down, and executed almost entirely according to his plan. Its interior is exceptionally tall and long, a polyphony of aspiring lancets. The west portal prefigures this simple centrality. Christ is shown three times on its central axis. You meet him first on the column as you go in, holding the Bible and blessing you. He's standing on a lion and a dragon, representing original sin and death, both of which he has conquered. Up above, he's seated in judgement on the last day, his raised hands showing the wounds of his Crucifixion, and higher still, he appears in majesty, two swords shooting from his mouth. On either side angels hold the sun and moon, for the Apocalypse marks the end of time. Just above your head as you go in, naked pink bodies climb out of their tombs, as St Michael weighs their souls. Those on the left are going to heaven; on the right they're being dragged into hell's mouth. Seven banks of angels, martyrs, ecclesiastics, virgins and elders make up the surrounding chorus, flanked by the prophets and apostles, pillars of the Church, for this doorway isn't primarily a warning, but a hymn to hope.

10 Hidden by Time

Museums and galleries have become the cathedrals of the modern age, preserving – some might say fetishizing – those things from the past that are deemed the most valuable. But as well as removing objects from their original context, these institutions also cement the false notion that art exists out of time, sanctifying their "permanent collections" behind pillared porticos. It's therefore startling, and all the more moving, to see the Haida people of Canada defy this modern notion and let the totem poles of Sgang Gwaay quietly rot away. And this sense that art can have a finite life and still be valued is evident in the project of the Los Angeles muralists, whose work has enhanced that city since the 1970s. But art can be lost, or hidden, by time in other ways. When the republic of Florence wanted to memorialize its glorious past, it commissioned Leonardo da Vinci to paint a battle scene in the council chamber of its city hall. But then the political climate changed and the unfinished painting was covered over, lost forever – or possibly not. Qin Shi Huang was the man who unified China and was the country's first emperor. Only the surrounding terrain of his vast pyramidal tomb at Xi'an has so far been excavated. The greatest art treasures ever accumulated by mankind may well lie intact in the tomb itself, and it's surely only a matter of time before the Chinese authorities dig them up – and the sooner the better.

Totem Poles of Sgang Gwaay Llanagaay

Artists unknown

Wood | Anthony Island, British Columbia, Canada

Sgang Gwaay Llanagaay will soon be gone. Descendants of the Haida people who used to live there have decreed that this abandoned village should be left to sink back into the forest from which it came – an apt tribute by a society that believes in the inextricability of mankind's relationship with nature. What other culture would allow its history to fade? A few old totem poles are on display in museums, the best collection being at the University of British Columbia in Vancouver, but virtually none are left in their original locations, except at Sgang Gwaay. This makes their imminent loss all the more meaningful and moving.

The art of carving totem poles effectively died out in the late nineteenth century, by which time most of the Northwest Coast Native Americans had been converted to Christianity, many becoming devout. With their making went their meaning, much of which must anyway have been intentionally obscure. Amateur anthropologists who tried to interpret them were told different stories according to whom they asked. One person would claim a face at the bottom of a totem pole represented a woman being carried off by a killer whale, while another said it represented a grizzly bear and the ghost it carried on its back. Perhaps the face represented both and something else besides. The meaning of the figures that climb up and down these poles was surely poetic rather than specific, representing qualities rather than characters acting to type. Each one always melds into the next, and no face or figure is entirely animal or solely human. The vision of the world so beautifully expressed in them is of animals and humans making eye contact, of the complex mixed inheritance that gives each of us our individual natures. We are all part human and part animal. Totem poles were erected in front of houses when a couple married, as declarations of ancestry, which the Haida saw as an agency for devouring as well as giving birth. You were what someone in the past had eaten. These weren't the fevered imaginings of a people who were always starving, but rather images of plenitude. "When the tide goes out, the table is set" was an old saying of their neighbours, the Tinglit: such, then, was the fecundity of their sea. These people only had to wait to eat, and they had the time and ease to joke. A long beaked bird often sits at or near the top of these poles. Many families claimed direct descent from the Raven, an impish, devilish spirit – like Monkey in Chinese mythology, or Maui, the trickster of Polynesia – who was cheekily nosing about at the beginning of creation and let the sun out of his tiny box, and humans from their cockleshell.

What makes totem poles such wonderful works of art, and why it's sad – however one accepts it intellectually – to see old ones rot away, is that their makers discovered universal forms in the shapes of eyes, jaws, wings, beaks, brows, hands and claws. Everything natural is imbued with a powerful grace, lines of force that can flow into each other. Brave attempts have been made to revive this moribund art, most notably by Bill Reid (1920–98). Ignored by the art mainstream, he created powerful Haida statues, but they remain essentially the view of an outsider looking into a vanished way of life.

The Isle of California

Terry Schoonhoven & Victor Henderson

Enamel paint | 128 x 198cm | 1970–71 |
Los Angeles, California, USA

A rt ventured out of doors in the Los Angeles of the 1970s. Bland white end walls, framed by the deep blue Californian skies, flanked by swaying palms, along freeways, beside vacant lots and on bleak street corners spontaneously acquired rainbow face-lifts. Multicoloured murals sprouted everywhere, hundreds of them: the city turned into an art gallery in the open air. This artistic flowering had its roots in destitution. Mexican-American immigrants, or Chicanos, had brought with them their delight in decorating buildings, a tradition that sprang from their pre-Columbian cultures (see p.12) long before mural painting was politicized by such artists as Diego Rivera (see p.127). In the 1960s, in their desperately poor, gang-torn East LA suburbs, wall painting was encouraged in a programme of community development. One painting of a park scene carried the message, in Spanish and English, "Please honour my wall. It is a gift to you. If you want to paint, call 8229560."

Almost all the early LA murals and many of the later ones were anonymous. They proved highly successful in counteracting vandalism and negative graffiti, and in helping to build local identities. Mural painting took off in other poor communities, and among minorities fighting for rights. Public art became an accepted political and social tool, as well as cheering up dreary neighbourhoods. Californians were used to huge billboards, blinking neon signs and giant manikins advertising alcohol, cigarettes and hamburgers. Why couldn't images brighten people's lives, without selling anything? So the dream of a genuinely public art came true, in the brilliantly lit, hothouse atmosphere of LA.

This ambition appealed to artists who wanted to break through the exclusivity of the modern art system of producing one-off images for the rich to hang in the privacy of their homes. Instead they made things for everyone to see, that couldn't be sold. The economics were problematic. Many worked for virtually nothing. One of the most brilliant, Kent Twitchell, painted huge, unemotional portraits of people standing still, looking out over the city, like Easter Island heads: gloriously cool understatements, on a colossal scale, of the mysteriousness of the ordinary.

Terry Schoonhoven (1945–2001) and Victor Henderson (b.1939) founded the LA Fine Arts Squad in 1969 to paint murals. Then, after it was disbanded in 1974, both continued on their own. Schoonhoven was fascinated by illusion. His 1991 ceiling mural, City Above, at Figueroa Street Metro Centre station is his tribute to Tiepolo (see p.49) and contains a portrait of him wearing a baseball cap, and a portrait of the artist himself as a wino, wrapped in a blanket. His Cityscape at Harbor Freeway South shows the Parthenon against the downtown skyline with the AT&T skyscraper shorn off. He wryly commented, "It's a surreal stage-set, the scene after a quiet cataclysm." The Isle of California shows what's left of LA some time after the San Andreas Fault has ruptured. The fractured freeway is pitted like the eyes in a skull; waves crash against the rock. Nature is returning things to normal. There's not a human left. All great art is played on a chord that resonates into the past and future. Schoonhoven's shining illusions are masks of fear.

The Fight for the Standard
Peter Paul Rubens, after Leonardo

Chalk, ink and wash on paper | 45.3 x 63.6cm | c.1605 | Musée du Louvre, Paris, France

The *Battle of Anghiari*, a colossal painting by Leonardo da Vinci (1452–1519) in the Palazzo Vecchio in Florence, was covered up several decades after he left it unfinished and has long been regarded as lost. Now it seems that it might well have been preserved – and could soon be viewable again after four hundred years. In 2007 Maurizio Seracini, who has spent over thirty years painstakingly piecing together the evidence, was appointed to head a Presidential Commission to investigate whether the lost masterpiece does in fact still exist, and if so to take all necessary steps to recover it. It should be possible to do so without damaging the mural by Giorgio Vasari that conceals it, because it's likely that Vasari didn't plaster directly over Leonardo's work, but on to a wall which he had built in front to protect it. Vasari greatly admired the painting. He describes it vividly in his biography of Leonardo, in which he states that it was abandoned because the oil paints the artist was using ran.

In 1500, citizens of the recently founded republic of Florence was feeling bullish. They'd won important military victories, their bankers were rich, and they were immensely proud of their democratic government. Florentine men elected 1700 councillors who met regularly in the Palazzo Vecchio. They decided to decorate their great hall with scenes of their most celebrated victories and chose two of the most famous artists of the day to do it, hoping that their rivalry would spur them on to marvellous heights. Leonardo was to paint the battle of Anghiari, a Florentine victory over Milan, and Michelangelo the battle of Cascina, the city's defeat of Pisa.

Leonardo began work in 1505. Starting in the centre of the wall, he painted the turning point in the battle, when the Milanese flag was seized by the Florentine cavalry, a ferocious clash of men and horses. People marvelled: it had the energy of a thundering, flashing storm. But suddenly work on the painting stopped. The politics had changed and the money had run out. Michelangelo never got to start on his wall, and set off to Rome to work for the pope, while Leonardo went to Milan. In 1512 the Florentine Republic fell. When the Spanish troops that had helped restore the Medici family to power were billeted in the Council Chamber, Leonardo's unfinished painting was boarded up to protect it. We know from the timber ordered that it covered about fifteen square metres.

After the republic was briefly restored, the painting was uncovered, long enough for it to be copied and engraved – the lively version opposite by Peter Paul Rubens (1577–1640) is based on a dull engraving by Lorenzo Zacchia executed in 1558. But in 1570 the republic fell for the last time, and Vasari was commissioned to remodel the hall as the throne room for the newly restored Medici dukes. He raised the roof and extended the walls, covering them with his own ponderous paintings. From the number of terracotta tiles he ordered, it has now been deduced that he almost certainly built a false wall in front of Leonardo's work: 9870 would have been needed if they were to have been laid flat; 39,010 if stacked horizontally to build a screen. Vasari used 39,243 (a sum which allows for breakages). It's known that he similarly protected a fresco by Masaccio when ordered to build an altar in front of it. An execrable painter himself (though an innovative biographer), Vasari couldn't bring himself to sanction the destruction of a great work of art.

Qin Shi Huang's Tomb

Artists unknown

215–c.210 BCE | Xi'an, Shaanxi Province, China

About a mile from where the Terracotta Army is still being painstakingly excavated, a vast tree-covered pyramid squats on the horizon. It is the artificial mound which covers the grave of the first emperor of China. There's a strong chance that this tomb was raided long ago: everyone knew where it was, and the Qin emperor was much hated both before and after his death. Any action that could have allayed his influence from the grave would have been welcomed, and the treasures buried there would have been too tempting to leave alone. But it's also possible that the tomb might still be intact. It was buried about 35 metres deep – a remarkable feat of excavation – and it must have had elaborate underground defences. If and when it's ultimately uncovered, it could well make Tutankhamen's tomb look like a broom cupboard.

If seven thousand warriors were needed to defend it, what was the tomb inside like? The historian Sima Qian, writing a century after the Qin emperor's death, gives us an idea: "700,000 men from all over the empire … dug down to the third layer of underground springs and poured in bronze to make the outer coffin. Palaces, scenic towers and the hundred officials, as well as rare utensils and wonderful objects, were brought to fill up the tomb. Craftsmen were ordered to set up crossbows and arrows, rigged so that they would immediately shoot down anyone attempting to break in. Mercury was used to fashion the hundred rivers, the Yellow River and the Yangtze, and the seas in such a way that they flowed. Above were set the heavenly bodies and below the features of the Earth. 'Man-fish' oil was used for lamps, which were calculated to burn for a long time without going out."

Scholars think this account is largely accurate. Qin Shi Huang had unified China in 221 BCE by systematically conquering all the independent states, eradicating their armies and bringing their ruling families to his new capital, Xianyang (a few kilometres northwest of present-day Xi'an). There he rebuilt their palaces – over 270 of them – in traditional styles, filling them with their best treasures and most beautiful women. He would probably have taken these treasures, and the women, with him to his grave.

Wu Yongqi, the current director of the museum responsible for the site, dreams of the day when technology will enable a virtual exploration of the tomb, "without disturbing the emperor's sleep". But this will never be a substitute for seeing real objects. Excavation of the main mound would involve considerable disturbance of the surrounding terrain and, at present, the Chinese seem content to focus on that for the next twenty-five years. It's true that they're discovering wonderful things, such as a pit where musicians played while cranes danced on their long legs in a pond, but they could and should be more ambitious. The Chinese have destroyed so much of their wonderful art over the centuries, not least during the Cultural Revolution, that they must now seize this chance to rediscover their outstanding heritage.

Qin Shi Huang's contribution to posterity includes the unification of China, the imposition of peace and uniform standards throughout the land, the construction of straight roads and the Great Wall, but his greatest legacy might yet turn out to be the preservation of glorious works of art from the world's oldest and greatest civilization.

Hidden Treasures

How to find them

How to find them

For artworks which are on view to the public, website addresses are given where they provide up-to-date official information on opening hours and other practical matters. In the case of items which are less easily accessible, books and websites are cited which contain the best available images.

Chapter 1: Hidden by Chance

Page 3 The **Chauvet Cave** is situated near Vallon-Pont-d'Arc in the Ardèche valley in southeastern France, but the French government has decreed that it will never be open to the public. A virtual tour is available online at tinyurl.com/chauvetcave. There are also two superbly illustrated books: *Dawn of Art: The Chauvet Cave* by its discoverers Jean-Marie Chauvet, Eliette Brunel Deschamps and Christian Hillaire (Harry N. Abrams, New York); and *Return to Chauvet Cave – Excavating the Birthplace of Art* by Jean Clottes (Thames & Hudson).

Page 4 The **Pair of Bison** modelled in clay are located at the very end of a 900-metre-long cave, closed to the public, at Le Tuc d'Audoubert in the department of Ariège, in the foothills of the central French Pyrenees. An evocative account of a recent visit to see them can be read at www.bradshawfoundation.com. *Le Sanctuaire Secret des Bisons* by Robert Begouen et al. (Somogy, Paris) is a comprehensive study of the cave, with exceptional photographs.

Page 7 The garden room from the **Villa of Livia** has been beautifully reconstructed in a walk-in display on the second floor of the Museo Nazionale Romano in the Palazzo Massimo, near Termini Station in Rome (tinyurl.com/29rpc94). This floor generally has restricted opening times. Little remains of the ruins of the villa that originally housed it, in the northern suburb of Prima Porta, though excavations are ongoing on its garden.

Page 8 The fishing port of Mazara del Vallo lies in the province of Trapani in the southwest of Sicily. Its well-arranged Museo del Satiro Danzante, housed in the former church of Sant'Egidio on Piazza Plebiscito (tinyurl.com/satiro), was opened in 2003 to display the **Dancing Satyr** that was discovered offshore here, along with other local underwater finds including a bronze elephant's foot.

Page 11 The fresco **Cycle of the Months** covers the walls of the main room on the second floor of the Torre Aquila, which can be visited as part of a tour of the Castello del Buonconsiglio in Trento, northeastern Italy (www.buonconsiglio.it).

Page 12 The **Cacaxtla Murals** can be seen in their original location at the archaeological site of Cacaxtla, 100km east of Mexico City and 17km from the town of Tlaxcala. Tlaxcala's tourist office (www.tlaxcala.gob.mx/turismo) can help with guided tours.

Page 15 The village of Maser is situated in the Veneto, a few kilometres northeast of Asolo. The **Villa Barbaro** is still a private home with a working farm and vineyard, but the six rooms painted by Veronese are open all year round (weekends only in winter). It has a good website, www.villadimaser.it.

Chapter 2: Hidden by Place

Page 21 The site of the ancient village of Deir el-Medina is on the west bank of the Nile, close to the Valley of the Kings and Valley of the Queens, across from modern-day Luxor. At the time of writing, the **Tomb of Ipy** was not open to the public, but three other tombs generally are, including the earliest one to be excavated, that of Sennedjem.

Page 22 The oasis town of Dunhuang in Gansu province, northwest China, is the base for visiting the **Mogao Caves**. Only a few are open each day – it's possible to negotiate access to special caves in advance. The caves are unlit so it's advisable to take a torch. A museum at the site has replicas of a number of caves on show, though these lack the intense atmosphere of the originals. The Dunhuang Academy is reportedly working on a project to digitize images of 170 of the paintings and make them available online.

Page 25 Suceviţa Monastery is one of over twenty painted monasteries in the region of Bucovina, northeastern Romania. The village of Suceviţa is in a lovely tree-clad valley 18km from the town of Rădăuţi. Though still a working convent, **Suceviţa** is open to visitors (www.romaniatourism.com/painted-monasteries.html).

Page 26 The medieval town of Città della Pieve is situated to the south of Lake Trasimeno in Umbria, near the border with Tuscany (www.cittadellapieve.org). Tickets to visit the Oratorio di S. Maria dei Bianchi, which houses Perugino's **Adoration of the Magi**, can be obtained at the tourist office in the town centre. Northeast of the town is the village of Panicale, where another Perugino masterpiece, the **Martyrdom St Sebastian**, is in the tiny church dedicated to the saint, just outside the town walls. Visitors must be accompanied by a guide from the tourist office.

Page 29 Sicily's Regional Art Gallery is housed in Palermo's fifteenth-century Palazzo Abatellis in via Alloro, to the east of the city centre (tinyurl.com/abatellis). The detached fresco of the **Triumph of Death** is displayed in the palace's former chapel, on the ground floor.

Page 30 Villeneuve-lès-Avignon is situated across from Avignon, on the west bank of the Rhône in Provence. Housed in a converted palace on rue de la République, the Musée Pierre-de-Luxembourg has a single room devoted to Enguerrand Quarton's **Coronation of the Virgin**. As it's impossible to get really close to it, it's advisable to take binoculars and marvel at the detail from the comfortable seating provided.

Page 33 South of Milan's centre, the basilica of Sant'Eustorgio (www.santeustorgio.it) is in the Piazza Sant'Eustorgio at the end of the Corso di Porta Ticinese. The **Portinari Chapel** is now officially part of its museum, which has its own separate entrance to the left of the church and opens daily. The evocative sarcophagus of the Magi is in a chapel in the right transept of the basilica, where it may be freely visited.

Page 37 The city of Colmar is in the Alsace region of France, near the German border, south of Strasbourg. Its Unterlinden Museum (musee-unterlinden.com), is housed in a thirteenth-century former Dominican convent. Grünewald's **Isenheim Altarpiece** is on permanent display in the chapel adjoining the cloister.

Page 41 Moulins lies northwest of Lyon, on the Allier river in the Auvergne region of central France. The magnificent **Bourbon Altarpiece** is in the sacristy of the Gothic Cathedral of Nôtre-Dame, which towers over the historic centre.

Page 45 There are hundreds of examples of Enku's work throughout Japan, but most are in temples and shrines that are closed for much of the time and inaccessible during religious observances. This is true of **Kakinomoto no Hitomaro** which is in the Higashiyama Shinmei Shrine in Takayama. The greatest concentration of Enku's carvings are in Gifu Prefecture, between Tokyo and Kyoto, while the Arako Kannon-ji Temple in the city of Nagoya contains a wealth of Enku pieces. The main book on him in English is Enku, *Master Carver* by Grisha F. Dotzenko (Kodansha International Ltd).

Page 46 Sandham Memorial Chapel is a small red-brick building sited in an orchard in the village of Burghclere, near Newbury in Hampshire. It's in the care of the National Trust, whose website page for Sandham (tinyurl.com/sandham) includes information on opening hours and how to get there. As there is no artificial lighting in the chapel, it's best to visit on a bright day to appreciate Spencer's murals fully.

Page 49 Würzburg is situated on the River Main, 120km southeast of Frankfurt in Lower Franconia, Bavaria, with the vast **Residenz** (tinyurl.com/wurzburgresidenz) to the east of the town centre. The Tiepolos' **ceiling fresco** is gradually revealed as you climb the staircase to the left of the gloomy vestibule. Guided tours (in English twice a day) are available but not obligatory.

Chapter 3: Hidden by Choice

Page 55 The **Trundholm Sun Chariot** can be found on the ground floor of the National Museum of Denmark in Copenhagen, in the recently redesigned Danish Prehistory section (tinyurl.com/2u6thbp). The museum is housed in an eighteenth-century mansion known as the Prince's Palace, near the inner harbour and just west of Slotsholmen.

Page 56 The contents of the **Tomb of Lady Dai** are among the rich holdings of the Hunan Provincial Museum in Changsha, southeastern China. Spread over a sequence of galleries, the tomb treasures are well displayed and interpreted. The museum's website, tinyurl.com/2vnd937, gives a taste of the wealth of material to be found there, particularly the exquisite red and black lacquerwork and the extraordinarily delicate fabrics.

Page 59 The little **Flying Horse of Gansu** is the star attraction of the Gansu Provincial Museum in Lanzhou, northwest China, where it's displayed with its retinue of horses and chariots. The brick-built tomb from which it came, at Leitai Si, just north of Wuwei city, is open to visitors, but has none of its original contents.

Page 60 The painted slabs from the **Tomb of the Diver** are on permanent display in the small museum opposite the archaeological site of Paestum (tinyurl.com/2b8ss29), near the coast south of Salerno in the Italian province of Campania. The museum also contains paintings from other tombs, of considerably inferior quality.

Page 65 The **Tomb of the Leopards** is one of some 6000 Etruscan tombs (200 of them painted) in the Etruscan Necropoli dei Monterozzi, just east of the town of Tarquinia in northern Lazio, Italy. The necropolis is now little more than an exposed hillside, the tombs marked by little sloping-sided sheds with doors covering staircases built to give access down to them. Most are kept locked, and it is impossible to predict which will be open on a given day.

Page 66 The **Portrait of Two Brothers** is in the Egyptian Museum in Cairo (www.egyptianmuseum.gov.eg), which houses by far the greatest collection of Egyptian artefacts in the world, crammed into a pink neoclassical building on the busy Midan Tahrir. Most of the encaustic portraits from Fayum are here; a few are in other collections, including the Louvre and the

British Museum. Euphrosyne Doxiades' *The Mysterious Fayum Portraits* (Thames and Hudson) is a lavishly illustrated and authoritative overview of the subject.

Page 69 This **Moche vessel** in the form of a head is in private hands. There are two great collections of Moche ceramics on display in Lima, Peru, at the National Archaeological Museum (tinyurl.com/museonacional) and the privately funded Museo Larco (www.museolarco.org), both in the suburb of Pueblo Libre. Christopher B. Donnan's *Moche Portraits from Ancient Peru* (University of Texas Press), based on the extensive photographic archives of the University of California, is the best, most authoritative illustrated survey.

Page 70 The **bronzes of Pergola** are displayed in the town's own Museo dei Bronzi Dorati (www.bronzidorati.com), 20km south of Fossombrone in the Italian province of Le Marche. The Museo Nazionale delle Marche in the provincial capital of Ancona has two gleaming full-size replicas of the group, one on the roof for the whole city to see, and one in a special display case inside, neither with adequate explanation of what they are or where the real sculptures are to be seen.

Page 73 This **Pictish Stone** is on permanent display, along with 25 others, in the tiny Meigle Sculptured Stone Museum, housed in a former school in the centre of the village, 15 miles north of Dundee. Historic Scotland's website (tinyurl.com/meigle) includes practical details on getting there. Some Pictish stones are still to be found in *situ* throughout Scotland, mainly in the east; notable examples include the four at Aberlemno, near Forfar (covered up for protection during the winter) and the great Sueno's Stone at Forres, near Nairn.

Page 74 The elegantly simple Viking Ship Museum in Oslo (tinyurl.com/vikingship) was specially designed to house the finds from ship burials, including the stunning **Oseberg Ship**, its wagon cart and other grave goods. Part of the Museum of Cultural History of the University of Oslo, it is located on the Bygdøy peninsula, home to four other interesting museums.

Page 77 This **Kula Canoe** is on permanent display in the Pacific Cultures Gallery of the South Australian Museum, on North Terrace in Adelaide (www.samuseum.sa.gov.au), alongside the Art Gallery of South Australia. It forms part of their world-class holdings of South Pacific artefacts, collected from an arc of islands from Papua New Guinea to New Zealand. Shirley F. Campbell's *The Art of Kula* (Berg) explores the meanings behind the Kula designs.

Page 78 Rodolphe Bresdin printed nine slightly different variants of **The Comedy of Death**, but the total number of prints taken from each edition is not known. Many are in major print collections in Europe and America, but nowhere displays Bresdin's work permanently. The British Museum in London has twenty-three of his prints, including *The Comedy of Death*, which can be viewed in the Prints and Drawing department study room (tinyurl.com/2vr3y7t). No appointment is needed but evidence of identification must be provided.

Page 81 Victor Hugo's **My Destiny** is in the Maison de Victor Hugo on place des Vosges in Paris (tinyurl.com/8x6zh7), where a small proportion of his drawings are displayed in a gallery on the ground floor. His home in exile, Hauteville House on the island of Guernsey, can also be visited (tinyurl.com/2uyojzq).

Page 82 Andrea del Castagno's **Last Supper** is still on the end wall of the convent refectory for which it was painted, the Cenacolo di Sant'Apollonia, in via XXVII Aprile, Florence. Now a small museum (tinyurl.com/cenacolo), it contains other works by Castagno and lesser artists, as well as the fascinating *sinopie* (see p.225) of the scenes painted by Castagno above the *Last Supper*. The museum of the Opificio delle Pietre

Dure (tinyurl.com/cutstones), with its display of decorative stones, is in via degli Alfani, five minutes' walk from the Cenacolo.

Chapter 4: Hidden by Hate

Page 89 The **Fragment of a Royal Woman's Face** is now on permanent display in the Egyptian Galleries of the Metropolitan Museum of Art, New York (www.metmuseum.org). In 1999 it was shown in an exhibition at the Museum of Fine Arts in Boston, whose catalogue, *Pharaohs of the Sun – Akhenaten, Nefertiti, Tutankhamen*, is an excellent book on this period of Egyptian art.

Page 90 The **Kailash Temple** is the most spectacular of 34 temples and monasteries excavated into a long, high basalt cliff at Ellora, in the Indian state of Maharashtra. There are regular buses from Aurangabad, but if you want to view Kailash (and the other Ellora sites) at a leisurely pace, it is a good idea to stay the night at Ellora or to leave from Aurangabad early in the morning.

Page 93 The statue of **Jayavarman VII in Meditation** is on permanent display in the National Museum of Cambodia, next to the Royal Palace in Phnom Penh (www.cambodiamuseum.info).

Page 94 The statue of **Coatlicue** is on permanent public display in the Mexica Gallery of the stupendous National Museum of Anthropology (www.mna.inah.gob.mx) in Chapultepec Park, Mexico City.

Page 97 The **Kandariya Mahadeva Temple** is no longer a functioning temple but a monument, one of a group of Chandella temples in an archaeological park adjacent to the village of Khajuraho in the central Indian state of Madhya Pradesh. The India Tourism office is in the main square of Khajuraho and there are several places to stay. The best book on the interpretation of the temples is *Divine Ecstasy – the Story of Khajuraho* by Shobita Punja (Penguin/Viking).

Page 100 The tiny island of San Pantaleo, the site of the ancient Phoenician settlement of Motya, or Mozia, is off the west coast of Sicily between Trapani and Mazara del Vallo, and accessible by ferry. The island is littered with remains from the Punic and later periods which were excavated by Joseph Whitaker in the nineteenth century. The statue of the **Young Man of Mozia** is the main attraction of Whitaker's home, which is now a museum. It's open daily, with restricted hours in the winter.

Page 103 The small town of Creglingen lies in the valley of the River Tauber, southwest of Würzburg on Bavaria's Romantic Road tourist route. Tilman Riemenschneider's altarpiece, the **Marienaltar**, is in the middle of the nave of Creglingen's fourteenth-century Herrgottskirche, a short walk south of the medieval centre. The church has its own website (www.herrgottskirche.de). Michael Baxandall's *The Limewood Sculptors of Renaissance Germany* (Yale University Press) positions Riemenschneider and his contemporaries in their artistic and religious context.

Page 106 Urnes Stave Church is near Lustrafjord in Sogn og Fjordane county, northeast of Bergen, Norway. Since 1881 it has been owned by the Norwegian Society for the Protection of Ancient Monuments, whose website includes some practical information on visiting (tinyurl.com/urnesstave). It is open in the summer only.

Page 109 Felix Nussbaum's **Self Portrait with Jewish Identity Card** is now on permanent exhibition in the Felix-Nussbaum-Haus in the artist's home town of Osnabrück, northern Germany. An extension of the existing Cultural History Museum, opened in 1998, this unconventional and intentionally oppressive building was the first completed project designed by architect Daniel Libeskind. At the time of writing it was closed for structural alterations. A catalogue raisonné of

Nussbaum's work can be viewed online at www.felix-nussbaum.de.

Page 110 The **Head of Idia, the Queen Mother** is on permanent display in the British Museum, among other artworks stolen at the time of the punitive expedition of 1897. Many of these unique treasures will surely be returned, at some stage, to Nigeria.

Chapter 5: Hidden by Convention

Page 115 Of the five hundred or so complete sets of Goya's **The Disasters of War** series known to exist, none are permanently on show. Most of the major museums with print collections in Europe and America, including the British Museum (tinyurl.com/2vr3y7t), have a set, but only occasionally are a few prints shown in mixed exhibitions. A book of reproductions in facsimile size of all eighty-two prints is available from Dover Publications, but nothing equals seeing them in reality.

Page 116 John Singer Sargent's **Gassed** has been moved from the staircase where it hung for decades and is now displayed in a special *Hall of Remembrance* gallery in the Imperial War Museum (london.iwm.org.uk) in south London, along with other paintings by Paul Nash and Stanley Spencer completed for this abandoned project.

Page 121 The **Hiroshima Panels** are on permanent display in the Maruki Gallery, opened in 1967 in the city of Higashi-Matsuyama, Saitama prefecture, Japan. A modest notion of their impact can be gained from the illustrations on the Maruki Gallery's website (tinyurl.com/marukipanels). The book *Hiroshima Murals* by John Junkerman & John W. Dower (Kodansha International) illustrates details in impressive colour.

Page 124 The High Victorian main building of Royal Holloway College is on the A30 just outside Egham in Surrey, 19 miles west of central London. Frank Holl's painting **Newgate: Committed for Trial** is part of the collection on display in the Picture Gallery. It's only open for public viewing on a few days in the year, but visits can be arranged by appointment. The college's website (www.rhul.ac.uk/Visitors-Guide) contains a virtual tour of the gallery, as well as a wealth of other information.

Page 127 Diego Rivera's mural **Capitalist Dinner** can be seen on the north wall of the Corridor of the Agrarian Revolution, on the third floor of the Ministry of Education building, known as the SEP, to the north of the Zócalo in Mexico City. It is open daily free of charge, though the upper floors are usually closed at weekends.

Page 128 Niccolò dell'Arca's **Lamentation** is in the chapel to the right of the altar in the church of Santa Maria della Vita on via Clavatura, just off the Piazza Maggiore in Bologna, Italy, which has recently reopened after restoration work. The chapel housing the Arca di San Domenico, to which Niccolò contributed, is in the basilica of San Domenico, a short walk south of the central square.

Page 133 The basilica of St-Denis (saint-denis.monuments-nationaux.fr/en/), generally cited as the earliest example of Gothic architecture, is at the end of a metro line 10km north of the centre of Paris, in what is now a run-down industrial suburb. A charge is made to enter the transept and choir with their array of royal tombs, which include the extraordinary sculptures of **Henri II and Catherine de Médicis** by Germain Pilon.

Page 134 The **Funeral Effigy of Henry VII** is exhibited in the small but utterly absorbing museum at Westminster Abbey in London (www.westminster-

abbey.org/visit-us/museum), which is located just northeast of the main cloister, in the eleventh-century vaulted undercroft of St Peter.

Page 137 This set of **Prelude to Desire** is from the Musée Guimet (www.guimet.fr). Most major public print collections around the world include sets of erotic prints by Utamaro and other Japanese artists, but these are hardly ever shown. They are however often displayed in the private sex museums, called Hihokan (House of Hidden Treasures), which proliferate throughout Japan. The main authorative text on Utamaro is Gina Collia-Suzuki's *The Complete Woodblock Prints of Kitagawa Utamaro* (Nezu Press).

Page 138 Courbet's **Origin of the World** is in the Musée d'Orsay in Paris (www.musee-orsay.fr), where it is on show with other paintings by Courbet in Room 16.

Page 141 The **Warren Cup** is on display in Room 70 of the British Museum in London (www.britishmuseum.org). The museum has also published a short book on the cup by Dyfri Williams.

Page 142 Marie Guillemine Benoist's **Portrait of a Black Woman** is on display in the galleries devoted to French eighteenth- and nineteenth-century painting on the top floor of the Louvre Museum in Paris (www.louvre.fr).

Chapter 6: Hidden by Art

Page 147 Gislebertus' **Last Judgement** is on the west portal of the great twelfth-century Cathedral of St-Lazare in the town of Autun, in the heart of the Burgundy region of France. Most of the capitals in the nave and aisles are also by him, but they're difficult to see properly without binoculars. However, a few were detached in the nineteenth century and replaced with replicas; the originals are on display at eye level in the chapterhouse.

Page 148 Jean-Baptiste Pigalle's marble **Voltaire Naked** is on permanent display in the section devoted to French sculpture of the seventeenth and eighteenth centuries in the Richelieu wing of the Louvre Museum in Paris (www.louvre.fr).

Page 151 The Graeco-Roman Museum in the Egyptian city of Alexandria is housed in a late nineteenth-century neoclassical building in the Greek Quarter, to the east of downtown. The **Head of Julius Caesar** is among a collection of busts of Roman emperors on show, though at the time of writing the museum was closed for renovation work.

Page 152 The **Nile Mosaic** can be seen on the top floor of the seventeenth-century Palazzo Barberini, home of the Museo Nazionale Archeologico Prenestino (tinyurl.com/37tr9sh), in the small town of Palestrina, 35km east of Rome. Outside you can walk around the ruins of the vast, tiered Sanctuary of Fortuna where the mosaic was found.

Page 155 Angers stands on the banks of the river Maine about 300km southwest of Paris. The **Apocalypse Tapestry** is hung around a huge hall in the Château d'Angers, the gargantuan fortified castle which dominates the heart of the city (angers.monuments-nationaux.fr).

Page 156 Francesco Pianta's **San Rocco Carvings** are ranged around the room at dado level beneath the great cycle of paintings by Tintoretto in the upper chamber of the Scuola Grande di San Rocco, just behind the basilica of the Frari in Venice. The Scuola has a good website providing a great deal of information and a virtual tour of its artistic treasures, at www.scuolagrandesanrocco.it.

Page 159 Holbein's **George Nevill, 3rd Baron Bergavenny**, in the collections of Wilton House (www.wiltonhouse.com), is shown in the South Ante Library, which is open only for specific periods during the high

season. The collection of Holbein drawings in the Royal Collection is not regularly on display. The drawings can be seen in miniature on the Royal Collection's website (tinyurl.com/38h96nm).

Page 160 Pierre-Joseph Redouté's **Study of a Cabbage Rose with Tulips** is in a private collection. The vast majority of works by Redouté in public ownership belong to the Jardin des Plantes (tinyurl.com/375epg2), the botanical garden in the 5th arrondissement of Paris, which occasionally shows a few sheets in its small exhibition hall. Redouté's two great books of engravings based on his watercolours, Les Liliacées and Les Roses, have been published in reproduction by Taschen.

Page 162 John James Audubon's **Black-billed Cuckoo** is one of the unique set of original Audubon watercolours owned by the New York Historical Society (www.nyhistory.org), which is located on Central Park West in New York City. A selection is always on display. A complete set of the plates of Birds of America owned by the University of Pittsburgh is available online at tinyurl.com/35kdwzd.

Page 164 Albert Eckhout's cycle of paintings, including the **Tapuya Woman**, is on permanent display in the Ethnography Galleries on the second floor of the National Museum of Denmark in Copenhagen (www.nationalmuseet.dk). The website also has a virtual gallery of all its Eckhout paintings (tinyurl.com/eckhout).

Page 167 Selected examples from its vast collection of the work of George Catlin, including **Shon-ka-ki-he-ga**, are always on show in the Smithsonian Institution's American Art Museum (www.americanart.si.edu) at 8th and F Streets in Washington DC. They are generally displayed on the second floor of the East Wing and the third floor of the Luce Foundation Centre. The museum's website includes a virtual version of a recent touring exhibition of his paintings.

Page 168 John Sell Cotman's **Devil's Elbow, Rokeby Park** is in the collection of Norwich's Castle Museum, Norfolk, where a large selection of his work is on display, together with paintings by other artists of the Norwich School. The informative Norfolk Museums website, www.museums.norfolk.gov.uk, includes images of Cotman's work.

Page 170 The **Panorama of Scheveningen**, otherwise known as the Mesdag Panorama, is still in its original location on Zeestraat, fifteen minutes' walk north of the centre of The Hague (www.panorama-mesdag.com).

Page 172 The small town of Stockbridge, two and a half hours from Boston in western Massachussetts, has the most famous Main Street in the USA thanks to **Norman Rockwell.** His **New Kids in the Neighborhood** is in the collection of its Norman Rockwell Museum (www.nrm.org), along with most of his major paintings. His last studio has been faithfully reconstructed in its grounds, and fitted out as it would have been in 1960.

Page 175 Mikalojus Konstantinas Čiurlionis' **Sonata of the Stars** is in the M.K. Čiurlionis National Art Museum in Kaunas, the second largest city in Lithuania. The majority of his life's work is on permanent display there in a dedicated suite of galleries. Details of opening times can be found at tinyurl.com/Ciurlionis.

Page 178 Gabriele Münter's **Houses in Riegsee** is in the collections of the Lenbachhaus (tinyurl.com/Lenbachhaus) in Luisenstrasse just off the Königsplatz in Munich. The gallery is closed for renovation until summer 2012, when it will have a permanent display of the work of Münter and Kandinsky. In the meantime temporary exhibitions of items from the collection are being held in the adjacent Kunstbau.

Page 181 Martín Ramírez González's **Untitled (Trains and Tunnels)** was among the collection of his works

in the Solomon R Guggenheim Museum (www. guggenheim.org) on Fifth Avenue in New York City, but, unaccountably, it has been deaccessioned. The museum has other works by him, but none are displayed on a permanent basis. The major book on the artist was written by Brooke Davis Anderson, curator of the American Folk Art Museum, to coincide with their ground-breaking retrospective of Ramírez' work in 2007.

Chapter 7: Hidden by Conceptual Art

Page 185 Eduard Bersudsky's **Sharmanka Theatre** can be seen, along with a great deal of his life's work, at the Sharmanka Gallery (www.sharmanka.com), within the Trongate 103 arts centre in Glasgow, Scotland. Performances of his kinetic machines are given regularly. His colossal Millennium Clock Tower, made in collaboration with Tim Stead, Annica Sandström and Jürgen Tübbecke, is on permanent exhibition at the Royal Museum of Scotland, Edinburgh.

Page 186 Niki de Saint-Phalle's **Tarot Garden** (www. nikidesaintphalle.com) is situated at Garavicchio in southwest Tuscany, just over the border with Lazio and near the Via Aurelia coastal road, from which it is startlingly visible to motorists.

Page 189 Nek Chand Saini's **Rock Garden** in the planned city of Chandigarh, India, is situated near the Capital Complex in Sector 1. It is open daily. Chandigarh is in the state of Punjab, a three-hour train journey north of New Delhi. Further information is available from the Nek Chand Foundation (www. nekchand.com).

Page 190 Elizabeth Nutaraluk Aulatjut's **Mother and Child** is exhibited, along with other fabulous examples of Inuit art from the collection gifted by Samuel and Esther Sarick, in the recently redesigned Art Gallery of Ontario (www.ago.net), which is located just west of University Avenue in downtown Toronto, Canada.

Page 193 Mathias Kauage's **Baku War** is in the collection of Glasgow Museums in Scotland (www. glasgowmuseums.com). No works by Kauage are on public display in his native Papua New Guinea, though there are three paintings in the City Museum and Art Gallery of Bristol, England and two in the collections of the National Gallery of Australia in Canberra.

Page 194 David Kemp's **Botallack Hoard** has no permanent venue, though it was shown in a temporary exhibition at the Royal Cornwall Museum in Truro in 2010. The Trundler Sun is in the artist's own collection. The seemingly boundless nature of Kemp's creativity can be witnessed via his website (www.davidkemp. uk.com).

Page 197 Jim Whiting's **Bimbo Town** is on Spinnereistrasse in Lindenau, an industrial area on the west side of Leipzig in Germany. It operates as a club, and opens its doors, late, on one Saturday a month. Visit www.bimbotown.de for information and details about new shows.

Page 198 Paddy Japaljarri Sims' **Night Sky Dreaming** is in the collection of the Museums and Art Galleries of Glasgow in Scotland (www.glasgowmuseums.com). Traditional Aboriginal art is now widely displayed in all the major galleries and museums of Australia. The finest collection of Aboriginal Art outside Australia is at the University of Virginia (tinyurl.com/2home8).

Page 201 Hock-Aun Teh's **Monkey King** is in a private collection. His work can be found in several public collections in Britain and the Far East; further information is on his website (www.hockaunteh.com).

Page 202 Peter Angermann's **Hinten, Fern...** is in a private collection, like most of this artist's work. He has paintings in several public collections, mainly in Germany. His website provides a lively introduction to his paintings (www.polka.de).

Chapter 8: Hidden by Collecting

Page 207 Deer in an Autumn Forest is one of over 5,000 Chinese watercolour paintings in the collection of the National Palace Museum in Taipei, Taiwan (www.npm.gov.tw/en/home.htm). The museum houses a vast collection of artefacts, but only one percent is on show at any given time. It now has a policy to rotate its collections every three months to ensure that more of its vast holdings are on view.

Page 208 The **Hours of Engelbert of Nassau** is in the Bodleian Library in Oxford (www.bodley.ox.ac.uk), but it is hardly ever on show. At the time of writing the library is about to undergo a huge programme of reorganization and rebuilding work, partly so that it can show more of its artistic treasures in changing exhibitions; this is expected to be completed in 2015. *Master of Mary of Burgundy: A Book of Hours for Engelbert of Nassau* by J.J.G. Alexander (George Braziller) reproduces many of the illuminations.

Page 211 One or two miniatures by Nihal Chand are usually on show in the National Museum in New Delhi (www.nationalmuseumindia.gov.in) in its first floor galleries devoted to the history of miniature painting in India. The museum is located on Janpath, just south of the royal mall of Raj Path. The Victoria and Albert Museum in London has a small but significant collection of Kishangarh paintings, most of which are in store.

Page 212 The vast and formidable Palazzo Pitti, more Roman in scale than Florentine, is on the south bank of the River Arno in Florence, just along the street that leads from the Ponte Vecchio (tinyurl.com/2d0bb30). The modest Raphael **Portrait of Tommaso Inghirami** is always on show in Room II, the Sala di Saturno, of the Galleria Palatina.

Page 215 The Vain Man and Daumier's other surviving clay sculptures are now on permanent display, in a single case, on the ground floor of the Musée d'Orsay (www.musee-orsay.fr), which is located on the riverside at quai Anatole-France in Paris.

Page 216 The Gustave Moreau Museum (www.musee-moreau.fr). can be found at 14 rue de La Rochefoucauld in the centre of Paris, just round the corner from the Trinité Metro stop.

Page 219 A tiny proportion of Turner's watercolours are now shown in rotation at Tate Britain, on Millbank in London, in the Clore Gallery, the purpose-built wing opened in 1987 to house the Turner Bequest. Larger shows are occasionally organized. The Tate's Turner Online site can be found at tinyurl.com/39gw4vp. The nearest thing to a catalogue raisonné of Turner's work, *The Paintings of J.M.W. Turner* by Martin Butler and Evelyn Joll, is published by Yale University Press.

Page 220 All the sculptures from the **Parthenon** that are still in Greece are now displayed, along with a great many other extraordinary and fascinating finds from the Acropolis area, in the new Acropolis Museum in Athens, far below but in sight of the Parthenon. The museum website (www.theacropolismuseum.gr) gives an excellent introduction to the collection.

Chapter 9: Hidden by Conservation

Page 225 Lorenzetti's fresco of the **Annunciation** and its associated *sinopia* are now displayed side by side in the small twelfth-century chapel of Montesiepi, about halfway between Siena and Massa Marittima. The chapel was built on the site of the hermitage of St Galgano, and the ruined thirteenth-century Cistercian abbey dedicated to him is close by.

Page 228 The book of the **Très Riches Heures du Duc de Berry** is never put on show. Facsimile pages and computerized images of the paintings can be seen in the library of the remarkable neo-Gothic Chateau at Chantilly (www.chateauchantilly.com), 40 km north of Paris, where the original is housed. An English translation of Edmond Pognon's facsimile edition of the hours appeared in 1979 but is currently out of print.

Page 231 The **Miniatures from the Falnama** are among the vast wealth of treasures of the Topkapi Palace Museum in Istanbul, Turkey (tinyurl.com/lspz5s). The Miniature and Portrait Gallery is mostly dedicated to showing portraits of sultans, and the vast majority of its collection of miniatures – about 10,000 in all – never gets an airing.

Page 232 The ancient city of Padua is situated a short way inland from the Venetian lagoon in the Veneto region of northeast Italy. The **Arena Chapel** (www.cappelladegliscrovegni.it) is open to the public on a timed ticket basis; prior booking is normally essential. Laura Jacobus's recent study, *Giotto and the Arena Chapel: Art, Architecture and Experience* (Brepols-Harvey Miller) gives a fascinating account of many aspects of the chapel, and includes illustrations of intriguing details of Giotto's frescoes.

Page 237 The **Mona Lisa** is on permanent show in the Musée du Louvre in Paris. Since 1985 it has been in its own special enclosure within the Salle des Etats in the Denon wing. The museum has recently produced an unwieldy, glossy tome on the technical aspects of this single work of art, *Mona Lisa: Inside the Painting* (Abrams), whose subtext is the rationale for leaving it uncleaned, though what it actually demonstrates is that the experts now have all the information they need to begin a safe cleaning of the panel.

Page 238 The site of Knossos is 5km south of the city of Heraklion on Crete (tinyurl.com/2vap37a). The Archaeological Museum in Heraklion (where the **Prince of the Lilies** is now exhibited) is to the east of the centre, near Platia Eleftherias (tinyurl.com/2vdypmq). It is currently closed for renovation, but highlights from the collection, including this wall painting, are on show in a temporary exhibition.

Page 241 The city of Amiens, 120 km north of Paris in the region of Picardy, is dominated by its vast Gothic Cathedral, whose spectacular forty-five minute light and sound show (www.amiens-cathedrale.fr) is put on late at night from June to September, and from the beginning of December until New Year's Day.

Chapter 10: Hidden by Time

Page 245 Sgang Gwaay is a UNESCO World Heritage Site in the Queen Charlotte Islands, or Haida Gwaii, about 130 km off the coast of British Columbia in northwest Canada. Situated on the east coast of Anthony Island, this Haida village is one of the most remote sites in the world, accessible only by sea-kayak, boat or float plane. The website of Parks Canada (tinyurl.com/3y6aoxc) gives further information.

Page 246 The **Isle of California** mural can still be seen in its original location at 1616 Butler Avenue, near Santa Monica Boulevard in Los Angeles, but, sadly, it is now extremely faded.

Page 249 Leonardo's Battle of Anghiari, of which the **Fight for the Standard** forms the central section, is still hidden – but, one hopes, not obliterated – beneath Giorgio Vasari's murals in the Council Chamber of the Palazzo Vecchio, in the Piazza della Signoria in Florence (tinyurl.com/palazzovecchio). The Rubens drawing of it is in the Louvre in Paris, though it is rarely on display.

Page 250 The **Qin Emperor's Tomb** is located about 26km east of the city of Xi'an, capital of the central Chinese province of Shaanxi. The wooded pyramidal mound which covers it is visible on the horizon a short distance from the pits containing the Terracotta Army, who defended it from spirit attackers. Climbing up the very long staircase to its summit is the best way to appreciate its immense size and the scale of the treasures that might be buried underneath.

Picture credits

Rough Guides would like to thank all those who have given permission for the use of the following illustrations (listed by page number). Every effort has been made to trace copyright holders, but we will be happy to correct in a future edition any errors that may have arisen.

Front cover: © The Print Collector/Alamy

Author photo: Gillian Tait

Page 2 Cliché n° 10 ministère de la Culture et de la Communication, Direction régionale des affaires culturelles de Rhône-Alpes, Service régional de l'archéologie

Page 4 © Yvonne Vertut

Page 6 The Art Archive/Museo della Civiltà Romana, Rome/Gianni Dagli Orti

Page 9 Photo Scala, Florence

Page 10 Photo Scala, Florence/Courtesy of the Ministero per i Beni e le Attività Culturali

Page 13 The Art Archive/Gianni Dagli Orti

Page 14 The Art Archive/Villa Barbaro Maser, Treviso/Gianni Dagli Orti

Pages 16–17 The Art Archive/Villa Barbaro Maser, Treviso/Gianni Dagli Orti

Page 20 The Art Archive/Gianni Dagli Orti

Page 23 © Pierre Colombel/Corbis

Page 24 The Art Archive/Suceviţa Monastery, Romania/Alfredo Dagli Orti

Page 27 © Justin Guariglia/Corbis

Page 28 Photo Scala, Florence/Courtesy of the Ministero per i Beni e le Attività Culturali

Page 31 © Gianni Dagli Orti/Corbis

Page 32 © OJPhotos/Alamy

Page 35 Photo Scala, Florence/Mauro Ranzani

Page 36 The Art Archive/Unterlinden Museum, Colmar

Page 39 The Art Archive/Unterlinden Museum, Colmar/Gianni Dagli Orti

Page 40 © The Gallery Collection/Corbis

Pages 42–43 Moulins Cathedral, Allier, France/The Bridgeman Art Library

Page 44 © Masashige Hasegawa

Page 47 ©NTPL/A C Cooper © DACS

Page 48 © Adam Woolfitt/Corbis

Pages 50–51 Photo Scala, Florence

Page 54 © The Art Archive/Corbis/Alfredo Dagli Orti

Page 57 © Bettmann/Corbis

Page 58 The Art Archive/Genius of China Exhibition

Page 135 © Dean and Chapter of Westminster

Page 136 © RMN (Musée Guimet, Paris)/Thierry Ollivier

Page 139 The Art Archive/Musée d'Orsay, Paris/Gianni Dagli Orti

Page 140 © The Trustees of the British Museum

Page 143 © The Gallery Collection/Corbis

Page 146 Cathedral of St-Lazare, Autun, France/Peter Willi/The Bridgeman Art Library

Page 149 The Art Archive/Musée du Louvre Paris/ Gianni Dagli Orti

Page 150 The Art Archive/Archaeological Museum Alexandria/Gianni Dagli Orti

Page 153 The Art Archive/Museo Prenestino Palestrina/ Alfredo Dagli Orti

Page 154 © The Art Gallery Collection/Alamy

Page 157 Photo Scala, Florence

Page 158 © Collection of the Earl of Pembroke, Wilton House, Wilts/The Bridgeman Art Library

Page 161 © Christie's Images/Corbis

Page 162 © Collection of the New York Historical Society, USA/The Bridgeman Art Library

Page 165 © The National Museum of Denmark, Ethnographic Collection

Page 166 © Smithsonian Institution/Corbis

Page 169 © Norwich Castle Museum and Art Gallery/ The Bridgeman Art Library

Page 170 © Bildarchiv Monheim GmbH/Alamy

Page 173 Printed by permission of the Norman Rockwell Family Agency © The Norman Rockwell Family Entities

Pages 174 & 177 Arūnas Baltėnas/M.K. Čiurlionis National Museum of Art

Page 179 © Christie's Images/Corbis

Page 180 © Copyright Estate of Martín Ramírez

Page 184 Sharmanka Kinetic Theatre (Photo: Maureen Kinnear)

Page 187 © United Archives GmbH/Alamy

Page 188 © Arvind Garg/Corbis

Page 191 Art Gallery of Ontario, Toronto/Gift of Samuel and Esther Sarick, 1988 © Estate of the Artist (Photo: Dieter Hessel)

Page 192 Courtesy of the Rebecca Hossack Art Gallery © Culture and Sport Glasgow (Museums)

Page 195 © David Kemp (Photo: Bob Berry)

Page 196 © Jim Whiting (Photo: Dan Wesker)

Page 199 © Culture and Sport Glasgow (Museums) © DACS 2010

Page 200 © Hock-Aun Teh (Photo: Gordon Burniston)

Page 203 © Peter Angermann (Photo: C. Dümmler)

Page 206 The Art Archive/National Palace Museum, Taiwan/Harper Collins Publishers

Page 209 The Art Archive/Bodleian Library, Oxford

Page 210 © Burstein Collection/Corbis

Page 213 © Burstein Collection/Corbis

Page 214 The Art Archive/Musée d'Orsay, Paris/Gianni Dagli Orti

Page 217 Musée Gustave Moreau, Paris, France/ Giraudon/The Bridgeman Art Library

Page 218 The Art Archive/British Museum/Eileen Tweedy

Page 221 The Art Archive/Acropolis Museum, Athens/ Gianni Dagli Orti

Page 224 Photo Scala, Florence

Pages 226–227 Photo Scala, Florence

Page 229 © Mary Evans Picture Library/Alamy

Page 230 The Art Archive/Topkapi Museum, Istanbul/ Alfredo Dagli Orti

Page 233 The Art Archive/Scrovegni Chapel, Padua/ Alfredo Dagli Orti

Pages 234–235 © The Art Archive/Corbis

Page 236 © Bernard Annebicque/Corbis Sygma

Page 239 © The Art Archive/Alamy

Page 240 © guichaoua/Alamy

Page 244 © The British Columbia Collection/Alamy

Page 247 Courtesy of Sheila Schoonhoven

Page 248 © Alinari Archives/Corbis

Page 251 O. Louis Mazzatenta/National Geographic Stock

Index

The 101 works of art discussed in the main text are all highlighted in **bold**.

S

T

U